PC Magazine®
Printing Great Digital Photos

PC Magazine® Printing Great Digital Photos

David Karlins

Wiley Publishing, Inc.

PC Magazine® Printing Great Digital Photos

Published by
Wiley Publishing, Inc.
10475 Crosspoint Boulevard
Indianapolis, IN 46256
www.wiley.com

Library of Congress Cataloging-in-Publication Data

Karlins, David.
 Pc magazine printing great digital photos / David Karlins.
 p. cm.
 Includes index.
 ISBN 0-7645-7578-3 (pbk.)
 1. Photography—Digital techniques. 2. Digital printing. 3. Image processing—Digital techniques. I. Title: Printing great digital photos.
II. PC magazine (New York, N.Y.) III. Title.
 TR267.K36 2004
 775—dc22

 20040colorredeye removal,17039

Credits

EXECUTIVE EDITOR
Chris Webb

DEVELOPMENT EDITOR
Ami Frank Sullivan

TECHNICAL EDITOR
Bruce Hopkins

PRODUCTION EDITOR
Eric Newman

COPY EDITOR
Stefan Gruenwedel

EDITORIAL MANAGER
Mary Beth Wakefield

VICE PRESIDENT & EXECUTIVE GROUP PUBLISHER
Richard Swadley

VICE PRESIDENT AND EXECUTIVE PUBLISHER
Bob Ipsen

VICE PRESIDENT AND PUBLISHER
Joseph B. Wikert

PROJECT COORDINATOR
Erin Smith

GRAPHICS AND PRODUCTION SPECIALISTS
Amanda Carter
Brian Drumm
Lauren Goddard
Denny Hager

QUALITY CONTROL TECHNICIANS
Susan Moritz
Dwight Ramsey

BOOK DESIGNER
Erin Zeltner

ILLUSTRATOR
Brian Drumm

PROOFREADING AND INDEXING
TECHBOOKS Production Services

COVER DESIGN AND ILLUSTRATION
Anthony Bunyan

About the Author

David Karlins is a graphic designer and photo editor who teaches at the San Francisco State University Multimedia Studies Program and University of California Extension School of Graphic and Interactive Design and Photography. He is the author or coauthor of 20 books on digital print technology and graphic design, including *Total Digital Photography: The Shoot to Print Workflow Handbook* (Wiley, 2004) with Serge Timacheff. Visit and contact David at www .davidkarlins.com.

To my sister and brother-in-law, Susan and David

Acknowledgments

I experimented with dozens of printers, calibration and other devices, paper and media, ink, and at least 30 software packages in the course of writing this book. Several manufacturers provided me with products or access to their technical folks. All of them did so without strings attached. Although in a number of cases they provided useful technical reviews of content, they in no way influenced what I wrote.

Thanks to the following companies for providing equipment, resources, and advice:

- Canon USA (www.canonusa.com)
- Epson (www.epson.com)
- Hewlett-Packard (www.hp.com)
- North Texas Graphics (www.northtexasgraphics.com)
- Pantone ColorVision (www.colorvision.com)
- Printroom (www.printroom.com)
- Sony Corporation (www.sony.com)

I drew on a wide variety of photographers and photos for this book, ranging from my editor's cute baby pictures to work from professional photographers with extensive portfolios. Thanks to all of you!

The following photographers contributed to this book:

- Joli Ballew (www.joliballew.com)
- Bruce K. Hopkins (www.bkhopkins.com)
- Robert Reiter (www.lightroom.com)
- David and Ingrid Sausjord
- Dave Taylor (http://portfolio.intuitive.com)

To order professional-quality prints of photos used in this book, go to the Web site of the photographer or to www.printroom.com/pro/davidkarlins.

Contents at a Glance

Contents

Introduction

Dedicated photographers know the wonderful thrill of translating a captured image into a printed photograph. While real life obviously is infinitely more textured and complex than a two-dimensional color photo, a printed photograph can capture and share a unique perspective on that colorful, complex world.

Why I Wrote This Book

The explosion of digital photography has opened up tremendous new vistas for digital printing. Traditional amateur photographers had to convert their basements into dark, smelly, chemical-filled lairs. Today's digital photographers can run a complete digital darkroom on a computer and printer. The ability to edit and print wonderful color photos is within the reach of every digital photographer.

All of this presents what can be a rather bewildering barrage of challenges. How many megapixels does your camera need to capture in order to make a nice 8" × 10" print? Why do skin tones turn blotchy and clouds lose their feathery look when you print them? Why did ink smear on your expensive printer paper? Can you set some budget constraints on how much a digital darkroom is going to cost?

This book provides you with information and techniques to navigate through this maze. You'll learn to minimize the amount of trial and error involved in printing great digital photos. You'll reduce the number of ugly surprises rolling off your printer. You'll learn to keep your expenses under control by sifting through the deluge of claims, promises, and numbers you confront when you set up your digital printing environment.

All that said, a theme running through this book is that while digital printing is a science, it's mostly an art. There is no recipe for great digital printing, and that is what makes the process so exciting and fun.

Whom This Book Is For

I've written this book for anyone who wants to print great digital photos at home, at work, or in a small-scale studio. There are many, many good books on taking digital photos — but this isn't one of them. You bring the digital photos — on a memory card, a CD, or in your digital camera — and I'll walk you through everything you need to know to produce really spectacular prints.

Throughout this book, you'll find digital print options for different levels of technology, skill, and quality. If you're brand new to digital printing, on a tight budget, and not sure you want to invest a lot of time in learning complicated photo editing software, I'll show you how to produce nice photos quickly and easily (and inexpensively) using free software, low-cost

printers, and photo paper and ink that fit your budget. I'll also show you how to push the envelope of what's possible with home digital print technology to create really stunning, professional-quality prints.

Whatever operating system and software you have installed is good enough — at least to get started. Throughout the book, I'll make you aware of additional investments you might want to make to raise the quality of your prints.

What You Need to Use This Book

The one thing you need to get something out of this book is an interest in printing great digital photos. Your enthusiasm for and skill at printing great digital photos will increase tremendously as you see how easy and fun it is to produce prints that almost everyone will consider at least as good as those from a traditional film developer.

This book will help you print great digital photos regardless of what software you have, what brand of printer you use, and what hardware and operating system you use. That said, editing and printing digital photographs does put some stress on your computer's processing resources. Chapter 1 explains the need for additional memory to work with the large photo files that are required for really great prints. But my advice is to start with what you've got; as you read this book, you'll be in a better position to make informed decisions about what hardware and software you might want to invest in.

Because this book provides detailed overviews of a wide scope of hardware and software, I do not recommend, much less require, that you have anything in place before you start reading. I demonstrate the benefits of hardware tools like calibration and profiling devices. I explain why you need large amounts of processing memory in your computer. I discuss, compare, and contrast the quality of prints produced by six-, seven-, and eight-color inkjets. I show you how to print wonderful small photos with dye sub printers. I explain how photo editing software like Adobe Photoshop works its magic. I illustrate how high-quality photo paper and long-lasting ink contribute to archive-quality photos. As I do all this, you can make your own decisions about what you want for the photo quality you need. This book is not sponsored by any one particular printer manufacturer or print technology. I candidly discuss the advantages and disadvantages of a wide array of print options, including sharing some insights on cost control.

All you need is your own digital photos. I do not spend much time on how to take digital photos or how to convert traditional film slides, negatives, or prints into a digital format. Instead, I write about digital photo file formats and help you work with your digital photos. The focus of this book is to do justice to the complex, challenging, and really fun experience of printing digital photos.

Conventions Used in This Book

To help you get the most from the text and keep track of what's happening, I've used a number of conventions throughout the book:

 ■ When I first introduce them, I highlight *important words* in italics.

- Characters I want you to **type** appear in bold font.

- I show keyboard strokes like this: Ctrl+A (⌘+A), which means that the Windows keystroke appears first and the corresponding Mac keystroke follows in parentheses.

- Photo print sizes are listed as numeral measurements only. Unless otherwise stated, you can assume that all print sizes are measured in inches. (For example, 8 × 10 means an 8" × 10" print.)

Following is a brief description of the other material in this book.

Asides

Each aside draws your attention to some additional information that enhances the topic under discussion. The information might be a suggestion to improve your efforts or an interesting piece of information. Occasionally, asides contain a reminder about a crucial piece of information that requires extra attention on your part.

Cross-Reference

Cross-References point you to other chapters or books that cover in more detail a point just mentioned in the text. I also place cross-references in parentheses within the text.

How This Book Is Organized

This book is structured to walk you through the process of preparing, editing, and printing digital photos from beginning to end. After learning all about the process and the equipment and supplies you need, you'll learn how to set up your computer system for the best prints and then how to set up your photos for the best prints. The next phase takes you through supplies and specifics for different kinds of printers. Finally, you'll spend some time experimenting with different options for printing using online services and printing to different media like T-shirts, mugs, and stickers. The book closes with a nod to the more artistic among you who might want to frame your hard work for posterity.

- Chapter 1 is a somewhat detailed introduction to the concepts, terms, and technologies used in digital printing. It's not dull — the actual process of producing millions of colors from an inkjet (or dye sublimation) printer with four, six, or eight colors can be pretty fascinating. A basic understanding of that process will demystify many of the challenges of producing great prints.

- Chapter 2 focuses on calibrating your monitor for accurate previewing of how colors look when your photos print.

- Chapters 3 and 4 show you how to edit photos using a variety of photo editing programs like Adobe Photoshop, Photoshop Elements, Ulead PhotoImpact, Jasc Paint Shop Pro, and free software that comes with printers. I walk you through techniques ranging from basic touch-up and color correction to effects like black-and-white prints and red-eye removal.

- A major emphasis of this book is on the final steps of printing great digital photographs. Chapter 5 explores the science and art of using and getting the most from appropriate ink and paper choices. Chapter 6 explores in detail how to squeeze the best quality out of inkjet printers. Chapter 7 is devoted to consumer-level dye sublimation printers like the little Olympus, Sony, and Canon printers that use the same technology as commercial photo printers.

- Your digital photos can be printed — with very high quality — on everything from T-shirt iron-on transfers to professional-quality greeting cards and mugs. I show you in Chapters 8 and 9 how to do that yourself or, when necessary, order these special prints online.

- Chapter 10 surveys online print options ranging from Walmart.com, Shutterfly, Ofoto, and iPhoto to professional-quality photo print services.

- Completing the process, Chapter 11 covers storage, digital scrapbooking, and framing techniques to preserve your photos.

PC Magazine®
Printing Great Digital Photos

Chapter 1

Preparing Your Digital Darkroom

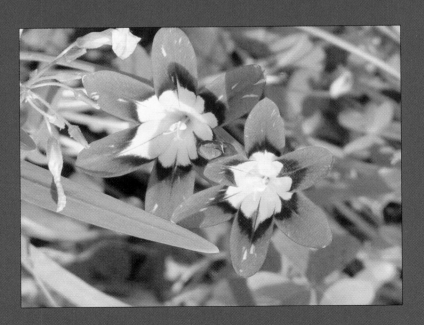

Y ou've taken a photo with your digital camera. A wide range of options is now open for you to produce a digital print of your photo. At the most basic end of the spectrum, many photo printers allow you to print directly from your camera or from a memory card.

Considering you've taken the time to pull this book off the shelf, you're probably interested in creating higher-quality prints than those that come straight from your camera. This book shows you that if you spend a bit of time in the "digital darkroom," you can produce much better color (and even black-and-white) digital prints.

What is the digital darkroom? It's many things—software that organizes and edits your photo files and hardware that allows you to view, store, and process photo files (see sidebar). The final stages of the digital darkroom include printer, ink, paper, and perhaps other media to create a print. This book walks you through the entire digital darkroom process, and this chapter gives you an overview of what you need and how you use it.

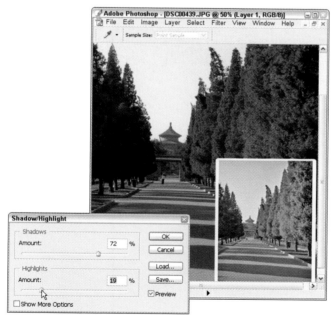

Figure 1-1: Half the work of creating a great digital print takes place before you adjust the settings on your printer.

Quality In, Quality Out ...

Keep in mind as you build your digital darkroom that equipment can do only so much. The adjustments you make to your printer, the paper and toner you select, and other printer-related elements will affect the quality of your print tremendously. That said, no printer can transform a blurry, dim, low-contrast photo into a spectacular presentation of precisely the scene you saw when you photographed it. Half the work of creating a great digital print occurs before you adjust the settings on your printer or select toner cartridges and paper.

This book guides you through the steps of transferring your quality-captured image into a spectacular print. I do not attempt to advise you on how to take photographs. There are many wonderful resources, teachers, classes, and books that can help you set up and take great photos. (Check out *PC Magazine Guide to Digital Photography* [Wiley, 2004] by Daniel and Sally Grotta.) Instead, I guide you through some photo-editing techniques you can use to enhance the quality of your prints. Even though I show you how to enhance your photos digitally to improve print quality, you still want to start with the best image you can get. Figure 1-1 shows a photo being digitally edited in Adobe Photoshop (also known as being "Photoshopped").

Evolution of the Digital Darkroom

The darkroom has always carried a kind of mystical quality. The traditional film photographer plunged into a chemical-filled, closet-like space illuminated only by red lights. After hours of experimenting with filters, cropping, and dodging and burning (brightening or darkening selected areas), the photographer emerged with a carefully crafted work of art.

The modern digital darkroom is just as exciting—but without the smell! Digital photography is just as much an art and science as its predecessor, traditional photo development and printing. The remainder of this chapter introduces you to the elements of creating great digital prints and previews the themes, topics, and techniques that will become familiar to you throughout the course of this book.

Editing Is Nothing New

Long before photos were digitized and edited with software like Photoshop, they were airbrushed, cropped, and, yes, even composited (one photo combined from several photos). A friend of mine who worked on *Playboy* centerfold photos twenty years ago once regaled me for hours about how little those photos corresponded to the actual models.

Setting aside techniques that distort or change the content of photos, darkroom techniques have traditionally been employed to add contrast to photos, to blur or brighten an entire photo or sections of a photo, to filter coloring, and so on.

Components of the Digital Darkroom

Before diving into the specific elements of printing great digital photos, it will be helpful to survey the components of your digital darkroom. Don't run out and buy everything listed here — certainly not yet. But as your standards rise, understanding these elements will help you gradually improve the quality and efficiency of your prints.

Of course, what you need first of all is a color printer. But even before you send any photo to a printer, you need the core component of your digital darkroom: a computer, monitor, and photo editing software. A properly configured monitor allows you to "proof" photos before you print them.

Which Printer Is Best?

In this chapter, and throughout the book, I explain the features to look for in a printer — inkjet cartridges, resolution, paper size, and so on. I do not, however, recommend any particular brand. For one thing, new models appear almost weekly — faster, cheaper, and better than last month's models. More to the point, there are numerous quality printers, and if you know what features you want and what you need to do to get the most from your printer, that's the most valuable help this book can provide. At the end of this chapter, I present a concise overview of the kinds of printers available for digital printing.

Table 1-1 summarizes what you want to have in place, or think about getting, to prepare to print great digital photographs.

Table 1-1　Elements of a Digital Darkroom

Component	Why You Need It	Buyer Beware
Printer	To create great digital photos.	New developments improve quality constantly. High print quality depends on special photo print cartridges and high-quality photo paper, as well as clean inkjet nozzles.
Computer	To organize, store, and edit photos. Large images are edited faster with high-speed processors. Appropriate settings and memory allow for more accurate image editing.	Image editing programs are memory hogs. You want at least 512 MB of RAM (accessible, temporary memory) and, sooner or later, one or more external hard drives.

Continued

Table 1-1 Elements of a Digital Darkroom *(continued)*

Component	Why You Need It	Buyer Beware
Monitor	To view photos before printing them. A high-resolution traditional CRT (cathode ray tube) monitor provides the most accurate view of photos. New (flat-screen) LCD (liquid crystal display) monitors are improving in color accuracy.	By age four, your CRT has typically lost so many red pixels that accurate calibration between the monitor and printed photo is impossible. LCD monitors are often less reliable than CRTs for color display.
Photo editing software	To crop, touch up, and edit photos. This software ranges from free and easy to learn to expensive and confusing.	Repeated saving of images in JPEG format degrades image quality.
Ink	To print photos on paper. New photo-cyan and photo-magenta cartridges enhance reds and blues.	For high-quality photo printing, avoid unauthorized third-party replacement cartridges for quality photo work.
Paper	To view photos outside the computer. Coated papers provide dramatically better prints, as shown in Figure 1-2.	You must synchronize appropriate toner cartridges and printer settings to maximize the impact of glossy and other photo paper.
Scanner	To convert analog photos and slides into digital images, ready for printing.	Scanners in the $300 range produce less digital "noise" (specks).
Calibration device	To measure and coordinate colors among the monitor, scanner, and printer.	These work best with a newer model CRT and are less effective with LCD monitors.
Calibration software	To match the profile (color display) of your monitor with your printer and other peripherals.	This can be helpful but less effective than physical calibration devices.

Camera Issues: The Great Megapixel Race

Better digital cameras take better pictures and create the possibility for better prints. A full survey of how to select a digital camera is beyond the focus of this book. Study the reviews, choose the best lens you can afford, and price other goodies ranging from a reliable flash attachment (necessary) to in-camera editing options and power packs.

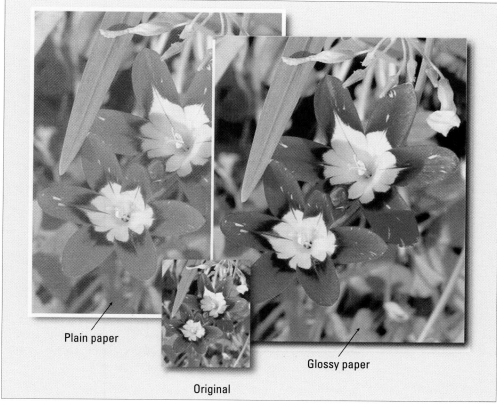

Plain paper

Glossy paper

Original

Figure 1-2: Upgrading to quality glossy photo paper produces dramatic results.

One element that is prominently displayed and discussed — and is particularly relevant to the quality of your digital prints — is the megapixel capacity of your digital camera. In short, larger megapixel values allow you to print higher-quality, larger photos. The megapixel capacity of your camera is also a major factor in the price you pay. Although you want to avoid paying for unnecessary megapixel capacity, be sure to buy a camera that takes large enough pictures to yield quality printed results.

As I write this, I'm hearing from sources in the digital camera industry that the standard is heading toward 10 megapixels — and we'll all be able to afford it, too. At the moment, however, 8 megapixels is the standard for high-end (professional quality) digital cameras and you probably do not need that much.

10 Megapixels?

While my industry sources insist we'll all need 10 megapixel cameras "soon," the fact is that more affordable 3, 5, and 8 megapixel cameras are fine for most photo enthusiasts. The additional memory in a 10 megapixel camera becomes critical only when printing poster-sized (or larger) photos.

If you're printing only 4 × 6 photos, you can do fine with a 2 megapixel camera. Your 5 × 7 prints will look good too but not as good as prints from your local photo print shop.

High-quality cameras like the Canon 10D support 6.3 megapixels, which create files that can be printed on 9 × 13 paper at a very high level of quality.

Higher Resolution Equals Easier Editing

In this section, I use a very conservative figure of 300 dpi resolution for saving photo files. For a looser estimate of what size print you can squeeze out of a particular megapixel value, double the values here (based on 150 dpi files). Many high-quality professional photos are saved in final form at 180 dpi or less but you have the most freedom to edit images when they are saved at higher resolutions.

Table 1-2 provides a rough estimate of how many megapixels you need for various print sizes (see sidebar). There are many factors to consider in choosing a digital camera and many features to investigate on your own, but this book focuses on the megapixel factor because it relates directly to print size.

Table 1-2 How Many Megapixels Does Your Camera Need?

Megapixels	Price Range	Size of High-Quality Prints
2	$130–$450	Excellent-quality 4 × 6 prints, fair-quality 5 × 7's, and proof-quality 8 × 10's
3–5	$200–$900	High-quality 8 × 10's
6–8	$600–$1500	Up to 11 × 17 high-quality prints

Your Computer, Your Monitor ... and Your Prints

Both accurate color representation and photo editing software put steep demands on your computer's processing capacity. Here I briefly alert you to issues related to your system and settings that will help smooth the path to great digital prints. In Chapter 2 you will discover how to use special software and calibration tools to configure a quality monitor to display colors accurately as they appear in prints.

YOU CAN NEVER HAVE TOO MUCH MONEY ... OR TOO MUCH MEMORY

A philosophical and moral argument can be made that there is such a thing as too much money. But you'll find that in working with and printing digital photos, more memory always helps.

To configure your system for accurate color display, you'll do yourself a favor by starting with a CRT (cathode ray tube) monitor that is no more than two to three years old.

Confused About Resolutions?

There are an awful lot of resolutions floating around out there, and I'm not talking about those promises you make to stick to your diet and exercise program every New Year's Eve. Your printer promises a resolution of 4800 × 1200 dpi. Your camera can capture 8 megapixels but you need a university computer lab to calculate exactly what that means. Meanwhile, your photo editing software saves images at 300 dpi (or something like that). In the course of this book, I break down each of these resolution factors in detail. For now, here's a quick explanation.

Image resolution is measured in *dots per inch* (dpi) or *pixels per inch* (ppi), the former more often to describe print resolution and the latter more often in reference to digital display (on a monitor). Image editing software can change the size of your photos without degrading the resolution of your image. Alternatively, you can reduce the size of your file while maintaining the same image size by reducing the resolution of your image. Photos you display online only (or in e-mail) will be fine at 72 or 96 dpi; however, photos you wish to print should be saved at 300 dpi. How all this works and is done is detailed in Chapter 4.

Higher resolution prints have more detail and look better in general. Your digital camera (or scanner, if you are using prints) must save image files with sufficient pixels to support high-resolution printing. How do you know if your camera is capturing enough pixels to produce a high-resolution print? You can use Table 1-2 or do the calculations yourself. Camera memory capacity is measured in *megapixels,* which is one million pixels. Printing at 300 dpi, a 4 × 6 print requires about 2.2 megapixels (4 × 300 × 6 × 300). So a 2.2 megapixel camera can produce a file that prints a very high-quality 4 × 6 print.

Inkjet printers advertise dpi resolution capacity that is much higher than required for your image file. The true resolution of inkjet printers is measured in *dots per inch* (dpi). A 1200-dpi printer means that each dot is 1/1200 inch. In general, higher resolution yields finer detail and smoother shapes. Additional resolution allows printers to generate four-color (or more) printing at higher speeds.

While it's helpful to understand the various resolution levels associated with cameras, printers, and scanners, it's even more important to understand that comparing the resolution rates for computer files and print files is an apples/oranges proposition. This is because monitors and printers generate color and content very differently. Chapter 2 explores in detail synchronizing your computer and monitor with your printer.

LCD Monitors Do Not Calibrate Well

Serious photographers rely mainly on CRT monitors for soft proofing. LCD monitors — like those wonderful, flat, space-friendly ones — do not reproduce color as reliably. As you'll see in Chapter 2, they do not calibrate as accurately either — which reduces their effectiveness for *soft-proofing* or accurately editing and previewing photos on your computer before printing. That said, I've seen pros do all the photo editing they need to do on a laptop (LCD) screen before shipping off a photo to a client. So although CRTs are better, you can get away with editing images on an LCD monitor.

You need sufficient memory in your computer to support the highest level of color display. Digital designers generally agree that 512 MB of RAM serves you much better than the recommended minimum memory that came with your operating system, or the "minimum" memory recommendations of your image editing software.

Not only is memory a huge help in enabling your system to display and edit photos; it's also a relatively good value. Your computer manufacturer or retailer is more than happy to sell you additional RAM. In many cases you can install it yourself. You've already invested money in your camera and other photo equipment; you don't want your computer to be the choke point in producing nice prints.

OPTIMIZING SYSTEM COLOR SETTINGS

One important element of relatively hassle-free color management is coordinating your monitor with what comes out of your printer. Chapter 2 explores in depth how your monitor presents colors and how to mesh that with how your printer produces color. Let's look quickly at some computer settings that facilitate calibrating and coordinating your system for consistent color management.

Your monitor generates colors using the red-green-blue (RGB) additive system. This means that colors other than red, green, or blue are created by mixing combinations of those colors. For instance, combining green with red pixels creates yellow. Your printer, on the other hand, layers cyan, magenta, yellow, and black toner to create colors. That system is referred to as the CMYK system. (The abbreviation stands for cyan, magenta, yellow, and black — the letter *K* being used to avoid confusion with *B* for blue.) The two color systems are illustrated in Figure 1-3.

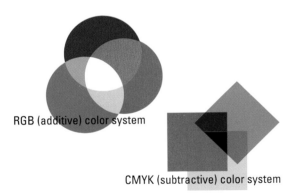

RGB (additive) color system

CMYK (subtractive) color system

Figure 1-3: The RGB and CMYK color systems

The RGB color system that generates a wide array of colors on your computer uses more than simply red, green, and blue pixels. Each of these three basic colors is subdivided into hundreds or thousands of tones to create subtle gradations in color that are essential for accurate color presentation.

By combining elements of red, blue, and green, computers generate thousands, millions, or even billions of different colors, tones, and shades. Higher color-quality settings (defined using your operating system) produce more accurate colors. The range of colors produced by your operating system and displayed on your monitor is measured in *bits* — which is a techie term for micro amounts of data.

A Bit More on Bits

The "bit" terminology is related to how computers function — in this case how they detect, digitize, and display colors. Older (by now obsolete) systems supported 8-bit color, which was capable of displaying only hundreds of colors. By comparison, 16-bit color produces thousands of colors, 24-bit color displays millions of colors, and 32-bit color can generate billions of colors. In general, the highest setting available for your system produces the most accurate view of your photo.

To make sure your system is configured for the highest available color setting, execute the following steps:

1. Right-click on your desktop and choose Properties from the menu.

2. Click the Settings tab.

3. Choose the highest possible setting available in the drop-down menu in the Color Quality section of that tab.

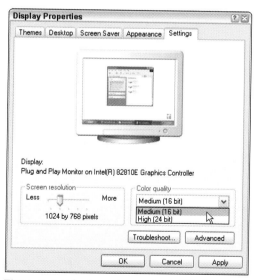

Figure 1-4: Selecting color quality in Windows XP

To define the best color quality for a Mac running OS X, follow these steps:

1. Click the apple menu icon in the menu bar.

2. Choose System Preferences → Displays.

3. Choose Millions from the Colors pop-up menu.

CALIBRATION HARDWARE AND SOFTWARE

The essential challenge you face with soft-proofing (previewing your prints on a monitor) is that your monitor generates RGB color by backlit pixels, while your printer mixes four (or more) colors of ink to generate color. These two systems do not communicate well.

One time-tested solution is simply to print, adjust the colors, and print again until your print comes out with just the right shade of red, blue, or mauve. This option can quickly become frustrating and expensive.

The better solution is to use software, and sometimes hardware, to calibrate your monitor with your printer output (see Figure 1-5). This means fine-tuning the color monitor and printer settings so they match. This calibration is not perfect, but it produces remarkably more synchronization between what you see and what you get.

Cross-Reference

Chapter 2 describes in detail how to use hardware devices, like the one shown in Figure 1-5, to detect accurate readings of what color is displayed when your monitor tries to produce that color.

Figure 1-5: A calibration device attached to a monitor

By defining, for example, exactly what red means on your monitor and then incorporating a profile from your printer (or other hardware device), you can use calibration to greatly reduce color mismatching between the monitor and printer. A profile is a file that documents how any device (monitor or printer) "sees" a defined color. Profiles for devices (referred to as ICC profiles) can be loaded into image editors like Adobe Photoshop to manage color coordination automatically.

Generating Quality Scans

Many people convert regular (analog) photos and slides to digital files to take advantage of accessible and powerful digital editing and printing technology. Others convert older, fragile photos to permanent digital files.

If you're shopping for a scanner, resolution is not the main issue. As I mentioned earlier, 300 dpi is all the resolution you need for high-quality prints, regardless of the high resolution numbers on your printer or in your scanner documentation. What you want to look for in reviews is an evaluation of the quality of your scanner: Look for scanners that minimize distortion and noise.

Windows XP and Mac OS X integrate your scanner with their software so you can import directly into your printer an image of something scanned. For best results, scan the object in its entirety. Later you can crop and resize the scanned image in the editing software, while preserving the original.

Two settings you should concern yourself with are colors and resolution. At this point, the more colors and the higher the resolution, the better. You can always decrease the file size by reducing the colors and resolution, but it's much harder, and fundamentally impossible, to "restore" color gradation and pixels lost in the original scan. Figure 1-6 shows a photo scanned at 300 dpi and 24-bit color.

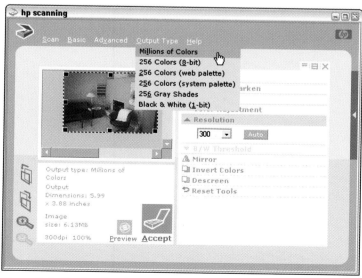

Figure 1-6: Configuring the scanner as you prepare to scan a photo

Millions of Colors?

Figure 1-6 shows an image scanned at "millions of colors," a term for 24-bit color.

Digital Darkroom Software

You cannot turn a pumpkin into a princess, but you can do a tremendous amount with photo editing software. In fact, it's safe to say that photo editing software is essential to getting great digital prints.

Cross-Reference

Chapters 3 and 4 explain how to turn good photos into great prints by brightening, cropping, resizing, color-fixing, and sharpening your photo image files.

Photo editing software is not just for correcting flaws in your photo. You may have composed your photo perfectly, set the lighting just right, and taken the "perfect" picture. Even in this unlikely scenario, your digital camera has probably integrated some digital noise — objects that aren't really there — into the file. In any event, you can still do quite a bit to enhance your photo with photo editing.

Use Camera Card Readers to Rough-Proof

You will not get great digital prints simply by popping your camera's flash memory card directly into a printer slot — even if your printer performs some minimal image editing. Although this technique is useful for seeing a *rough proof* of what your digital camera saw, it's not an acceptable way to maximize the quality of your final print.

Very basic photo editing tools come with your computer's operating system. They allow you to organize, rename, and view your photos. In Windows XP, for example, you can view photo thumbnails in Windows Explorer. Double-clicking a photo in Explorer previews a full-sized, zoomable version of the image in Windows Picture and Fax Viewer, as shown in Figure 1-7.

Many of the features I explore in this book are available in almost any photo editing package, of which there is quite a good selection. Your printer may have been bundled with its own photo editing software, or with Adobe Photoshop Elements. Photoshop Elements is essentially a subset of the professional-level Adobe Photoshop. An example of editing in Photoshop Elements is shown in Figure 1-8.

Whenever I explore touching up photos with photo editing software, I'll keep my advice and instructions generic, so that you can comfortably use whatever tool is at your disposal. If I ever need to describe a specific tool in Photoshop, I'll take you there. For instance, Figure 1-9 shows me touching up just the blue in the sky with Photoshop.

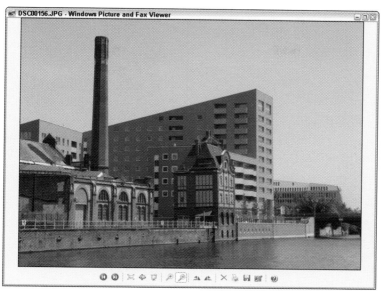

Figure 1-7: Windows XP comes with the Windows Picture and Fax Viewer.

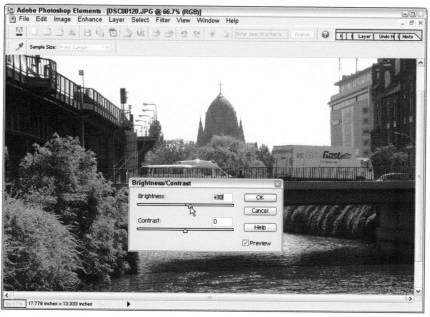

Figure 1-8: Editing an image in Adobe Photoshop Elements 2.0

Figure 1-9: Adobe Photoshop ships with some powerful selection and touch-up tools.

REMOVING DIGITAL NOISE

You can improve almost any photo using features like contrast, color, and brightness correction. But there are also issues related specifically to images captured with digital cameras (or scanners) that require some correction to remove artificial input (junk) that ends up in your photo.

Noise is sometimes short-handedly described as grain in a photo. Noise can be unintended visible specks in a photo. On the other hand, photos with no noise at all can look artificial — resembling designed graphics more than real photographs. Image files with too much noise look grainy and distorted.

Decreasing "Digital Noise"

Cameras and scanners collect digital noise as they digitally imprint objects. Higher-quality cameras and scanners produce less digital noise. Image editing software can help correct digital noise, as well as other distortions that occur during the digital capture process.

IMPROVING COLORS AND CONTRAST

Because art imitates life and, more specifically, because your digital camera reflects part of what you see, you can almost always enhance your image by raising the brightness and, often, the contrast of your photo.

There are times when, for effect, you won't want to do this; you might want to darken a photo for artistic reasons. In any case, the brightness and contrast controls available with the most basic photo editing tool can improve your printed photos tremendously. Figure 1-10

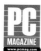
shows a photo enhanced by adding brightness — the simplest, most universally available tool for image editing that comes with every operating system and photo software package.

Figure 1-10: An image improved by brightening

HANDLE DIGITAL FILES WITH CARE

While an exploration of the whole process of taking and transferring digital photos to your computer is beyond the scope of this book, I do want to caution you against repeated resaving of files in some formats, such as JPEG.

Most digital cameras save by default to the JPEG format. This format records enough data to preserve a highly accurate image. More expensive, professional-quality digital cameras also allow you to save photos in the RAW file format, which captures even more data and allows for more freedom in digital editing.

However, you need to take caution when saving your photos. The JPEG format is very "smart" — perhaps too smart. It tries to economize the file size by eliminating some of the data associated with the photo. Every time you edit a photo in JPEG format, you lose some of the quality. This happens quite invisibly. For example, if you use software that comes with your camera or operating system to resize a file, you will likely lose the data that would allow you to enlarge it later to the original size.

Cross-Reference

For more on why JPEGs do not work well for editing purposes, see Chapter 3.

For optimal digital archiving of photos, do not reduce the file size. It's wisest to save your image files in the RAW format from your digital camera (if available), or to the stable TIFF format, at the original resolution with which they were captured. You can then save *copies* of your file as JPEGs for sharing on the Web, or smaller sized TIFFs for digital printing.

Printers

All three components of printing digital photos are in the process of undergoing revolutionary changes:

- Cameras continue to add features and capability, and drop in price
- Image editing software has become firmly embedded as the middleman between camera and digital prints
- Printers are improving rapidly in quality

Of these three components, probably no element of the equation has developed as rapidly as accessible, almost professional photo-quality printers.

The most rapidly developing and widely accessible printer for the home or home-office enthusiast is the adaptable inkjet printer. Inkjets have evolved in a few short years from office machines for folks who couldn't afford a laser printer to high-quality equipment capable of producing color photos that most people cannot distinguish from traditional photographs.

At the same time, you should be aware of other digital photo printers, some that may, in fact, well suit your requirements as you acquire the need for either higher-quality or faster printing. The four main print options are as follows:

- Dye sublimation (or dye transfer) printers
- Inkjet printers
- Laser printers
- Photo printers

Each of these types of printers has distinct technology and provides quite different results. Don't rush out and buy any new printer(s) just yet. The techniques described in this book to help you prepare photos for printing are equally appropriate to each type of printer. I identify unique considerations for different print output options along the way.

INKJET PRINTERS

Intuitively named inkjet printers shoot out tiny jets of ink to create dots on a page. High-resolution, photo-quality inkjet printers spew out dots so tiny that they are hardly discernable to the naked eye.

Given that inkjet printers provide the best overall mix of quality, value, and speed for most of us, it's worth taking a moment to climb inside one and see how they produce those nice prints you want to admire and show off.

Inkjets reproduce photo images by generating lots and lots of really small dots. The higher the resolution (dots per inch), the less noticeable those dots are. That said, high resolution is

not required to conceal the fact that an inkjet photo is composed of dots. Most people cannot detect dots in a print with a resolution of much more than 800 dpi, unless they use a magnifying glass. Therefore, when your inkjet promises 2400 dpi, realize that there are many, many more dots than are necessary to create a smooth-looking print.

The high resolution in photo-quality inkjet printers is there to facilitate accurate color reproduction. Essentially, inkjets use *dithering*—the combining of several tiny cyan, magenta, and yellow dots of ink next to each other—to generate the appearance of a wide range of colors. The colors generated from these three primary colors (plus black ink and, in some cases, other colors) represent the spectrum of color that can be reproduced on paper. Figure 1-11 shows the Canon i860, a photo-quality inkjet printer.

Figure 1-11: The Canon i860 inkjet printer

In general, inkjet printers do not provide the range of dot sizes that dye sublimation printing can—much less the dot sizes that old-fashioned chemical processes provide for traditionally developed prints, which allow for color elements at the molecular level. Not only do different colors depend on how many dots appear in a small area, but the density or saturation—for instance, a range from dark red to light pink—depends on the resolution value (see sidebar).

DYE SUBLIMATION PRINTERS

Dye sublimation has been around for many years. It produces marginally higher quality photos than inkjet printers. The look, and the underlying technology, is closer to that of traditional chemistry-based photo developing than any other print technology.

The Math of Inkjet Printer Resolution

In an earlier sidebar, "Confused About Resolutions?", you learned about the various kinds of resolution values you may run into. Let's look more closely now at the apparent paradox that says you can save a photo file in Photoshop safely at 180 pixels per inch and yet get better prints if you use a 4800 dpi printer to print it. What the heck happened between your image editor and your printer that requires all those extra dots?

Take the following example: A very high-quality photo file saved at 300 dpi is translated to a 4800-dpi printer by making 16 printer dots available for each photo file dot. Those 16 printer dots are dithered (placed side by side) to generate what looks like the color and shade that is captured in the file and reproduced on your monitor. (Monitors can combine portions of red, green, and blue into a single pixel and therefore do not need extra pixels to reproduce color.)

If your printer had a resolution of 300 dpi, only one dot would be available for each dot in your photo. It would therefore not be possible (unless the dots were cyan, magenta, yellow, or black) to reproduce the color on the page accurately.

All that said, print quality is not reducible to resolution. There are very sophisticated techniques available that generate and mix dots coming off your inkjet. It is quite possible for a printer at 9600 dpi to produce worse prints than a printer at 1200 dpi. Generally speaking, however, you do need a lot of dots, and a resolution of at least 1200 dpi, to produce the best-quality photo prints.

Dye sublimation is available in 4 × 6, sometimes 8 × 10, photo printers that are widely available at computer and electronics stores. These are not multipurpose printers; you won't pop out a photo cartridge, replace it with normal color, and whip out some letterhead or a business card — the size, technology, and cost prohibit that.

Unlike inkjets, where each dot is the same size, dye sublimation printers create spots of infinitely variable size, corresponding to the actual placement of color in a photo. Not only do the generated dots vary in size, but the dye sublimation process itself creates very soft dots, in contrast to the relatively hard-edged dots that inkjets generate.

Dye sublimation printers produce color from a ribbon covered with three colors — the same cyan, magenta, and yellow used in all nonphoto printers. The dye is sensitive to heat. When the ribbon is pressed against paper, individual heating elements generate vapors that transfer to the photo paper with very smooth edges. Figure 1-12 shows a dye sublimation printer.

Because the quality is so high, why doesn't everyone print photos with dye sublimation printers? The main reason is cost. While the printers themselves are loss-leaders (sold under value to rope you in), the print cartridges drive the cost of an 8 × 10 print up to around $8. Compare this with the cost of printing an 8 × 10 on an inkjet, which is closer to $1.25. However, if you're mainly looking to print small quantities of 4 × 6 photos, the dye sub printer cost of 40 cents for a 4 × 6 print is in the ballpark with what you'd pay at a photo lab, after you figure in shipping. Dye subs also offer you the advantage of seeing your prints instantly — only minutes after shooting a photo.

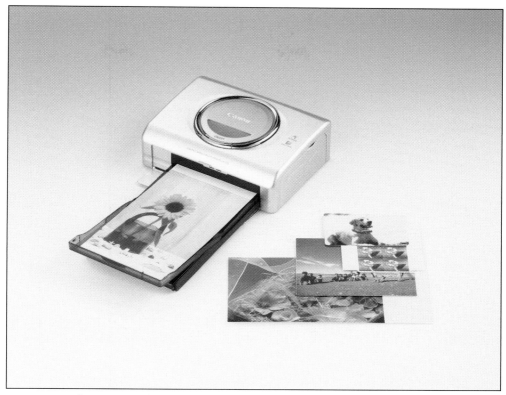

Figure 1-12: The Canon CP-330 dye sublimation printer

LASER PRINTERS

Color laser printers, like the ones you find at Kinko's or in many corporate environments, are an additional option for photo prints. The quality is a bit lower than that of inkjet prints because the resolution is not as high, but the cost of prints is significantly lower, particularly if you print a large number of photos.

With laser prints, the upfront cost is much higher but the long-term cost per print is much lower. The much faster speed of a laser print is an additional consideration. A $5000 laser printer, shared with a room full of professionals, can be an effective way to churn out decent 8 × 10's in 30 seconds.

PROFESSIONAL PHOTO PRINTERS

Photo printers use the same chemical technology to create prints that have been used to develop and print traditional prints. Photo printer technology is the highest quality available for printing but a professional photo printer hardly fits in the budget, or even the home office, of most digital photographers.

Photo printers, like the Fuji Frontier line, run $150–$200. Before you jump online and order one, that's in *thousands*. They work by exposing photo paper to stimuli to generate color; they are not constrained by dot-per-inch resolutions.

While photo printers are not accessible to most of us, photo printing is. You can easily order professional photo printer prints online from companies like Yahoo Photos, or from professional-quality print shops like Printroom.com. Or, you can walk into a Walgreen's or generic camera shop and print digital photos using traditional photo printing technology.

Cross-Reference

I address issues related to preparing photos for print shops throughout the book and return to them in detail in Chapter 10.

CONFIGURING YOUR PRINTER

Every printer has its own settings, like those shown in Figure 1-13. Printer manufacturers work hard to set the defaults in these printer dialog boxes to print quality photos but for *great* photos you'll want to understand, and tweak, these settings.

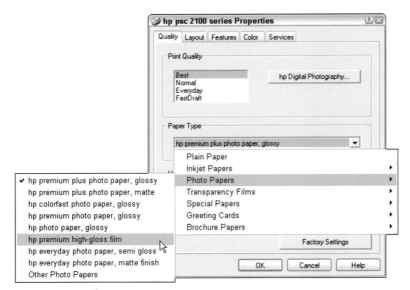

Figure 1-13: Defining printer settings

Cross-Reference

Chapter 7 walks you through the types of choices you can make when you send your files to your printer to maximize the quality of your prints.

Photo-Quality Paper

So now you have the camera, scanner, monitor, calibration device, editing software, and ever-important printer. You're missing only one thing: paper. Photo-quality paper is not just a "little bit better" than regular office paper; it's a lot better. The process of merging tiny droplets of ink from your inkjet printer, or congealed gaseous ink from a dye sub printer, requires a surface that accurately absorbs ink without smearing it. The good news is that there is a competitive market for photo-quality paper and many online vendors provide a huge variety of sizes, qualities, and types of paper.

Photo-quality printer comes in two basic styles. Glossy paper has a shiny, highly reflective surface that tends to produce brighter colors, but more glare. Matte paper is a flatter, more "normal" surface. Within these basic styles, you find many variations — high-gloss, semi-gloss, and so on.

Standard photo paper sizes are 3½ × 5 wallet size, 4 × 6 snapshot size, and regular letter size (8½ × 11) paper. For traditional photo sizes suitable for framing, like 5 × 7 or 8 × 10, you generally want to print on letter-sized photo paper and trim it to fit the frame.

Cross-Reference

For a full discussion of framing photos, including trimming paper, see Chapter 11.

You can't go wrong if you purchase photo paper made by (or for) your printer manufacturer. Epson, HP, Canon, and other printer manufacturers offer full sets of photo paper in different sizes, finishes, and quality. Other paper manufacturers (like Kodak, or boutique photo paper available online) provide software files (called ICC profiles) that configure your printer to work well with their paper.

Cross-Reference

Chapter 5 explains how paper and ink work together with ICC profiles.

Creating a Budget

Many considerations go into planning a budget for a digital darkroom. You have to think about what you already have that you can use, how many prints you make in a given timeframe, and what you do with those prints (mail them to Grandma, make calendars as holiday gifts, print flyers for your home-based business, offer marketing services to small businesses, create advertisements for your work, and so on). Still, there are some generic guidelines to follow. This section gives you a barebones list with upgrade options and what you can expect to spend.

Surprisingly, perhaps, I'm going to start by emphasizing the importance of having a computer with at least 512 MB of RAM. As you expand your collection of digital photos and increase your level of photo editing skills, you may well want to add an external hard drive (and, later, more than one) to store photos. Without enough RAM to process your image files, however, you'll experience frustration, slowness, and infuriating crashes. Digital darkrooming isn't much fun with less than 512 MB RAM; in fact, 1 GB (*gigabyte = 1000 megabytes*) is a good baseline level if you plan to do a lot of editing with more advanced image editors like entry-level Photoshop Elements or professional-level Photoshop.

Good photo printers start at $200; you can produce really excellent photos from printers that cost less than $600. You might elect to get a high-quality photo printer right away, or you may decide to squeeze pretty decent photos out of a regular home inkjet printer for a while and get your higher quality prints from an online or walk-in photo shop.

The calibration alternatives explored in Chapter 2 range from free (downloadable eyeball tools for tuning the color in your monitor) to several hundred dollars for automated calibration systems. Calibration is an option, not a requirement, and most amateurs will not need to start out with a super-accurately calibrated monitor.

Quality photo paper is available at a wide range of prices. Feel free to start out with whatever you find on sale online or at your local computer mart or office supply store. Later you can raise the quality of your prints by ordering special paper configured specifically for your printer.

Ink costs vary widely, too. More expensive printers usually have lower ink costs because they require individual color cartridges to run. Because I print a lot of red, I replace the magenta (near red) cartridge in my printer twice as often as I replace the green cartridge. If had to throw away a four-color cartridge every time I used up the red, I would be throwing away too much money. On the other hand, cartridges with three or more colors in a single cartridge, like those that ship with most HP color photo printers, are convenient.

Like every other endeavor, printing great digital photos involves nonquantifiable costs—better lighting, an upgraded workspace at home, shelving for materials and supplies, space for larger printers, connecting USB cords, and additional outlets. But hey, why worry about that now? Start pumping out awesome digital prints and *then* approach your significant other, parents, or roommates and break the news that you'll be taking over more of the house and using most of the budget so they can enjoy your great prints. If you prefer a more rational plan for paying for all of this, perhaps Table 1-3 can help.

Table 1-3 Planning a Digital Darkroom Budget

Item	*Considerations*	*Cost Range*
Computer memory	You need at least 512 MB of RAM to keep your computer from freezing up when you edit large photos. Make sure the RAM you purchase is compatible with your system!	Adding 256 MB of RAM to your system costs between $50 and $100.

Item	*Considerations*	*Cost Range*
Hard drive storage	External hard drives store hundreds or thousands of photos. Without them, you'll eventually fill up your computer's hard disk space.	Expect to pay about $130 for 80 GB, $170 for 160 GB, or about $250 for 250 GB of storage.
Printer	Inkjet quality (and therefore price) depends mainly on resolution (dots per inch) and the number of inks.	Lower resolution, four-color ink photo printers start at less than $200. Very high-resolution, eight-color personal photo printers start at around $500.
Ink	Individual cartridge refills are cheaper (but a bit more hassle) than replacing all-in-one ink cartridges.	Individual photo ink cartridges cost $10 to $20 each. Many all-in-one color cartridges range from $30 to $40.
Paper	Paper prices vary widely depending on quality, size, and coating. You can find competitive sales online and at stores.	You can find very good 4 × 6 paper priced at under 25 cents a sheet. Very high-quality glossy, letter-sized paper can be found for as little as 50 cents a sheet but can run up to $10 a sheet for the best, longest-lasting paper.
Monitor	Good quality CRT monitors reproduce color best. LCD monitors take up less space, produce less heat, and can produce sufficient color for most amateur photographers.	High-quality 17-inch CRTs cost under $400. The same size LCDs begin at about $500.
Software	Image editing software comes free with most operating systems. More powerful software is often bundled with printers and even packs of photo paper. High-powered photo editors can be downloaded from the publisher and tested for 30 days or more.	Adobe Photoshop CS costs over $600. Photoshop Elements, the stripped down version with most of the tools a serious amateur needs, sells for under $100 online.
Calibration	Follow the advice in Chapter 2 to hand-calibrate your monitor. When you find you need more accurate color synchronization between your monitor and printer, purchase a precision calibration hardware and software kit.	The Pantone ColorVision calibration suite is available for under $300.

Prices May Vary

This industry grows daily, so prices are never final. Keep your eye out for good sales and know that the prices you see here might be different by the time you read this book or go shopping.

Summary

For great digital photo prints, you want more than you get from plugging your flash memory card into the slot on a printer. A digital darkroom allows you to turn your wonderful photos into great prints.

The digital darkroom has three main components: computer and monitor, image editing software, and printer with ink and paper. The remaining chapters survey these elements in detail and show you how to use them to print vibrant color photos.

Survey your existing equipment and prepare it to manage your photo printing. This includes the following:

- Max out your computer memory, if possible

- Configure your operating system for optimal color display

- Capture photos at 300 dpi, where possible, for the most freedom to resize, edit, and adjust photos for printing

- Survey the image editing software you have; if you don't have Adobe Photoshop Elements, consider a trial download (available at www.adobe.com/products/tryadobe/)

Chapter 2

Calibration and Soft-Proofing

You captured a wonderful image as a digital photo and you want the colors in your print to match the colors in real life. Easier said than done. The road from real life to your final print is paved with obstacles that can turn your brown eyes blue, to mix my metaphors.

The process of capturing color in your camera and translating it to your printer requires *digitizing* the color — assigning numbers to identify the color — and then transferring that information from your camera to your computer (and photo editing software), printer, ink, and paper. Along the way, there is plenty of room for miscommunication, resulting in mix-ups about what color comes out of your printer.

This chapter explains how to get your computer's photo editing software to speak the same language as your printer so that your prints come out looking as much as possible like what you see on your monitor.

Soft-Proofing

As you learned in Chapter 1, your computer serves as a digital darkroom, allowing you to preview, crop, edit, and finally print your photos. Throughout the course of this book, I show you techniques for fine-tuning your photo before you print it. The tools covered in the rest of this book, and in Chapters 3 and 4 in particular, will give you tremendous freedom to retouch, tweak, and perfect the coloring of your photo before you print it. That will solve half the problem of making your photo colors look the way they should.

Soft-proofing refers to the process of examining your colors (and the other elements of your photo) on your monitor before you click the Print button and take your chances with an expensive sheet of photo paper and a page full of photo ink. The most complete soft-proofing tools are available in Adobe Photoshop, which provides you with a print preview based on the specific characteristics of your printer, ink, and paper configuration. Figure 2-1 shows a photo previewed in Photoshop for the specific printer (Canon i860 SP4) it will be printed on.

The challenge you face with soft-proofing is that the red on your monitor may not resemble the red in your printer at all. Before you embark on photo editing projects, be sure to calibrate or synchronize your monitor with your printer. This chapter walks you through the process of doing just that.

Monitor Colors Do Not Equal Printer Colors

Mismatched colors occur when a printer and monitor are not calibrated. There is an additional limitation on how closely a printer can produce colors that match what the monitor displays, however. Monitors have a wider range of producible colors than printers do.

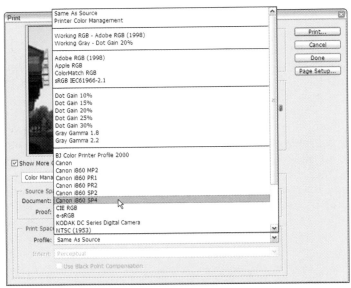

Figure 2-1: Using the print-preview feature in Photoshop to soft-proof a photo before printing it

Calibrating Your Monitor and Profiling Your Printer

Calibrating means measuring — in this case, measuring color. By quantifying the exact color produced by your monitor and printer, you can synchronize the display of color on your monitor with the output of color from your printer. A *profile* is a record of how your monitor, computer, and other devices display color. A device profile documents the results of calibrating the device and makes that information available to photo editing software. Together, calibration and profiles allow monitors and printers to work together so that the color displayed on a monitor matches the color that comes out of a printer.

There are two basic steps to synchronizing your computer with your printer. The first is to calibrate your monitor so that the red, blue, and green you see onscreen conform to a standard that you can apply to the printer as well. Monitor calibration can be done by hand but there are very nice hardware and software packages for sale that automate the process and do a much more accurate job than you could do "eyeballing" the colors.

The second step in the calibration/profiling process is to acclimatize your software to your printer — so that as you retouch your photo, the image you see conforms to the particularities of your printer, paper, and ink configuration. Before I explain the nitty-gritty of both calibration and profiling, let's take a quick look at how we measure color.

Colors Can Be Measured

Why it is it necessary to calibrate your monitor to match your printer? To put it in personal terms, your printer has never met your monitor. All your printer knows is how to take the three (or four or five) colors in its ink cartridges and mix them up with black to make thousands of shades of colors.

If you've ever paid close attention to two different monitors, you've noticed that the blues, reds, and greens (and all shades in between) can—and usually do—look very different from one to the other. In order to synchronize the colors displayed on monitors, let alone getting them to match colors in printers, it is necessary to standardize the gamut of colors.

It is possible to create such a standard because color is quantifiable. Just as you measure musical notes by their pitch (middle-C is 261.6 Hz, for example), you measure color by its wavelength. Figure 2-2 shows the range of printable colors (with many colors "in between" those displayed).

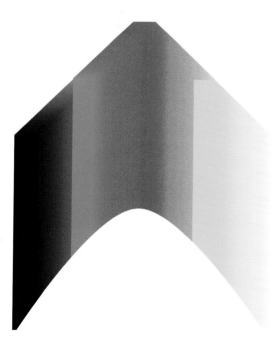

Figure 2-2: The printable color spectrum, which is a subset of the purely visible spectrum

Color Is Measured in Nanometers

Colors result from light waves at different wavelengths, which are measured in nanometers (nm). Nanometers are very small: There are one billion nanometers in one meter. The spectrum of visible light ranges from around 400 nm (deep purple) to around 700 nm (dark red).

If color is a product of the wavelength of light, why do we refer to a rose as red or the sea as blue? The rose and the sea absorb the same light source (the sun) but have properties that cause them to reflect some light waves, while reflecting others—resulting in a rose that we discern as red or a sea that appears blue.

In short, color is a combination of the interaction of light waves with an object that absorbs and reflects some of the wave spectrum. In other cases, you see colors produced directly by a light source, such as the colors on your computer monitor. That is as far as I'll venture into the science of color measurement, but it's helpful to understand that color can be measured objectively.

How Monitors and Printers Define Color

Printers and monitors produce colors in very different ways. Printers mix inks on top of one another to produce a spectrum of colors. Monitors mix colors together to project light and can emit a larger spectrum of color than is possible simply by mixing inks on paper.

Already you may have noticed a potential problem—the range of color available in print is smaller than that available on the computer. The darkest purples and the deepest reds on your monitor cannot be reproduced fully by using techniques that generate printed colors. There is no way to get around this printing limitation, but by soft-proofing your photos in image editing software, you can know beforehand how your colors will appear on photo paper. First you should understand monitor and printer colors a little more.

DEFINING RGB COLORS

Your monitor mixes channels of red, blue, and green to produce millions of different colors. Each pixel or dot on your monitor contains a combination of red, blue, and green. Those combinations are quantified with the RGB color system. The RGB system allows a maximum value of 255 for red, green, or blue. For instance, the following RGB setting yields the color shown in Figure 2-3:

Red = 255

Blue = 0

Green = 0

If you mix more complex combinations of red, blue, and green, you get another range of colors. Figure 2-4 shows a mix of 99 red, 99 blue, and no green. Because the RGB system used to define monitor colors adds proportions of red, blue, and green to create other colors, RGB is referred to as an *additive* system for defining colors.

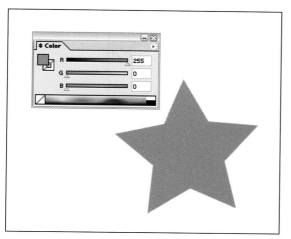

Figure 2-3: Red, as defined in the RGB color system

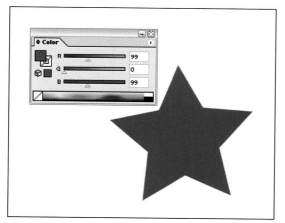

Figure 2-4: Mixing red and blue to make purple

RGB Matches Your Eye

The RGB color system matches the way your eyes detect and define colors. Unless you are color-blind, your eyes are made up of receptors tuned to receive red, blue, and green light. Colors that fall in between red, blue, and green are generated in your brain by impulses from your eye that "mix" reds, blues, and greens.

USING THE CMYK SYSTEM

While monitors add red, blue, and green to create colors, printers layer cyan, magenta, yellow, and black — collectively referred to as CMYK. Because cyan, magenta, and yellow are layered on top of one other in successive turns using the ink cartridges in your printer, this process is called *subtractive* color processing.

Because cyan and magenta are not as commonly known by name as red and blue, they're illustrated (along yellow) in Figure 2-5. Note that where cyan, magenta, and yellow overlap, they form red, blue, and green — the additive color set.

Figure 2-5: Cyan, magenta, and yellow

Why Is Black Called K?

There are a number of explanations floating around for how *K* came to represent black in the CMYK system. Most explanations I've heard attribute the *K* to the need to avoid confusing *blue* with *black*. Some old-timers say that the terms *blue* and *cyan* were commonly used to refer to the same color, so using *B* for *black* would have confused the people running the printing presses.

Because the RBG and CMYK color systems combine different colors in different ways, the software that drives your printer and image editing software must translate colors from RGB to CMYK. Your printer drivers (programs that configure your operating system to work with printers) and your image editing software are up to this task. However, the process of translating an image from your monitor to your printer can be only as accurate as your monitor calibration and printer profiling.

Other Factors in Producing Color

Before getting into the down-and-dirty process of calibrating and profiling, it's necessary to note other factors that influence how colors appear.

Colors look different on your monitor depending on the lighting in the room, the angle the monitor is tilted (particularly with an LCD monitor; when you look at one, tilt it and see how the colors change), and even the state of your eyes and glasses.

Prints, too, change color depending on the viewing environment. Take a color photo and hold it under a high-intensity light. See the difference in how colors appear?

The variation in colors produced by a viewing environment means that calibrating your monitor, and profiling your printer, are relatively accurate procedures. Your monitor and printer will be more accurate if you calibrate and profile, but they will never be absolutely accurate.

For these reasons, as well, you should always display your photos in well-lit areas so they look their best.

Cross-Reference

Chapters 8 and 9 explain how printing on various media, ranging from T-shirts to postcards, affects color.

Checkin' in with the ICC

The International Color Consortium is the standards-setting organization that defines what red, blue, and green, actually are so that manufacturers of monitors, printers, scanners, and software have a common yardstick with which to measure colors.

When some image editing software, such as Adobe Photoshop Elements, offers to preview a photo based on your particular printer and paper, your software is projecting how your print will look based on the ICC profile of your printer. Most major printer manufacturers include ICC profiling information with the printer drivers and software that come with your printer. ICC files, which store ICC profiles, work invisibly in your operating system and with your image editing software. You know they are there because when you try to soft-proof a photo in your image editing software, you'll see an option for your printer, like the one shown in Figure 2-6.

Which Printers Support the ICC?

Support for ICC profiles is not universal, but it is growing. The ICC was initiated by Apple Computer, and slowly, but not steadily, others have come aboard. All Adobe software supports the ICC standard. So do most better photo printers. I have found ICC support among all my Canon and Epson photo printers, and a public relations representative from HP told me they started supporting ICC profiles in their 2003 products.

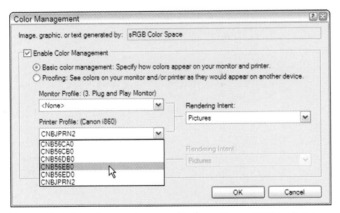

Figure 2-6: Selecting a printer profile for a Canon i860 in Paint Shop Pro

Soft-Proofing with or Without Calibration and Profiles

Image editing software programs like Adobe Photoshop, Photoshop Elements, Jasc Paint Shop Pro, and Ulead PhotoImpact, among others, allow you to match your printer with the image you see of your photo onscreen so that when you adjust the colors, you closely mesh with what actually comes out of your printer.

Image Editing Software Options

While this book cannot be a detailed manual or "how to" book covering any, let alone all, of the many popular image editing software packages, I do explain how to perform basic photo editing processes in several of these programs — enough to walk you through what you need to do to get great prints. The remainder of this chapter explains how image editors work with calibration and profiling.

Chapters 3 and 4 walk you though the process of editing color, content, and effects for your photos in popular image editing software. A quick overview of the most popular image editing programs is available in Table 4-1 in Chapter 4.

When you select a color profile in any of these programs, you're actually invoking the ICC file that comes with your printer. How you select a color profile depends on which software package you use:

- In Photoshop, choose View → Proof Setup to open the Proof Setup dialog box. Choose your printer from the Profile list, as shown in Figure 2-7.

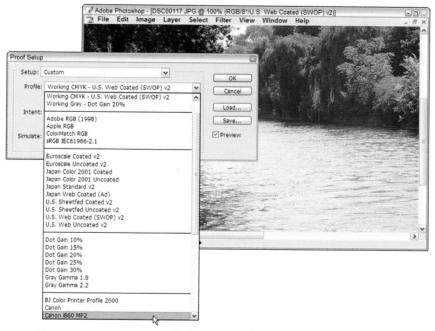

Figure 2-7: Selecting a printer profile for soft-proofing in Photoshop and Photoshop Elements

- In Photoshop Elements, choose File → Print Preview. Click the Show More Options check box in the Print Preview dialog box to access more preview choices. In the Output drop-down list, choose Color Management. The Profile drop-down list is now accessible. Choose your printer from the Profile drop-down list.

- To enable a printer profile in Jasc Paint Shop Pro, choose File → Preferences → Color Management. In Ulead PhotoImpact, the menu command is File → Preferences → Color Management.

■ In both Paint Shop Pro and PhotoImpact, the Color Management dialog box opens. Selecting the Enable Color Management check box activates the dialog box. Select a profile for your printer, as shown in Figure 2-8, and for your monitor.

Selecting appropriate profiles for your printer and, where possible, your monitor (more on this shortly), you can improve the level of synchronization between your printer and computer.

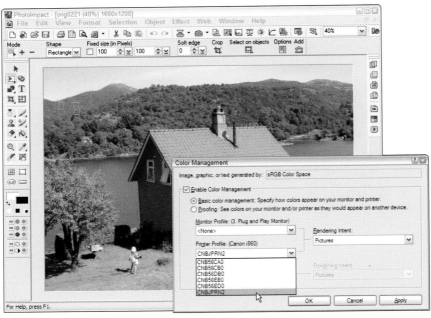

Figure 2-8: Configuring your ICC printer profile in PhotoImpact

Calibration Options

There are many ways to calibrate your monitor. The old style is to take a printout of solid red, blue, and green (or cyan, magenta, and yellow) from your printer and hold them up to your monitor next to a block of a similar color. Then tediously adjust your monitor settings — those controls that you activate by the Menu (or similar) button at the front of your monitor — until they match.

You can find several online monitor calibration tools by entering "monitor calibration" in a search engine. In general, they provide a display of colors and advise you on how to adjust the settings on your monitor to make a match.

The calibration screen provided by Lunn Fabrics Ltd. (www.lunnfabrics.com/monitor.htm) appears in Figure 2-9. If you go to their Web site, tune your red, green, blue, brightness, and contrast settings so that the color palette looks they way they tell you it should look.

Printed calibration palettes are also available for you to compare a specific color on your monitor with a printed color. Both of these manual techniques for printer–monitor calibration work, and they're better than nothing, but eyeballing it is awfully tedious — and it works to calibrate only the particular printer and monitor (and paper, ink, and so on) configuration that you test. A better option is to use an automated calibration system based on the ICC standard.

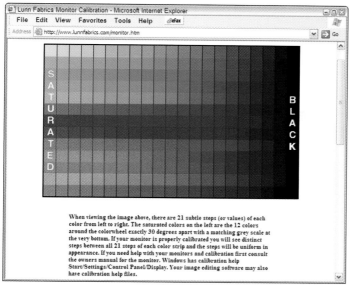

When viewing the image above, there are 21 subtle steps (or values) of each color from left to right. The saturated colors on the left are the 12 colors around the colorwheel exactly 30 degrees apart with a matching grey scale at the very bottom. If your monitor is properly calibrated you will see distinct steps between all 21 steps of each color strip and the steps will be uniform in appearance. If you need help with your monitors and calibration first consult the owners manual for the monitor. Windows has calibration help Start/Settings/Control Panel/Display. Your image editing software may also have calibration help files.

Figure 2-9: Tuning your monitor calibration by hand using an online color palette

Calibrate and Profile?

In this chapter, I use *calibrate* to describe the process of measuring color and adjusting your monitor to conform to ICC standards. I use *profile* to refer to the file that tells your photo editing software how to communicate with your printer.

So there is kind of a connection between calibration and monitors, and profiles and printers. However, in actuality a monitor can have a profile (a file that tells software how to adjust colors) and a printer can be profiled (tested to see exactly what color it produces when, for instance, the printer is supposed to print red).

It's important to make this distinction because the PrintFIX package not only calibrates your print output by scanning it and measuring the colors in a scan of a printed palette but also generates profile files that can be used with image editing software.

External Light Affects Color

The external light hitting your monitor greatly affects the way colors appear on it. Before manually calibrating your monitor, adjust the lighting in the room (closing the shades and turning off, or moving, lights) until the external light in the room is as close as possible to the light emitted from the monitor. Professional photographers who use manual calibration techniques obtain the quantified "color temperature" for their monitor from the monitor manufacturer and then purchase lights from photography stores which match that setting.

Calibrating and Creating Profiles with Automated Tools

Automated monitor calibration and printer profiling tools, of which there are many, attach to your monitor and work with software to measure the color on your screen accurately. The software configures your system to adjust your monitor to conform to standard ICC settings, providing as accurate a match of print and monitor colors as you can get from your monitor.

Image editing programs can usually embed your printer's profile to display your photos more or less as they appear when printed. For an even higher level of perfection, use a printer calibration and profile system that provides a palette of colors for you to print. Scan that palette and compare the printer's output to the screen's display. There are custom ICC files that you can use with Photoshop, Paint Shop Pro, PhotoImpact, and other photo editing software.

The most effective, easy-to-use, and complete package I've found on the market is the ColorVision setup (www.colorvision.com), which includes the SpyderPRO monitor calibration tool and the PrintFIX printer calibration/profiling tool. The Monaco EZcolor system (www.monacosys.com) is similar to the ColorVision package in features and price (both cost around $500). I prefer the ColorVision setup because it comes with a handy miniscanner for profiling printers, whereas the Monaco EZcolor system requires a separate scanner.

If you use other calibration/profiling tools, you'll find the process similar to that which I describe in the rest of this chapter.

Calibrating Your Monitor with SpyderPRO

The SpyderPRO calibration set that comes with the ColorVision suite works on either a CRT monitor or a flat-screen, LCD monitor. Traditional wisdom teaches that serious photographers use CRTs to preview and edit photos but I've been impressed with the quality of color matching I get on my laptop and desktop LCDs as well.

SpyderPRO works with Windows 98, 98 SE, ME, 2000, and XP, as well as Mac OS 9.*x* and OS X. (I tested it in OS X "Jaguar.")

Windows Users: Delete Adobe Gamma Settings from Startup

Removing the Adobe Gamma startup item in Windows is important for accurate calibration with SpyderPRO. There is no such item in Macs so there is nothing to remove for OS X. Removing the Photoshop Color Settings file is not recommended or necessary and won't stop the Windows Adobe Gamma startup item. Windows users need to remove Adobe Gamma settings from the startup menu by finding and deleting a file called "Color Settings.csf."

In Windows XP, this file is found at C:\Documents and Settings*username*\Application Data\ Adobe\Photoshop\8.0\Adobe Photoshop CS Settings\Color Settings.csf. If your install drive is called something other than "C," substitute that in the path above.

With SpyderPRO, or any calibration system, you assemble the monitor calibration device — essentially a small camera. After you install software that comes with your system, it prompts you to place the device on your screen, as shown in Figure 2-10.

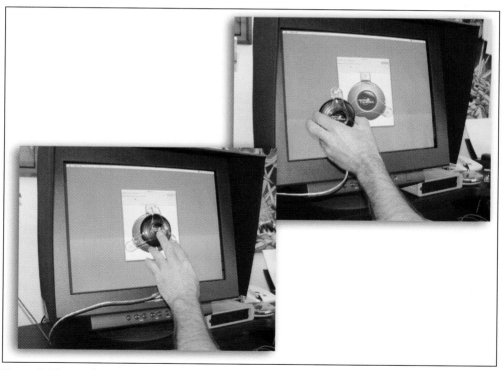

Figure 2-10: Attaching a calibration device to your monitor

For CRT monitors, little suction cups attach the device to the screen. That doesn't work for LCD screens, however, so you simply hang the device over the screen. After that, you install the software that comes with your calibration system, plug your calibration device into a USB port, and follow the directions. You'll take pictures of many colors and compare them to what your monitor should be projecting, as shown in Figure 2-11. Finally, the software with the calibration system adjusts your monitor so it displays colors according to ICC standards.

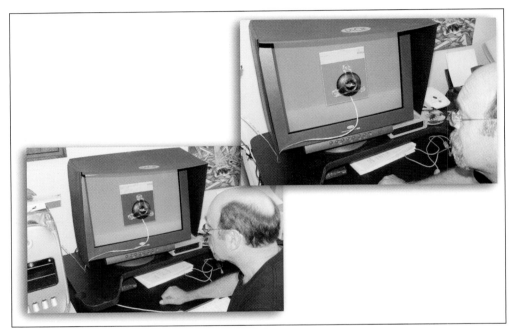

Figure 2-11: Reading colors to calibrate your monitor

Creating Precise Printer Profiles with PrintFIX

The PrintFIX package included in the Pantone ColorVision suite actually tests your printer output and accurately configures the way colors appear in your image editing software for each of your printers. One limitation of PrintFIX is that, at the time I tested it, it supported only the latest Canon and Epson photo printers. The support folks at ColorVision told me they add new printers each month. An updated list of supported printers is available at www .colorvision.com.

The other limitation of PrintFIX is that you need Photoshop or Photoshop Elements (the free trial version works) to create printer profiles. After you create precise profiles for your printer, you can use those files with any image editing software that supports ICC profiles (such as PhotoImpact or CorelDRAW/Corel PhotoPaint).

After you install PrintFIX, the instructions walk you through the process of opening a color palette file and printing it on the printer you want to configure. The calibration palette is shown in Figure 2-12.

Figure 2-12: Printing the PrintFIX calibration chart open in Photoshop

After you print the palette, attach a tiny, dedicated scanner that comes with the package to scan the printed palette back into Photoshop. This process is nicely documented for Mac and Windows users in the materials you get with the ColorVision suite, or you can download documentation from their Web site. The little scanner is shown in Figure 2-13.

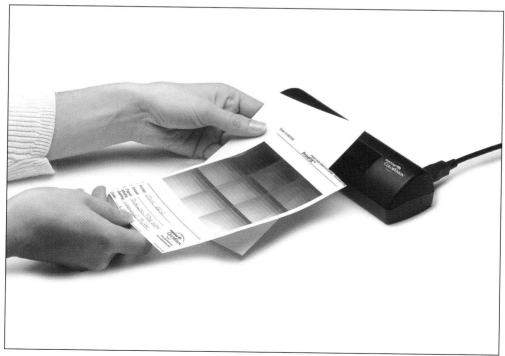

Figure 2-13: Scanning an image back into Photoshop to correct a printer profile

As Photoshop compares your scanned colors with the printed colors, an accurate, adjusted printer profile is generated, which you can save. Figure 2-14 shows a profile being generated by PrintFIX in Photoshop.

If you want to make the ICC file you generate with PrintFIX available for other software, copy the ICC file to the folder in which your image editor looks for color profiles. Generally, this is the default color profile folder for your operating system:

- **Mac OS X:** Mac HD/Users/*your user name*/Library/ColorSync/Profiles

- **Mac OS 9.x:** Mac HD/System Folder/ColorSync Profiles

- **Windows XP:** C:\Windows\system32\spool\drivers\color

- **Windows NT/2000:** C:\WINNT\system32\spool\drivers\color

- **Windows 98/ME:** C:\Windows\System\Color

Figure 2-14: Creating a printer profile in Photoshop with PrintFIX

Other Sources for Printer Profiles

Many printers ship with ICC profiles that are automatically installed in the appropriate folder in your operating system. These ICC profile files are available for all software programs. There are also online services that create and sell precision profiles for printers. They include specific ICC files for various types of paper and ink. Finally, if you create your own printer profiles using a program like PrintFIX, you can save generated ICC files to the appropriate system files so they are available for all software programs.

Summary

Calibration tunes your monitor like a piano repairman tunes your piano. It ensures that your red matches a standardized red and that you can see reasonably close versions of what your photo print will look like onscreen. Profiles are files that tell your image editing software how to display a photo so it looks the way it will when it comes out of the printer. Together, a calibrated monitor and an accurate printer profile take much — but certainly not all — the guesswork out of photo editing and printing.

How essential is calibration? It depends. It may well be the case that after reading this chapter, you make a little note to the effect that "When I come across three hundred bucks and nothing else to spend it on, I'll pick up one of those calibration packages." Or you might figure that, given what you've sunk already into your camera, printer, ink, paper, and image editing software, it's worth the money to configure your monitor and printer so they more or less match.

There are a number of things you can do in between an all-out calibration and no calibration at all:

- Make sure your monitor settings are at the default values

- View your monitor without the interference of glary, high-intensity lights or tinted lighting

- Find an "eyeball" calibration palette online and tune your monitor settings so they more or less conform to the directions that come with the palette

- Make sure your monitor is less than three years old — after that, colors start to burn out and fade and calibration isn't possible

- The perfectionists among you can purchase a calibration software program such as SpyderPRO and use it

It would be nice if printer manufacturers were more consistent in their support for ICC standards. As you proceed through this book to edit and print great photos, you'll find many more print options available if your printer supports ICC profiles. In general, quality photo printers do, but check the Web and look at the product documentation before you buy anything to confirm that ICC support is complete and accessible.

Chapter **3**

Editing Your Whole Photo

I recently watched one of my photographer friends whip out his laptop, make a few judicious adjustments to a digital photo, and transform a nicely shot photo into a great picture in just minutes. He adjusted the contrast, tuned the levels, did a little cropping, and the photo produced a much nicer print. Now true, he's experienced, and what he did in a couple minutes might take a bit longer for a beginner, but in either case a little work with your photo editing software can make a significant improvement to your final print.

You don't need to be a Photoshop expert to make this kind of adjustment. In fact, a half dozen or so techniques will improve almost any photo, using the basic tools found not only in Photoshop but also in Photoshop Elements, iPhoto, or the software that came with your photo printer or digital camera. In fact, simply choosing the autocorrect feature(s) in your image editing software frequently results in a much better print, as shown in Figure 3-1.

This chapter demonstrates how to improve your photos quickly with some easy photo editing techniques and how to avoid some pitfalls that can degrade the quality of your image. For example, most photo editors include some kind of "auto-fix" tool that automatically makes helpful adjustments to a photo's color and contrast. Alternatively, you can fine-tune the color and contrast using tools that I explain later in this chapter.

Figure 3-1: Making a few adjustments with image editing software improves this photo significantly. The edited version on the left uses leveling to strip away the "hazy" look in the original.

Cross-Reference

For automatic photo fixing, see the section "Using Preset Photo Editing Tools" later in this chapter.

Avoiding Lossiness

Before you plunge into your photo editing software, be aware of the danger of degrading the quality of your image as you edit it.

Reducing file size is often useful—it reduces the amount of storage space you need to store the file on your hard drive. Compression is particularly essential for photos destined for the Web—where larger file sizes mean longer download times for Web browsers. However, sometimes reducing the size can create the undesirable "lossy" side-effect.

JPEG Is a Lossy Format

File formats that use compression techniques to reduce the file size when saving images—the JPEG format is one such example—are referred to as lossy because the compression results in a loss of both file size and image quality.

The algorithms used to reduce file size essentially reduce the amount of data defining the number of dots in the file and what their colors are. Sometimes compression is not harmful at all. For example, if your photo contains a large block of solid red, compressing the file allows that information to be rationalized so that the file has to "remember" the color of only one red pixel and apply that to any pixels of the same color. Most photos, however, have wide arrays of intricately nuanced shades, and compression almost always reduces the quality of the image. Figure 3-2 shows an image that has been "JPEG'd" too much, resulting in too much compression and loss of image quality.

Saving with Little or No Compression

The way to avoid lossiness in your photo is to save it in a lossless format—a file format that does not use compression (or provides a save option with no compression). File formats that permit lossless file saving include TIFF and JPEG 2000.

When you save in JPEG format, there is always some compression. Even if you minimize the amount of compression by choosing high-quality compression (sometimes called "low compression," depending on how your image editing software is configured), you'll still end up with some compression. The effect of this builds up if you save a file repeatedly.

Lossy Isn't Always Bad

There are times when you want compression—for example, if you are saving a very small version of your file to e-mail to family and friends, or to post on a Web site. But if you are planning to print your photo, you generally want to avoid compression altogether.

Figure 3-2: Repeated saving in JPEG format has stripped subtle color differentiation from this photo, giving the sidewalk a whitewashed look.

More on File Formats

JPEG and TIFF (or TIF—the same thing) are the two most widely used formats for managing photo files. In general, JPEG is better for publishing photos to the Web and TIFF is better for printing photos. JPEG's ability to reduce file size dramatically by eliminating unnecessary data is helpful for creating fast-loading Web photos, while retaining decent color. However, that feature is not helpful for printed photos when high-quality color is critical and download speed is not an issue.

The JPEG 2000 format provides TIFF-like features for preserving all data in photos. The RAW format is an option for high-quality digital cameras. RAW files store even more photo data than TIFFs and provide extra versatility for professional photographers. Photoshop CS supports the RAW format but most photo editing programs do not. The JPEG format is a fine way to capture images for serious amateurs. Once you've transferred your photos to your computer, save them to TIFF format to avoid losing image quality.

The PNG (pronounced "ping") and GIF formats are used for online graphics but do not match JPEG for color photo quality.

Figure 3-3 shows a typical "Save As" dialog box — in this case, one in Photoshop Elements. The compression setting for a file saved in JPEG format here is 3, which is low — meaning that the file size will be small, but the amount of compression, and hence the color distortion, will be significant.

Figure 3-3: Low-quality compression is appropriate for Web images but not for printing.

The Progressive Option

In Figure 3-3, Progressive is a format option in the JPEG Options dialog box (in this case, in Photoshop Elements). Progressive JPEGs open gradually in Web browsers. Rather than downloading one line at a time (from top to bottom), they fade in so that the first iteration of the photo is very blurry and grainy, and successive waves of downloading the file make it clearer. Progressive settings are used for Web images only and therefore are not selected in the figure.

The basic means of preserving the full quality of your photo is to keep an unedited original file intact and start with that file whenever you rotate, crop, or enhance your image and save it. That way, any degradation to the colors caused by saving it will not be cumulative.

There are lossless formats, including the JPEG 2000 format, that allow you to save with no compression. However, this format is not universally available. To save files in JPEG 2000 format in Photoshop CS, you need to install the JPEG 2000 plug-in (available on the CD). The TIFF file format also has a No Compression option. If you use the Save As menu feature in your image editing software and chose TIFF as the file format, the Save As dialog box will provide you with an option called "No Compression" — look for it when you save files in the TIFF format.

Rotating and Resizing Photos

Say you've just captured an image at 1280 × 960 pixels and you want to print a nice 4 × 6 or maybe a 5 × 7. The quick (but not very good) solution is simply to choose File → Print in your image editing software and print the image on a piece of 4 × 6 (or 5 × 7) photo paper.

That's OK for a quick-and-dirty print, but if you want a great digital photo, things aren't quite that simple. Take your 1280 × 960 image file and grab a calculator. Better yet, I'll grab my calculator and share the results. If you print at a good-quality 180 dpi resolution, your image will be 7.1" × 5.3". This is pretty close to a 5 × 7 print, but you'll lose ³⁄₁₀ inch from the shorter dimension. If you print at a very high-quality 300 dpi, your image is 4.2" × 3.2". No matter how you stretch things, it still won't fit on a 4 × 6 sheet of paper.

Let me break that down a bit. The basic concept here is that you cannot simply resize a photo file to fit an arbitrarily sized piece of paper. For example, you'd have to distort an 8 × 10 to make it fit a 5 × 7 exactly. That's because these print sizes aren't just bigger and smaller than each other; they're actually differently proportioned rectangles. Resizing a photo generally requires cropping part of the top, bottom, or side to make the photo fit a differently sized sheet of paper — or fit a differently sized frame.

In real life, nobody wants to grab a calculator just to resize a photo. Photo editing tools come with cropping tools that make it easy to cut out part of a photo and make it conform to a different print size. I go into this topic in more detail in the "Cropping Photos" section of this chapter.

Photo editing programs like Photoshop, Photoshop Elements, iPhoto, and so on allow you to crop a proportional area from your image. Cropping can be used to resize images that don't fit properly on your photo paper. Cropping can also enhance the aesthetics of a photo, as shown in Figure 3-4.

Preserving Quality While Editing Photos

Cropping is a great way to fit a print to your particularly sized sheet of photo paper. It can also be used as a "zoom" tool to enlarge a small area of a photo and print just that section. Doing this often means effectively enlarging a section of your photo — which raises important issues of resolution. Before you chop off a section of your photo, consider the ever-present issue of resolution and image quality.

It's easy to make a photo smaller. If you have enough resolution in your image file to print an 8 × 10, you can print a crystal-clear 4 × 6. But if you have just barely enough pixels to print a 4 × 6 of your photo at a fairly minimal 150 ppi resolution, it will not print well as a larger photo.

The reason is, of course, that there must be enough dots (pixels) to produce a high resolution, high quality print. To take one more example (got your calculator out?), if your photo file is 600 pixels by 900 pixels, you can print a pretty decent 4 × 6 at 150 dpi. But that same image printed as an 8 × 10 will print at only 75 dpi — which produces a grainy image.

To protect photo quality — and have the most freedom to print them at a wide variety of sizes — shoot photos at the highest resolution your camera supports and then *keep the original file unedited and do not resize it.* I know that this requires that you transfer images from your camera or flash memory card to your computer more often, but that's the price of excellent prints — especially if you are printing larger than 4 × 6 photos.

Figure 3-4: Cropping out the fake grass in the display bin makes the garlic photo more organic.

Photo Editing Software Tries to Help

Many photo editing software programs, such as Photoshop, prompt you to save a file as a copy if you save in a format that will lose some of the image's original data. This feature may be helpful, but it's important to think consciously about protecting your original file. Warnings and cautions in Save As dialog boxes do not always prevent you from inadvertently trashing your original photo.

Resizing Photos

The general rule is that while photos can be easily printed as smaller sizes than the image file supports (with enough pixels for high-resolution printing), they cannot be made larger. There is simply no way to "recreate" missing pixels.

That is the general rule, but there is an exception to that rule. If you really must squeeze a nice 5 × 7 or 8 × 10 out of a low-resolution image file, image editors like Photoshop and Photoshop Elements include tools to "resample" (invent new) pixels. They do this by using various algorithms (calculations) based on the existing pixels.

To resample an image to make it larger, follow these steps:

1. Use the Image Size options in your photo editor (in Photoshop Elements, choose Image → Resize → Image Size).

2. In the Image Size dialog box, click the Constrain Proportions check box to maintain the height-to-width ratio of your photo.

3. Enter a new, larger image size.

4. Choose a method of resampling, as shown in Figure 3-5.

Figure 3-5: Resampling to make a low-resolution image larger requires generating new pixels.

Resampling Methods

Bicubic is the optimal resampling method for color photos. The Nearest Neighbor method is used for black-and-white images.

Rotating Photos

Cameras take rectangular pictures. Because sometimes you want a wide photo and sometimes you want a tall photo, the rotation tool is perhaps the single most used tool in photo editing software. Rotating an image by 90 degrees clockwise or counterclockwise makes it easier to edit and print — as shown in Figure 3-6.

Nearly all photo editing software has rotation tools. Even the simplest photo viewer that comes with Windows XP rotates photos — just click the Rotation icon, as shown in Figure 3-7.

You can also easily rotate images with Apple's iPhoto. Just click the Rotate button once, twice, or three times to rotate to the correct orientation, as shown in Figure 3-8.

Figure 3-6: The original image has been rotated counterclockwise by 90 degrees.

Figure 3-7: Rotating an image using the built-in photo viewer in Windows XP

Figure 3-8: Rotating an image with Apple iPhoto

Cropping Photos

Cropping can enhance your digital image in two ways. You can crop for artistic effect — to enhance the size, composition, balance, and substance of a photo. Or you can crop to reframe your photo to your piece of paper.

You can also crop for artistic, editorial effect — to remove elements of a photo you don't want to include in the print. In any case, you usually want your photo to fit correctly on the paper without cropping out a section of the photo or leaving an awkward white bar on the top, bottom, or side. In Figure 3-9, 4 × 6 has been selected from the Constrain pop-up in iPhoto. The constrain feature preserves proportion. In programs like Photoshop Elements and Photoshop, you enter height and width constraints in the Options bar that appears at the top of the program window when you select the Crop tool (see Figure 3-10).

Figure 3-9: Cropping an image while preserving its 4 × 6 height-to-width proportion

As an element of artistic cropping, you can use your image editor's crop tool to "zoom in" on a section of a photo. Do this only if your image was captured with sufficient pixels to enlarge a zoomed-in section. For instance, if your image is 3200 pixels by 2400 pixels, you could crop out a section as small as 1080 pixels by 720 pixels and still print a reasonably high-quality 4 × 6 photo.

Cross-Reference

For a review of the significance of file and printer resolution, see Chapter 1.

By default, your printer crops a bit from the top and/or bottom and from one or both sides. My own array of photo printers all seem to handle auto-cropping differently. The bottom line is that I never leave the decision to the printer.

The best way to fit your image onto a given sheet of paper is to crop it yourself so that you control what ends up in the print. Most photo editing programs allow you to set your cropping tool so that the crop area is automatically defined as a proportional rectangle that crops a section of the photo that fits your paper. In both Photoshop and Photoshop Elements, you constrain the cropping dimensions in the Status bar, as shown in Figure 3-10.

Don't Forget Orientation

In Figure 3-10, the dimensions are actually 6 × 4, not 4 × 6. The paper size, of course, is the same. But the paper will be printed in the *landscape* (sideways) orientation, not in the default *portrait* layout. Orientation settings are defined in your printer dialog box. For more on setting paper size and orientation in inkjet printers, see Chapter 6.

The crop area is constrained to multiples of 6 × 4

| Width: 6 in | Height: 4 in | Resolution: 180 | pixels/inch ⌄ | Front Image | Clear |

Figure 3-10: Setting cropping constraints in Photoshop (or Photoshop Elements)

Find the Crop Options

The Crop Options bar is available in Photoshop and Photoshop Elements when you click the Crop tool in the Toolbox. If you don't see the Toolbox, choose Window → Tools. If you don't see the Options bar, choose Window → Options.

Using Preset Photo Editing Tools

Many image editing packages include automated settings to adjust contrast, levels, brightness, and color. These settings take into account color distortion often generated by digital cameras, color lost in the printing process, and frequent lighting issues and apply a set of adjustments to your image.

Many of these preset formatting tools work quite well. I've even seen seasoned pros quickly shape up an image by applying something as simple as the Photoshop Auto Levels option.

Automatic tools vary depending on your image editing software. Apple iPhoto for Mac OS X has one all-purpose, auto-fix tool: the Enhance wand. More sophisticated image editors provide

a set of automatic tuning tools to correct leveling, brightness and contrast, and colors. Try the automatic tools included in your software or roll up your sleeves and make the adjustments manually. Keep two things in mind if you use automatic tools:

- Most auto-correction tools improve photos because there are a number of deficiencies in photo color and contrast resulting from the digitizing process in cameras and scanners.

- All programs allow you to undo the applied auto-correction changes by pressing Ctrl+Z (⌘+Z). So experiment away and if the auto "correction" doesn't help, undo it.

I explore editing image levels, color correction, and adjusting brightness and contrast in more detail later in this chapter. In essence, adjusting levels cuts off the high or low end of the color spectrum to produce higher-contrast, sharper photos. Color correction adjusts the actual colors — transforming an overly reddish photo, for example, into one with more balanced colors. So if your digital camera has slightly distorted an image by adding too much blue, you can alter the balance between blue and red, as shown in Figure 3-11.

Brightness increases (or decreases) the lighting in a photo. Contrast increases (or decreases) the distinction between bright and dark tones, changing the intermediate tones either to dark or light.

To access these automatic tools in Photoshop Elements, open the Enhance menu and select options to apply to your photo. In Photoshop, choose the Image → Adjustments menu to access auto levels, auto contrast, and auto colors. In iPhoto, all automatic adjustments are rolled into the Enhance tool.

Figure 3-11: Applying color correction to compensate for too much blue

Fine-Tuning Photos

The process of improving photos in image editing software is an art and science with limitless boundaries. You can do much with these preset image tuning tools but you can do even more by manually adjusting attributes like sharpness (focus), levels, brightness, and contrast.

Most image editing software includes at least some basic image tuning tools — like brightness and contrast adjustment, or color-to-grayscale conversion. Complex, professional-level image editors like Photoshop allow infinitesimally minute adjustments to every element of your picture.

Adjusting Brightness and Contrast

Your digital camera instructions likely advise you to capture images with the best possible exposure settings — avoiding overexposure (too much light) or underexposure (too little light). Do your best to follow that advice. Overexposure typically washes out coloration and blows out the highlights, while underexposure obscures details and renders a murky image.

Brightness adds or removes light from your photo. Contrast increases the difference between dark and light pixels in your photo. Both brightness and contrast commands are a shotgun approach to image editing because they act equally on all pixels in your photo. That kind of one-size-fits-all adjustment in pixel color levels rarely improves photos and often produces either a washed out or overly dark image. Levels provide more control over brightness and contrast.

While brightness and contrast settings are a crude way to alter your image, they are universally available in any image editing software. Their usefulness is limited, however, particularly in lightening underexposed images. In Photoshop Elements, Choose Enhance → Adjust Brightness/Contrast → Brightness/Contrast to open the Brightness/Contrast dialog box, as shown in Figure 3-12.

The Limitless Potential of Photoshop

In the remainder this chapter, I visit some of the basic image editing techniques available in Photoshop, along with more basic options accessible with programs like Photoshop Elements and iPhoto. Photoshop techniques used by serious professionals are beyond the scope of this book, but professional digital photographers apply these tools in the form of adjustment layers — they leave the original photo undistorted in a Photoshop layer (transparent level) while adding filters (edited layers) on top of the original image.

The following sections describe briefly how Photoshop (among other tools) allows editing of color, contrast, and other features of a photo. While I won't delve more deeply into layers, you can ensure that your original photo is uncorrupted by editing a copy of your photo file.

For a more complete exploration of the digital photography workflow, including managing image editing with layers, see *Total Digital Photography* by Serge Timacheff and David Karlins (Wiley, 2004) or *Digital Outback Fine Art Photography Handbook* by Bettina and Uwe Steinmueller (e-book at www.outbackphoto.com/handbook/DigitalOutbackPhotography.html).

Figure 3-12: Brightening an underexposed photo

Setting Levels Manually

For a higher degree of control over brightness and contrast, image editing professionals use levels — controls that fine-tune adjustments to which pixels are brightened and darkened. I'll leave a full exploration of adjusting levels to advanced-level Photoshop books, but we can take a quick look at how they work. If you have Photoshop, experiment with fine-tuning the contrast using this feature.

To understand levels, think about another kind of level you're already comfortable with: sound. You set the level of your sound system by adjusting the volume. You can even fine-tune the sound by adjusting the level of bass and treble, or — on a really nice sound system — by tweaking the balance between a series of tones with a graphic equalizer.

Adjusting levels in a photo is similar to adjusting the sound of your stereo, except that you apply adjustments to both colors and intensity. You can even isolate red pixels in your image and adjust the contrast of just that color. To explore the Levels dialog box in Photoshop, choose Image → Adjustments → Levels. Dragging in on the left and right sliders adjusts contrast, while moving the middle slider enhances or decreases the midtones. Select a color from the Channel list to focus your contrast adjustments on a single color, as shown in Figure 3-13.

Editing Selections

You can apply level adjustments to selected elements of a photo only. Similarly, you can apply any of the image adjustments discussed in this chapter to selected elements of a photo. Programs like Photoshop, Photoshop Elements, and more sophisticated image editors allow editing selected areas. Chapter 4 explains how to edit selected pixels.

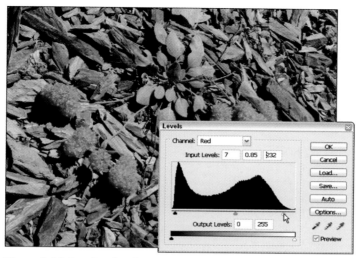

Figure 3-13: Leveling heightens contrast and brings out colors — red in this case.

Sharpening Photos

Sharpening a photo increases the definition of discrete elements with an image. Sharpening brings out details of a human face, sticks on a path, or cracks in a wall. Sharpening adjustments contrast with blurriness, which makes elements of your photo more indistinct. In Figure 3-14, the sticks on the path and other details are made clearer and more focused with sharpening.

Don't count on sharpening to refocus an out-of-focus image or change a blurred speeding car into a sharp image. But in many if not most cases, sharpening improves photos by intensifying contrast to distinguish details of a photo. To sharpen a photo in Photoshop or Photoshop Elements, choose Filter → Sharpen → Unsharp Mask and adjust the Amount, Radius, and Threshold sliders in the Unsharp Mask dialog box. With the Preview check box selected, you can see the changes as you experiment with each slider, as shown in Figure 3-15.

The three sliders in the Unsharp Mask dialog box work together, so experiment with all three. You can adjust three different options using each slider:

- Amount defines how much contrast to apply — start by adjusting this slider.

- Radius defines essentially how thick the "line" that gets generated will be — higher values result in more defined objects in your photo, while a very thin line (a low radius setting) produces almost no noticeable sharpening.

- Threshold defines how extreme you want your sharpen effect to be. A low threshold (default is zero) applies sharpening to all edge pixels.

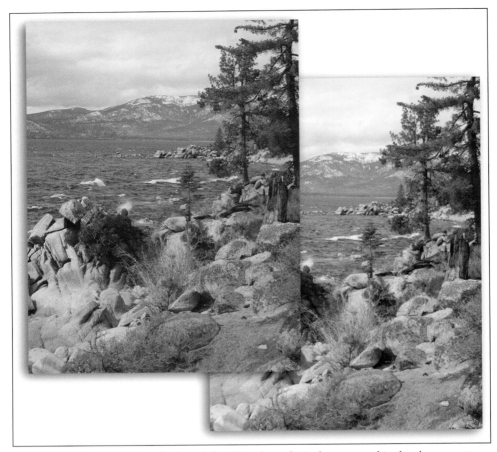

Figure 3-14: Sharpening reveals blurred details in the path, in the trees, and in the choppy water.

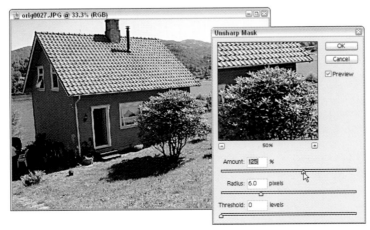

Figure 3-15: Tweaking sharpening in Photoshop Elements

The Sharpened Edge

By definition, sharpening applies to, and helps create and emphasize, so-called edge pixels — those that form an edge between two elements of a photo.

Achieving Special Effects

The image editing tools I've explored so far generally improve the quality of a photo in a way that looks natural, essentially enhancing the existing color of your photo. Other effects, however, can create cool photos by distorting or radically altering the content or color of your photo.

Popular alteration techniques include inverting photos (turning the colors into their opposites), printing photos in grayscale (shades of black-and-white or other monochromatic shades), drastically changing hue and saturation to create different coloration, and tweaking threshold settings to create artistic, sketch-like photos.

Photos enhanced with special effects can make artsy prints, ranging from stark black-and-white prints to trippy distortions, such as the inversion effect in Figure 3-16.

Figure 3-16: Inversion creates a psychedelic effect.

Altering Hue and Saturation

Hue and saturation are two elements that combine to create colors. *Hue* refers to the color itself, like red, green, or blue. *Saturation* refers to the amount of that color — for instance, a blue can range from a very faint light blue to an intense deep blue. The light blue has a low saturation setting, while the deep blue has a high saturation setting.

Hue and saturation settings for a photo can be adjusted in more sophisticated image editing programs like Photoshop and Photoshop Elements. By adjusting the hue and saturation of a photo, you actually alter the colors.

To adjust hue and saturation in Photoshop or Photoshop Elements, select Image → Adjustments → Hue/Saturation to open the Hue/Saturation dialog box, shown in Figure 3-17. Use the Hue slider to change color and the Saturation slider to adjust the depth of color. The Luminosity slider adds or decreases light.

Figure 3-17: Adjusting hue and saturation

Tweak hue and saturation to compensate for bad lighting or distortion — to make a photo look "more real." Or distort hue and saturation to achieve a special effect. Extreme hue and saturation changes can produce interesting, disturbing, or fun changes in a photo. Figure 3-18 shows hue and saturation applied to create two different tints (magenta and yellow) to a photo.

Inverting Photos

Inverting means transforming a color into its hue opposite. Programs like Photoshop and Photoshop Elements use numeric values that express different colors and use math to alter colors in a photo. The results radically transform your photo and produce interesting, often unpredictable results.

Figure 3-19 shows inverted color sets. In real life, you're unlikely to try to calculate the results of color inversion. It's something you just try, and if it produces an enjoyable result, you can make a print of it.

Figure 3-18: Tinting the Shanghai docks with magenta and yellow

Apply color inversion in Photoshop or Photoshop Elements by selecting Image →
Adjustments → Invert, as shown in Figure 3-20.

Printing Black-and-White Photos

Black-and-white photography has a distinct aesthetic quality that has endured long past the
technical innovations that made color prints universally accessible. Reducing tones to shades
of gray gives us unique insights into an image. A black-and-white print can be a wonderful
artistic expression too.

Figure 3-19: Inversion transforms colors into their opposites.

Figure 3-20: Setting inversion in Photoshop Elements

Figure 3-21 shows a photo of a bridge in Berlin converted to a classic grayscale photo. In this case, I've enhanced the surface of the stone by stripping color to emphasize texture and contrast.

There are two techniques for printing black-and-white photos: Translate the intensity of colors to shades of gray or reduce all colors to either black or white. The first technique is achieved by using grayscale tools, while extreme black-and-white contrast is created by adjusting threshold settings.

CONVERTING TO GRAYSCALE

Grayscale conversion produces a traditional black-and-white print. You can use this to simulate old photos or for artistic effect.

The first step in printing your grayscale photo is to use the grayscale feature in your photo editing software to convert colors in your image to shades of gray. This is done by translating the luminosity or brightness of the color to a shade of gray. For instance, bright red and bright green both translate into the same shade of gray.

To convert a photo to grayscale in Photoshop, choose Image → Mode → Grayscale. In Photoshop Elements, choose Image → Mode → Grayscale as shown in Figure 3-22. In iPhoto, click the B & W icon to convert an image to grayscale.

ADJUSTING THE THRESHOLD

Adjusting threshold is another, more complex and different way to convert a photo to black-and-white. In this case, however, you convert all colors to either black or white, producing a very high-contrast, almost pen-and-ink print. Figure 3-23 shows the sketch-like effect created by converting a print to pure black and white tones.

Figure 3-21: Converting a color photo to grayscale enhances texture and contrast.

Figure 3-22: Converting to grayscale translates the red and green into shades of gray.

Figure 3-23: The stark effect of converting to black-and-white produces a timeless look.

You can convert a photo to black-and-white in Photoshop by selecting Image → Adjustments → Threshold. The Threshold dialog box shows a histogram that controls which cut-off point, measured in luminosity, will be used to decide if a color pixel is converted to black or white. Figure 3-24 shows me tuning the luminosity in Photoshop to produce a light photo — with most pixels converted to white.

Figure 3-24: Tweaking luminosity to convert a color photo into a high-contrast black-and-white image

Summary

This chapter introduced you to a wide range of tools and techniques for improving, adjusting, and just having fun with your photo before printing it. Programs like Photoshop provide almost limitless abilities to adjust your photos, but the relatively simply software that comes with your operating system, printer, or camera likely provides many tools for applying global edits to your photos. Here are some key things to keep in mind as you edit your photos:

- Avoid saving files over and over in JPEG format.

- Always preserve the original file and edit extra, saved copies of the file.

- Use TIFF, not JPEG, format to save edited photo files.

- Rotate or resize your photo before printing for best results.

- Cropping is necessary when you resize your photo to make it fit on different sizes of paper.

- Autocorrect can be a useful tool in many image editors, but manual adjustments are often most effective.

- Adjusting levels is the single most powerful tool for improving photos. Brightness and contrast, and sharpness settings often enhance photos before printing.

At this point, you have a good sense of which tools can enhance your photo to produce a great print. The limitation of the techniques I've explored here is that they are applied to the entire photo. Sometimes you need to adjust only part of your photo — for instance, to remove an offending object that ruins the picture, to adjust only the color of the sky or sea, or to improve the coloration of one person's face. Making these types of adjustments requires first making a selection in your photo and then tweaking the selection. You learn to do that in Chapter 4.

Touching Up Photos for Printing

As you saw in Chapter 3, you can improve photos tremendously using editing techniques that apply equally to the entire photo. This includes adjusting brightness and contrast to compensate for a photo shot with insufficient lighting or to highlight bright colors; adjusting levels to fine-tune the intensity of various ranges of color; and altering an image's hue to increase or reduce red, blue, green, or all colors. Global photo editing tools, even automatic image editing tools, are a wonderful option for improving the quality of a final photo print.

Other entire-image editing techniques include cropping photos, rotating images, and resizing photos. Such techniques improve almost any photo, and tools for doing these tasks are accessible using software you probably already have — even the software that comes with your computer, printer, or digital camera.

So far, so good. However, if you're intent on printing really great digital photos, you might be ready to consider the next step — selectively editing only a portion of your photo. If you've heard scary things about getting into selection techniques, well, they're all true. As with anything else, there is a simple and complex way to do things. You can do quite a bit of selective editing of your photos without taking a 12-week Photoshop class. This chapter shows you some quick, easy, and very fun things you can do to improve your printed photos without a lot of skill. It also addresses workarounds for those of you whose budgets do not permit shelling out a few hundred dollars for Adobe Photoshop.

Enhancing Photos with Selective Editing

When you edit only a section of your photo, you open a whole new range of possibilities for creating really special prints. Selective editing ranges from deleting an unwelcome guest from a wedding photo to blurring the background of a photo to make a flower, or your three-year-old, stand out from the background.

Selection editing works for nearly all the editing techniques explored in Chapter 3. You can, for instance, alter the size, brightness, levels, sharpening, inversion, grayscale, and threshold — all for just part of a photo.

In Figure 4-1, for instance, the color of the car has been changed for fun, but the background remains unchanged.

In Figure 4-2, a Shanghai taxi is held still while everything else is blurred to capture the hustle and bustle of that fast-moving city.

Tricks like this require some understanding of the concept of *selection* — choosing to edit only selected pixels within a photo. Here's a quick look at how that works.

Figure 4-1: The color of the car has been transformed, but the background has not.

Selections Work for All Editing Techniques

First of all, realize the implications of the fact that selection works for nearly all of the photo editing techniques you discovered in Chapter 3. When you think about this, the potential for really improving the impact of a photo becomes clear.

For instance, Chapter 3 explored techniques for turning a color photo into a grayscale print. This can be done not just for an entire photo but for just an element of the photo. In Figure 4-3, for instance, all the oranges except one have been grayscaled.

There are two basic ways that your photo editing software makes selections — by color or by shape.

Selecting by Color

When you select pixels by color, your image editing software says, in essence, "Dave" (in my case), "you seem to want to choose all the bright red pixels in this photo so you can change just those pixels." And I say, "You're so right, do it and stop talking to me!"

Figure 4-2: With everything but the car selected, the background of this photo has been blurred.

Once all the red pixels are selected, for instance, I can then turn them blue, knock them out of the photo altogether, dim them, or heighten the contrast for these pixels. Image editors often have a tool called something called a "magic wand" that you use to click on a single pixel and then select all pixels of that same color.

Magic wands are present in most intermediate- and expert-level photo editors and they share similar attributes. *Tolerance* defines how closely the image editor sticks to the color you point to with the magic wand. A high tolerance value selects more colors of pixels, while a lower tolerance setting restricts pixel selections to colors very close to the one you point to.

Figure 4-3: Applying grayscale to a selection

Match mode options tell your photo editor how to measure pixels. RGB match mode uses the values assigned to a color defined by red, blue, and green to measure matching pixels. *Hue mode* uses position on a color wheel to define matches. Many programs have options for matching not only by color but also by attributes like brightness, which you can use to select pixels of similar darkness/brightness values.

A couple of important selection features apply both to magic wand and region selection tools. Most selection tools allow you to add to a selection. Generally, holding down the Shift key as you click with a magic wand (or any selection) tool increases the set of selected cells, but some programs also have special Add modes that allow you to add to your selection by simply clicking on other pixels.

Finally, higher-level image editors include *feathering* settings. Feathering creates a buffer or blended area around your selection for more seamless editing. Higher settings define a larger buffer area. Feathering is covered in more depth later in this chapter. Figure 4-4 shows some objects being selected with the Magic Wand in Jasc Paint Shop Pro.

Like Paint Shop Prop, Photoshop allows you to add to or subtract from your selection so that you can choose a number of different colors to select at once.

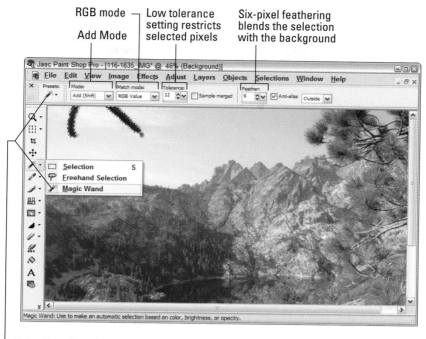

Paint Shop Pro Magic Wand tool

Figure 4-4: Selecting with the Magic Wand in Paint Shop Pro

Photoshop also allows you to make either contiguous or noncontiguous selections with the Magic Wand. When Contiguous is not checked, all matching pixels are selected — whether they are connected to the original pixel or not. In Figure 4-5, all the black pixels in the background (behind the oranges) are selected.

Selecting by Shape

The alternative to selecting pixels by color is selecting them by shape. For instance, you can use a selection tool in your image editing software to draw a selection *marquee* (a geographical area on the photo) and then edit only that area.

Figure 4-6 shows an example where I drew an oval selection area on a photo and then deleted everything that was outside the selection.

Editing Unselected Regions

To apply photo techniques to nonselected parts of a photo, first reverse the selection you've made. Many image editing programs have a menu option in the Select menu that allows you to invert the selection — change everything selected to unselected and vice-versa. In Photoshop and Photoshop Elements, you do this by choosing Select → Inverse. In Jasc Paint Shop Pro, choose Selections → Invert. Similar options are available in other software.

Option bar setting
for adding
to a selection

Contiguous is not checked
so that all black pixels are
selected, whether connected or not

Photoshop
Magic Wand
tool

Figure 4-5: Selecting pixels of one color Photoshop

Figure 4-7 shows the Edit → Clear command in Photoshop being used to delete the selected region.

Selection Is the Key to Complex Photo Editing

The highest level of photo editing involves selecting regions of a photo — either those with the same (or related) colors or geographic regions (rectangles, ovals, or polygons) in the photo, and then applying separate adjustments to different sections of the photo.

For example, if you look closely at many photos of famous people in magazines, you'll note that the background has been blurred to emphasize — not detract from — the person who is the center of attention. With traditional photography, this is usually a product of lens settings; with digital photography, this effect can be more easily added later — while editing the photo. A more dramatic example of selective editing is where the background of a photo is actually replaced by extreme editing (changing background color, for example) or even by replacing the background altogether.

Photo editing pros are highly skilled at the science and art of selecting various regions of a photo and making fine adjustments to them. A photo showing two rows of people might look better if the faces in the back row are brightened just a bit to equalize the lighting on both rows. The grass in a yard might be made greener, while the coloring in the rest of the photo is untouched.

In all these instances, the key skill involved is the ability to select regions very carefully. A significant reason why photo professionals tend to rely on Photoshop is its arsenal of selection

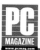

tools and menu options. Photoshop, for instance, has a tool called the Magnetic Lasso tool that makes it easy to draw irregular selection lines around objects. In Figure 4-8, it would be difficult to select the background behind the statue using a Magic Wand tool because the color differentiation is not that great. Instead, the Magnetic Lasso tool zeroes in on just the statue, isolating the background more effectively.

It's time to return to the concept of *feathering,* which is essentially a way to merge a selected area with the rest of a photo. For instance, if you're going to edit Uncle Ted's handout of your photo, you'll want to blur the distinction between the object you select and delete, and the rest of the photo so the viewer hopefully won't notice a big hole. To take a less extreme (and more likely) example, if you select the grass in a yard to brighten it or make other adjustments to, you'll want a smooth, natural transition between the grass and the rest of the photo. Feathering helps smooth the transition between an edited region and the rest of a photo by acting as a kind of buffer, where effects gradually transition into other parts of a photo.

Figure 4-6: To make this photo, I drew an oval selection area and then turned everything outside the area white.

Figure 4-7: Deleting a selected area with the Edit → Clear command in
Photoshop

Once you learn to make selections moderately well, you can do just about anything with a
photo. The power lines in Figure 4-9, for example, were selected and replaced by portions of
blue sky from the photo, leaving just the flowering tree and the blue sky in the final print.

The selection techniques explored in this chapter are ones you can begin to use right away.
As you improve your skills, you'll become faster at making complex selections. With a little
practice, nobody will be able to tell what changes you made to the original photo to make it
look so good.

The Price of Photo Editing

As noted, one reason why serious photo editors are attracted to Photoshop is its unprece-
dented power to allow complex selections. Other factors include a wide range of third-party
plug-ins that offer unique effects and editing tools. Photoshop is so identified with high-level
photo editing that the name of the software has become a verb, as in "He Photoshopped me
right out of the picture." Certainly Photoshop is a powerful, full-featured, and useful program.
And there is a consensus among professional and very serious photographers that Photoshop's
selection tools, in particular, are the best there is. But Photoshop does have its downsides and
it is not your only alternative if you want to select elements of your photos for editing.

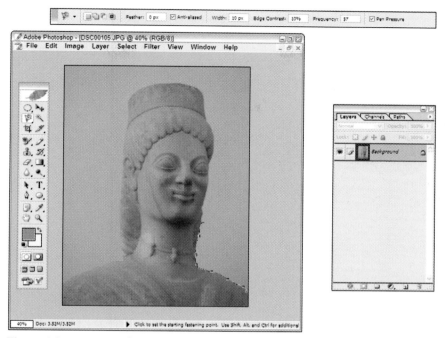

Figure 4-8: Drawing a selection marquee with the aid of the Magnetic Lasso tool in Photoshop

You pay a price for Photoshop. Literally, of course, you can shell out several hundred dollars for the latest version. But there is also a price to pay in the rather steep learning curve and serious demands on computer processing power. The next section alerts you to the hidden costs of setting up a digital darkroom with Photoshop and suggests suitable alternatives.

IS PHOTOSHOP OVERKILL FOR YOU?

When considering whether or not to spring for a copy of Photoshop, you should be aware that Photoshop's cost, memory demands, and learning curve are driven in part by the fact that it includes many tools that are not all that essential to photo editing. For instance, Photoshop CS has adopted stripped-down versions of drawing tools from its software cousin Adobe Illustrator. If you don't plan to draw with curves, these are features you don't need.

If you plan to do much drawing, you won't find the truncated set of Illustrator tools included with Photoshop satisfactory, anyway. For projects like creating maps, designing logos, drawing sketches, or designing brochures, postcards, or other type-heavy projects, you'll need Illustrator.

COST AND COMPUTER MEMORY ISSUES

Working with images puts a strain on your computer. Period. If all you do is save images on your hard drive, you might find yourself shocked to turn on your system one fine morning and discover that your computer crashed because you filled your entire hard drive with huge image files. It happened to me!

Figure 4-9: Unsightly power lines were selected and replaced with blue sky from elsewhere in the same photo.

Which Do You Need: Photoshop or Photoshop Elements?

Photoshop Elements provides most of Photoshop's editing power at a fraction of the price. Most folks who edit photos for printing will find the Photoshop Elements subset of Photoshop tools just fine for selecting and editing regions in a photo. Elements doesn't have the same depth of drawing tools as Photoshop, but you don't need those tools to touch-up your photo. Photoshop's color adjustment tools (including the options for fine-tuning colors known as "curves") are stripped out of Photoshop Elements, as are tools for matching colors, some tools for fixing bad spots in photos (the Healing Brush and Patch tools), and the ability to edit photos by defining finely tuned adjustment layers that act as filters over all or part of a photo.

Both Photoshop and Photoshop Elements are available in free, 30-day trial versions. I suggest that you try before you buy to see which program is the best match for your needs.

Check Your RAM

In Windows XP, check your available RAM by opening the Control Panel and selecting See Basic Information About Your Computer. Click the General tab in the System Properties dialog box to see your actual working RAM. In earlier versions of Windows, find your System Properties dialog box to check your RAM. In Mac OS X, choose Apple → About This Mac to see your available memory (you can click the More Info button to see details, including how much RAM is in which available slots).

I've used the terms "actual working RAM" and "effective RAM" because the amount of RAM that comes with your computer, or that you stick in a slot, is not always completely available for processing your software. Some systems use some of your RAM to manage the graphic display, further depleting what is available for your real, working RAM.

If you plan on doing much image editing and you have only 256 MB RAM available, you can order additional RAM from your computer manufacturer.

A full exploration of file management is beyond the scope of this book, but I suggest you keep your files on a *large* (like 60, 80, or 100 MB) external drive.

Cross-Reference

For a review of the reasons why it's important to capture and preserve images in the largest possible file size, see Chapter 1. I discuss memory and file sizes throughout the chapter in relation to camera attributes, file formats, and file management.

Not only do image files consume lots of disk space, but image editing software takes a lot of processing resources. To get concrete here, if your PC or Mac came with 256 MB RAM, it will crash frequently if you try running sophisticated image editing software, and it will crash all the time if you try running your image editor with other programs running in the background.

In my experience, you need a minimum of 512 MB RAM on your system to run Photoshop and 768 MB (256 + 512) to run it smoothly.

Lower Cost Alternatives to Photoshop

While Photoshop is the industry standard image editor, there are many cheaper alternatives that provide equivalent image editing and selection power.

Because Photoshop so dominates the photo editing terrain, these programs often offer help features or interfaces that connect with Photoshop users. Most of the selection techniques and editing tools discussed in this chapter are available in the budget alternatives to Photoshop listed in Table 4-1.

Table 4-1 Photoshop and Lower Priced Alternatives

Program	Mac or PC?	Approximate Cost (US $)	Free Trial?	Download URL
Corel PhotoPaint (bundled with theCorelDRAW graphics suite)	Both	$400	Yes	www.corel.com
Paint Shop Pro	PC	$100	Yes	www.jasc.com
PhotoImpact	PC	$90	Yes	www.ulead.com
Photoshop	Both	$650	Yes	www.adobe.com
Photoshop Elements	Both	$50	Yes	www.adobe.com
Microsoft Picture It! Photo Premium 9.0	PC	$40	No	www.microsoft.com
Serif PhotoPlus 5.5	PC	Free	(Free)	www.freeserifsoftware.com
Photolightning	PC	$40	Yes	www.photolightning.com
FotoFinish Basic	PC	$70	Yes	www.fotofinish.com

Because Photoshop is the most popular high-powered image editor, and the terminology imposed by Adobe has become the general language of image editing, I use Photoshop in most examples in this chapter. But some examples use other image editing software, including Paint Shop Pro, PhotoImpact, and Photoshop Elements. Most of the techniques discussed for Photoshop work in a very similar way in Photoshop Elements and vice versa.

Editing for Content and Aesthetics

Now that I have encouraged you to dive into the world of editing selections to improve your photos and also cautioned you that there is some expense and work involved, let me show you how to make some quick, simple changes that will produce really great photos.

The remainder of this chapter walks you through some techniques you will use frequently: removing red-eye, removing a portion of a photo, and enhancing the contrast of part of an image.

I also show you how to make the most frequently demanded alteration to a photo: changing the background (so that cousin Lisa appears on her surfboard under a huge wave, not safely on the beach where you actually photographed her). There are some fun things you can do to transform your photos drastically for artsy effects, such as the flower in Figure 4-10 with a changed color foreground and a blurred background.

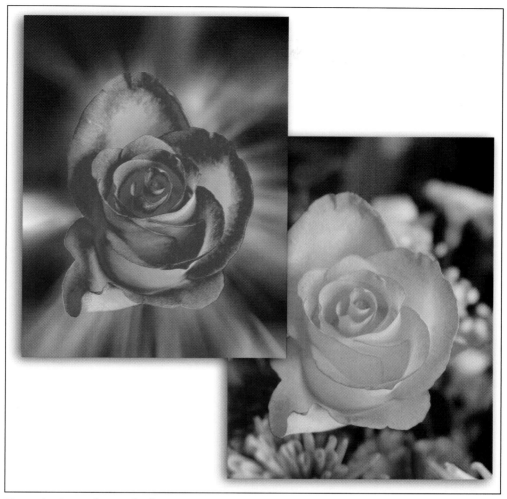

Figure 4-10: By selecting the flower, you can apply different effects to the background as well as to the flower.

Removing Red-Eye

As long as people (and pets) have been blinded by flash bulbs, photographers have had to deal with photos distorted by red-eye — the effect produced when a subject's pupils appear bright red in a photograph. Sophisticated image editing software has tools that automatically detect and fix red-eye.

You're likely to find features for reducing red-eye in your digital camera and tools for removing it in the free software that came with your camera. If you need to fix red-eye with photo editing software, the task ranges from complicated to manageable. If you're editing in Photoshop, repair red-eye by following these steps and refer to Figure 4-11 for help:

1. Open the image you want to repair.

2. Choose dark gray or black as the foreground color by clicking on the Foreground Color swatch in the bottom of the tool box, as shown in Figure 4-11.

3. Select the Color Replacement tool. The Options bar for the Color Replacement tool becomes visible (choose Window → Options if it's not).

4. In the Options bar, make the following choices:

 ▓ Choose a small, hard brush tip

 ▓ Select Color in the Mode list

 ▓ Choose Once from the Sampling list

 ▓ Select Discontiguous in the Limits list to select all red pixels

 ▓ Select 30% in the Tolerance list

 ▓ Click the Anti-aliased check box

5. Click and scroll over the area of red-eye to replace it with gray or black.

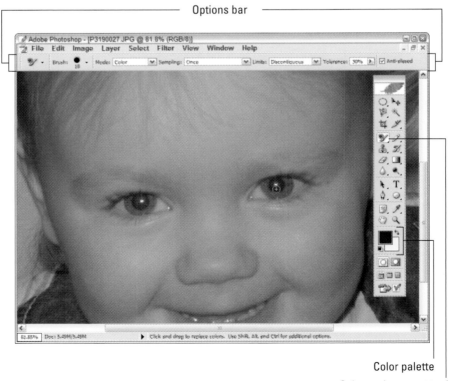

Figure 4-11: Fixing red-eye in Photoshop

What Is Red-Eye and Why Does It Happen?

In real life, spring flowers turn my eyes a blurry, achy red. In photography, red-eye is an effect caused by light from the camera's flash bulb reflecting off the retina of the subject's eyes. The effect is similar to what you see at the eye doctor when he or she shines that annoying bright light into your eyes for a long time. What you see are your own red blood vessels.

Red-eye appears at its worst when you take flash photos in the dark because people's pupils dilate, exposing their retinas more than at daytime. The intensity of the flash exacerbates the effect.

High-quality digital cameras include features that can reduce red-eye. Whatever ends up in your photo can be removed further with digital photo software.

Older Versions of Photoshop

If you have an earlier version of Photoshop without the Color Replacement tool, select the red in the pupil using the Magic Wand and just paint over the selection with the appropriate color.

I really appreciate the autocorrection feature for red-eye in Paint Shop Pro. It automatically detects and fixes red-eye. Because Paint Shop Pro automatically detects red-eye, you just follow a set of simple commands. Start with nothing selected (choose Selections → Select None to make sure nothing is selected). Choose Adjust → Red-Eye Removal and choose one of the correction methods, as shown in Figure 4-12.

Figure 4-12: Paint Shop Pro's automated Red-eye Removal window previews changes as you adjust your photo.

Eye-color Distortion in Animals

Different animals (and different breeds of animals) produce different versions of "red" eye. Dogs, cats, and other pets have better night vision than humans and evolved different eye biology. Additional layers in animal eyes that enhance night vision can produce blue or green or yellow distortion, while other animals including some pets (like Siamese cats and Siberian Husky breeds of dogs) are prone to red-eye just like humans.

You can remove blue-eye, green-eye, and yellow-eye from animal photos using the same basic techniques discussed here for removing red-eye.

Enhancing Selected Lighting

You can often add interesting qualities to a photo by adding lighting. Figure 4-13 shows a statue illuminated with a halo of light affecting just part of the photo. Altering a section of an image requires first selecting the area you want to change and then adding effects — in general, the same set of alterations described in Chapter 3.

Figure 4-13: Adding lighting to selected elements of an image

To add lighting to a selection in Photoshop, first make a selection. Then experiment with any of the effects available in your image editing program. In Figure 4-14, brightness is increased for a selected area.

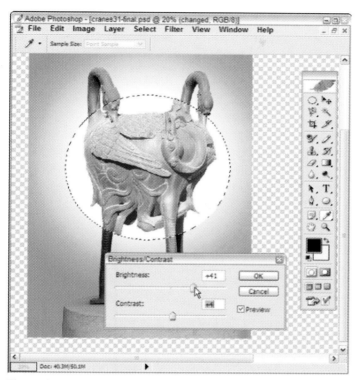

Figure 4-14: Creating a vignette

Removing Offending Objects

A bird on a wire is a poetic image, not to mention the inspiration for a beautiful song from the '70s. But a phone wire running through a pristine photo of spring flowers can ruin the whole thing.

Removing offending objects involves using your image editor's clone tool(s) to "fill in" the deleted section of a photo with pixels that blend well. Cloning replaces pixels from one area of a photo with pixels from another area. Sophisticated cloning tools often combine both steps discussed here into one — you simply use your clone tool first to pick the pixels you want to copy and then click again to paste the pixels into the new area.

In Photoshop, the easiest way to clone is to select the Clone Stamp tool, Alt+Option-click in a region you want to clone (the clone area), and drag the pointer to paste the new pattern on top of existing cells (the replaced pixels). Figure 4-15 shows the Clone Stamp tool replacing the wires with pixels copied from the blue sky in the background. In other programs, your options are restricted to using the clone tool to drag pixels from one area to another.

Replaced pixels Clone area Clone Stamp tool

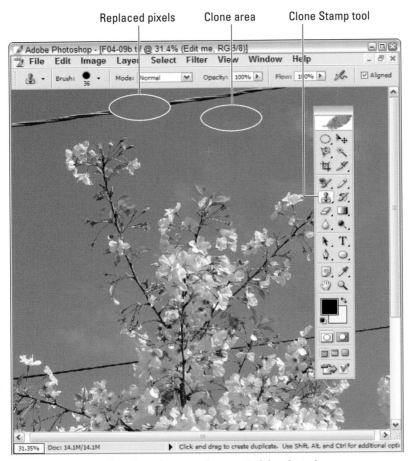

Figure 4-15: Using the Clone Stamp tool to repair deleted pixels

Altering Backgrounds

Another frequent alteration made to photos is replacing the background. The key element of this process, naturally, is selecting the background in the first place. Typically, this process requires using a selection tool like the Lasso tool or Photoshop's hyper-effective Magnetic Lasso tool to select the object.

The next step is to use the inverse selection feature to select everything except your main subject. Figure 4-16 shows the background selected in Photoshop and hue adjustments used to change the background color.

You can apply more extreme effects for more dramatic changes to an object's background. The Shanghai taxi photo in Figure 4-2 shows a significantly blurred background, for example.

Figure 4-16: Adjusting the hue to darken the background only

You can also copy and paste a selection, moving it from one photo to another with a different background. This kind of image editing takes us a bit beyond the scope of photo editing, but feel free to experiment in this direction.

Recoloring Part of Your Photo

Most image editing software offers other methods of altering photos. This is your opportunity to push the envelope and try some techniques that will either get your photo laughed at by your family, framed in an art museum, or something in between.

One simple technique for changing the color of a selection is to use the Pencil or Brush tool in Photoshop, Photoshop Elements, or other photo editors.

First, use any selection technique (like drawing with the Polygonal Selection tool) to select part of a photo. Figure 4-17 shows a section of sky being selected in Paint Shop Pro. This section of sky can later be turned into a dark shade of blue.

Before using the pencil or pen tool that comes with your photo editor, set the foreground color to define the color applied by those tools. To set a foreground color, click the Foreground Color swatch in the image editing program. Figure 4-18 shows the Set Foreground color swatch in Photoshop.

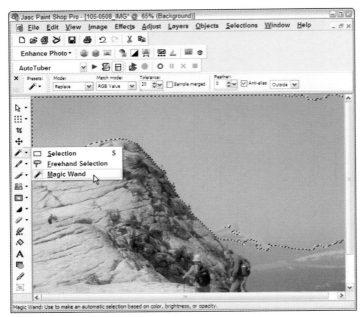

Figure 4-17: Selecting a portion of sky to make it bluer

Figure 4-18: The Foreground color swatch in Photoshop is similar to tools in
Paint Shop Pro, PhotoPaint, PhotoImpact, and other image editors.

After you click the Foreground color swatch in your image editor, choose a color from the color palette that appears. Then use a pen or pencil tool to "color over" a selected region to change its color.

Select the Region First

You can use recoloring tools like the pencil or brush tools without first selecting a portion of your photo. However, if you select the region first, you won't have to be as careful with your brush or pencil tool because only the area of the selected region will be recolored, even if your tool strays "outside the lines" of the selected region.

Using brush or pencil tools is one way to recolor a section of a photo. You can also select a region and use tools like Hue, Saturation, or Brightness to make subtle (or dramatic) changes in the coloring of a selected region. In Figure 4-19, for example, I first selected the blue water in the lagoon with the Lasso tool in PhotoImpact and then adjusted the hue to make the water bluer.

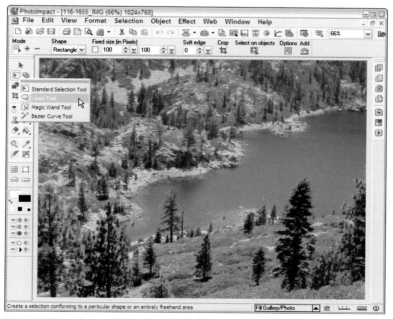

Figure 4-19: Selecting blue water with the Lasso tool before adjusting its hue to deepen the color

Finally, you can push the envelope by experimenting with whatever filters come with your image editing software. The technique for applying filters is the same as for recoloring: First select part of the image and then change that selection.

In Figure 4-20 I applied several Photoshop filters to the background of the museum piece. With your imagination suitably piqued, have fun experimenting with the filters, effects, and tools in your own image editor.

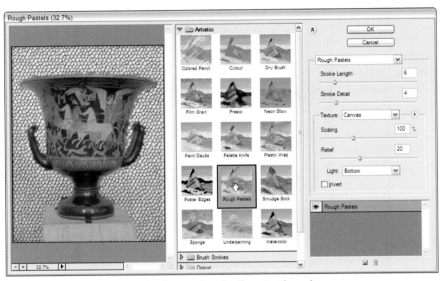

Figure 4-20: Transforming a background with effects in Photoshop

Summary

You can achieve complex, subtle photo effects by editing small portions of a photo. For example, you can brighten one section of a photo while darkening another, or make a sky bluer while leaving the rest of the photo untouched.

Editing elements of a photo involves two steps: selecting part of the photo and then applying an effect to it. A major challenge in complex photo editing involves mastering the two basic ways to make selections — by color or by shape.

You select shapes within a photo by using tools usually called a lasso — a metaphor for the rope used by cowboys to rope in cattle. You select pixels by color using tools usually called a magic wand. You can find tools that match these basic categories in Photoshop, Photoshop Elements, PhotoPaint, Paint Shop Pro, and PhotoImpact.

Editing selections can produce subtle results, like adding a bit of light or contrast to a face. Or it can produce dramatic changes, like fixing red-eye, lightening an area of a photo, removing part of an image, inverting a photo background, or applying a blurring effect.

Editing photos with high-end programs like Photoshop is something you can ramp up to. If your current system has 256 MB RAM and shelling out several hundred dollars for Photoshop sounds unnecessary, squeeze the most out of the software that came with your operating system or your camera or printer. When you're ready to evolve to more complex photo editing abilities, you can do quite a lot with alternatives to Photoshop like Paint Shop Pro.

Chapter 5

Choosing Paper and Ink

Photo by Dave Taylor

Proper paper and ink selection makes a huge difference in the appearance of your photo prints. In Chapters 3 and 4, I showed you how to improve photo quality dramatically with a few photo editing tricks. To translate your touching-up work into beautiful prints, you need to master the use of appropriate paper and ink.

Paper, ink, and inking technology are developing at a fast pace — and in tandem. Decent-quality, borderless prints are available from nearly any photo printer at a low price. Refinements in inkjet technology (as well as dye sublimation printing) have been complemented by new paper technology to produce digital photos that are becoming more and more difficult to distinguish from high-quality, old-style photo prints.

Traditionally, a major issue for digital photo printing has been faithful reproduction of light skin tones. Mixing cyan and magenta (near blue, and near red) with yellow usually fails to produce satisfactory nuances of light tones. New "light cyan" and "light magenta" ink cartridges, help solve the problem of rendering the color of light-skinned people accurately, as shown in Figure 5-1.

Figure 5-1: "Flesh" color has always posed a challenge in printing digital photos.

Science of Paper and Ink

Chapter 1 began with a discussion of the significance of the very high print resolutions advertised by today's inkjet printers. While your digital photo doesn't need to be saved with a resolution any higher than 300 dots per inch (dpi), your printer might well support 4800 dots per inch, or more. For example, the Epson Stylus Photo R800 prints with a horizontal resolution of 5760 dpi. That means if your image is saved with a resolution of 300 dpi, each image pixel can be composed of more than 19 different ink dots.

The significance of all those ink dots is not mainly a "higher resolution" per se but more accurate color reproduction. High printer resolution means that many different colors can be *dithered* (placed next to one other) to create a wide range of colors. Every color in your photo needs to be generated by combining cyan, magenta, yellow, and black dots — plus possibly additional "photo colors" (such as light cyan and light magenta). Figure 5-2 shows an image "dot" composed of 24 tinier printer dots that dither black, cyan, magenta, yellow, light cyan, and light magenta to create composite colors.

All those dots require a paper surface that can accurately absorb the ink without running, smearing, or penetrating too deep (or not enough) into the paper. Printer manufacturers put a lot of research into carefully matching ink and paper so that the extremely fine jets of ink that come shooting out of a modern inkjet printer are absorbed with precision by the paper.

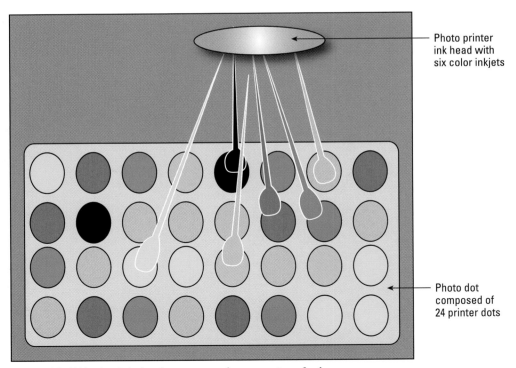

Photo printer ink head with six color inkjets

Photo dot composed of 24 printer dots

Figure 5-2: Dithering ink droplets to create the perception of color

Print Resolution Is an Inkjet Thing

The emphasis here on the significance of high-resolution printers is relevant to inkjet printing only. Dye sublimation printers use a very different process to produce accurate colors. Instead of dithering many dots to create colors, they more accurately combine colors in a single, larger dot. I describe the process of dye sub printing in Chapter 7.

Similarly, color laser printers are able to produce relatively accurate colors with lower resolution — in the 300 dpi range. While dye sub color quality is equivalent to — or better than — that of inkjets, laser printers do not support the color range and accuracy available from dye subs and inkjets.

Finally, by comparison, old-style chemical photo development used on traditional film prints allows the creation of an even wider range of colors. The "dots" produced in this process are so tiny that they're on the molecular level; for all practical purposes, they aren't really dots at all. While photo printing remains the standard, higher-resolution inkjets produce prints indistinguishable from those out of a photo printer.

Ink droplets shot out by inkjet printers are measured in *picoliters*, which is a thousandth of a liter. For readers not imbued with the metric system, a liter is about a quart and a picoliter is about a thousandth of a quart.

Note here that the ink droplets fired from your inkjet are not measured in diameter (as in dots per inch) but in volume. That measurement is then translated by your printer manufacturer to dots per inch. So you won't see printers advertised by the liquid volume of each ink blast they produce — that wouldn't make much sense to anyone. But you can imagine that the lower the quantity of ink in picoliters, the higher the resolution and resulting color accuracy.

The Epson Stylus Photo R800, for instance, produces 5760 dpi resolution (although the real resolution is constrained by the dpi resolution of the image file). That high resolution is a product of the fact that each inkjet burst is of an extremely small volume — in this case, 1.5 picoliter droplets.

It might be apparent from this discussion that the final resolution and quality of your print depend highly on the ink droplets from your printer meshing perfectly with the paper you use. Given the lack of quantifiable standards for ink and paper, you are pretty much at the mercy of your printer manufacturer's product line.

Cross-Reference

Later in this chapter, Table 5-1 surveys inkjet droplet size and resolution for leading printers from Epson, Canon, Lexmark, Hewlett-Packard (HP), and Canon. For an analysis of inkjet printers, their advantages, disadvantages, and features, see Chapter 6. You can read about the ins and outs of dye sublimation printers — an alternate technique for photo printing — in Chapter 7.

Compatibility, Anyone?

With all the emphasis I place on matching ink, print technology, and paper, you might wonder if there is ever a good reason to use third-party paper in your printer. Sure, there are lots of good reasons.

You might find some really good values by purchasing photo paper made by another manufacturer. From a quality standpoint, you can find a wider variety of surfaces, paper types, and sizes (including greeting cards, postcards, and other special paper sizes) if you're not constrained to using paper solely from your printer's manufacturer.

Configuring Third-Party Paper with Your Printer and Ink

Companies like Media Street, Pictorico, Hahnemühle FineArt, Moab Paper, Lyson, Crane & Co., and others make a wide variety of paper surfaces, textures, and coatings that are fun to experiment with. Available paper surfaces include rag, silk, canvas, velvet, and watercolor paper. You'll find these specialty photo papers online from sources like www.inkjetgoodies.com.

Cross-Reference

Chapter 9 shows you how to print to alternate (nonpaper) media, such as transparencies, iron-on transfers, sticker paper, and even printable CDs and DVDs. If you want to start designing beautiful color photo greeting cards right now, jump ahead to Chapter 8.

My local office supply store offers a few special texture photo papers from companies like Kodak that HP, Sony, Epson, or Canon do not sell.

Manufacturers of high-quality photo paper provide either ICC profiles or compatibility charts to tell you what settings to use on your printer to match their paper. Moab Paper, for example, provides downloadable profiles for high-quality Epson printers but encourages you to create your own—a bit off-putting to anyone but a serious professional. On the simpler end of the spectrum, Kodak papers adopt settings already configured with your printer. For instance, in Figure 5-3 I'm at the Kodak compatibility page on their Web site (www.kodak.com/go/inkjet) and I'm selecting compatibility for my Canon i860.

Figure 5-4 shows the settings Kodak recommends for my printer. Kodak also offers downloadable software that automatically figures out what settings to use and manages the entire print process.

Check Before You Order

Before you place an order for a specialty, third-party photo paper, find out whether ICC profiles are available for your printer. If not, you'll be gambling on how well your prints turn out.

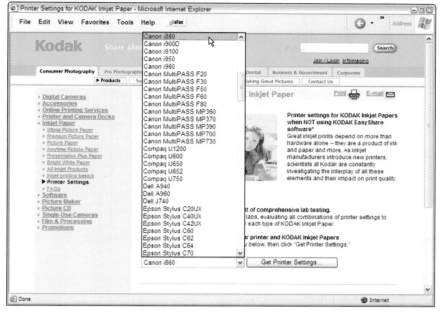

Figure 5-3: Finding compatibility for using Kodak paper with a Canon printer

Mismatched Paper and Ink: A Bad Experience

Under appropriate circumstances and with adequate profiling, you can get good results using third-party paper with your printer. However, if you just grab some photo paper and throw it in the printer without paying attention to its compatibility, you're likely to be unpleasantly surprised with your results.

In Figure 5-5 I've laid out the 4 × 6 paper for my Canon printer next to the 4 × 6 paper for my HP Photojet. Will the 4 × 6 photo paper from one manufacturer work in the other company's printer?

What? Printing from a Printer?

You've probably noticed a theme in this book: If you want high-quality digital photo prints, you'll have better results printing from your computer instead of directly from your printer. Even simple photo editing software provides more options for cropping, resizing, fixing colors, and sharpening photos than you'll find in the most sophisticated controls on a printer. Printers are smart but they aren't that smart — yet.

That said, printing from your computer is just a theme of this book; it is not a rule. There are definitely times and places when it's just too much fun to pass up the instant gratification of printing directly from your inkjet. I explore that process in Chapter 6.

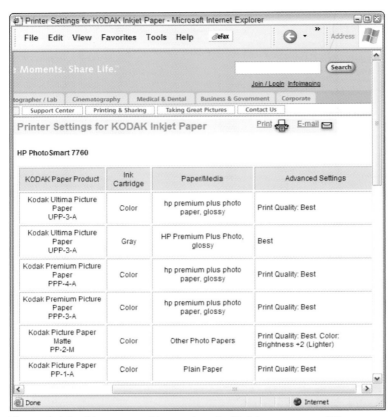

Figure 5-4: Looking up matching settings for Kodak paper on an HP
Photosmart 7960 printer

In this particular case, my snapshots printed decently, but the odyssey to get good prints using Canon paper in my HP printer is a lesson in the problems you run into when you experiment with product mismatches.

First of all, the HP paper is a different size 4 × 6 from the Canon paper. As you can see in Figure 5-6, the HP paper includes a tab, about a half-inch long, to pull the paper through the printer. You tear off the tab after you print the photo.

When I tried using the Canon 4 × 6 paper in the HP printer, the HP left a half-inch blank stripe. I was able to get around this by finding a setting in the print dialog box for 4 × 6 paper without a tear-off strip but that option wasn't available using just the print controls on my printer.

Finally, I had a very strange experience with color on mismatched paper. When I printed photos from my HP printer onto Canon paper, the colors looked faded and distorted but only at first. After a few hours, the colors matured and the final results are hard to distinguish, as shown in Figure 5-7.

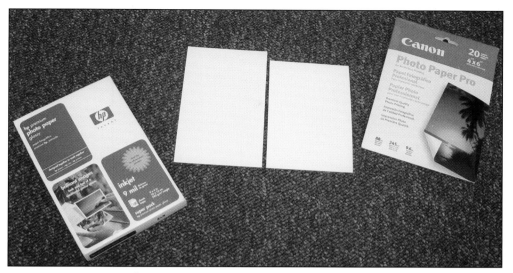

Figure 5-5: Mixing paper from one manufacturer with the printer of another: Don't tell anyone I'm doing this!

Figure 5-6: HP's 4 × 6 paper has a tear-off tab.

Figure 5-7: Both Canon and HP paper printed nice 4 × 6's but it took some work.

Using Proper Paper Settings

Your printer's inking system, your photo paper, and your ink type work in tandem to produce high-quality prints. To ensure that these three elements of the printing process mesh properly, the general rule (which I'll return to and modify) states that you should stick to paper and ink that are manufactured by your printer company — and make sure to select the proper paper in your print dialog box, as shown in Figure 5-8.

Chapter 2 explained how ICC profiles work to synchronize the color display on your monitor, in your image editing software, and by your printer. ICC profiles are at least as important for your paper and ink as they are for the printer. A mismatch between your print software setting and your paper, in particular, will produce unpleasant results.

Paper and ink settings are generally available through your printer driver software, not your image editing software. So a full set of ink and paper options will be available regardless of what software you use to print your photo. Even the most basic programs, like the image editor that comes with your printer or operating system, provides you with access to the full set of print options for your printer. The print options vary depending on your printer. The features available for the Photosmart shown in Figure 5-8 are similar to those for my Canon 8i860, shown in Figure 5-9.

You will become more familiar with print dialog box issues in Chapter 6. Just remember the importance of making sure that the paper you select is supported for your printer and of carefully selecting the proper paper option when you print.

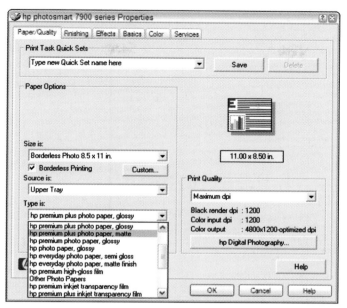

Figure 5-8: Selecting matte paper for an HP Photosmart 7960

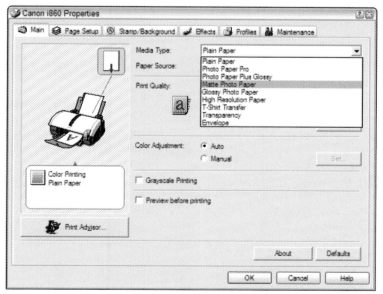

Figure 5-9: Selecting paper from the Canon printer's Print dialog box

Epson's Downloadable ICC Specs

As the company with the largest base of photo printing customers, Epson has done the most to make ICC profiles accessible to users. You can get updated ICC profiles from www.epson.com for any Epson printer. When you download these profiles, they are accessible to your operating system's print dialog box.

Special Inks for Photo Printing

Extremely high-resolution printers generate highly nuanced dithering that faithfully reproduces a wide range of colors. However, some colors are very hard to reproduce in photos. Among them is the skin tone of light-skinned people, sometimes referred to as "flesh color." This is a color found frequently in photos.

Six- and Eight-Color Printing Costs

What's a better deal — four-color, six-color, or eight-color printing? Overall, six- (or seven- or eight-) color printing isn't significantly more expensive than four-color ink printing. That's because you generally use the same amount of ink to print a photo. With most color photo printers, you can replace individual ink cartridges as they run low on ink; you don't need to replace the whole set.

You do pay more for printers that use six, seven, and eight color cartridges but not that much more. A quick trip to the mall reveals that six- and eight-color printers cost about $50 more than their four-color cousins with similar features. Actually, the printer itself is only a small part of the equation. When you consider that a set of all eight-color cartridges for an Epson printer runs over $100, the difference in printer price becomes a minor factor in your ongoing color photo printing budget.

What saves you money is using a photo printer that uses separate ink cartridges — whether four, five, six, seven or eight — instead of color printer cartridges that contain all four colors in the same replaceable cartridge. If you're printing a lot of sky and ocean shots, you'll run out of ink in your cyan or blue cartridges long before the red or magenta cartridge expires.

Besides having to replace the entire cartridge even if you run out of just one color (yellow, cyan, or magenta), these small cartridges hold very little ink, so you'll find yourself replacing them frequently. On the other hand, the marketing folks at HP have told me their surveys show that buyers don't want the hassle of buying separate cartridges. HP photo printers, therefore, use a single, replaceable color cartridge.

Aside from this convenience factor, the only reason to put up with single cartridge systems is the convenience of tiny portable photo printers, like the HP Photosmart 245 or Epson PictureMate miniprinter that bundles paper and ink in packets.

To enhance the range of printable colors, sophisticated and more expensive photo printers include additional print cartridges. In addition to the basic cyan, magenta, yellow, and black cartridges they add light black, photo black, light magenta, or light cyan. The light cyan and light magenta help solve the "flesh tone" issue, while the special photo black allows a more subtle gradation of black and gray than is achievable from standard black ink.

Printers that use six colors of ink include the following:

- HP 3650, 5150, 5650, Photo 7660, Photo 7760, 9650, 9670, and 9680
- Lexmark P707, Z705, Z715, Z815, 45, 45N, and 45N Solaris
- Canon I900D, I960, and I9100
- Epson Photo R300 and 1280

The Epson Photo 2200 is a seven-color printer. Printers that provide eight colors of ink include the Epson Stylus Photo R800 and the HP Photo 7960.

These six-, seven-, and eight-color printers provide a wider and truer range of colors and enhance the printing of photos of people. But many four-color printers also produce excellent prints. If you're an aspiring (or even accomplished) portrait artist, it might be worth the extra money to invest in the extra ink capability. If you don't have a need for perfect skin-tone matching, it might not be worth it. You won't have ever to worry that the skin looks downright green (unless you're taking pictures of aliens).

How Photo Paper Works

Digital photo paper is designed to absorb ink droplets accurately that the printer jets shoot at it. Having spilled soup on my shirt many times, I appreciate how hard it must be to configure a surface to absorb a droplet of anything precisely.

Photo paper is composed of multiple layers. You sometimes hear people talk about four-, five-, or even 10-layer paper. These layers absorb not only ink from the printer but excess water in the water-based ink.

The ability to absorb ink properly is the defining characteristic of inkjet photo paper. If you've ever printed a photo on plain paper, you can tell that you lose much color ink — it sinks right through the porous surface of the paper. If you print on a surface that is too impermeable, ink and water are not absorbed at all and the ink just smears.

Using the Wrong Paper Makes Messy Printers and Prints

Printing on mismatched paper bad is for not only your photo; it can be bad for your printer. Really bad mismatches of print surface and ink can leave unabsorbed ink droplets on your print heads and ruin your next print. Happily, it's a pretty easy fix. When your print heads become clogged, you can "flush" out your printer simply by putting a couple of blank sheets of (nonphoto) paper in the printer feeder tray and using the printer's eject or feed button to run them dry through the printer.

While there are many varieties of photo paper, the layers that make up the paper fill four general roles: a surface layer retains ink, an underlying layer absorbs water, a second underlying layer acts as the final absorption sheet, and the paper backing helps feed the paper into and out of the printer. These various layers appear in Figure 5-10.

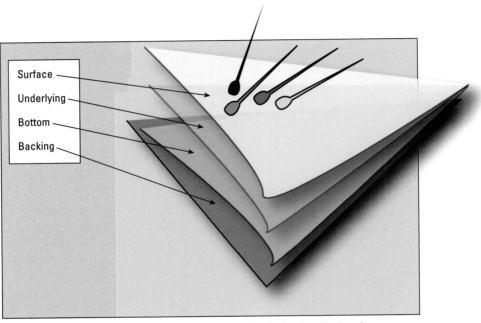

Figure 5-10: The basic layers in photo paper — with ink droplets fired at the paper

Business of Paper, Ink, and Printers

Many industry folks have confided in me something that is hardly a trade secret: printers are a loss-leader for manufacturers — paper and ink are where the money is made. Manufacturers claim, in many cases with justification, that for the highest-quality prints, you should match their printer, their ink cartridges, and their paper.

Can you safely save yourself a few bucks by comparison-shopping for paper and ink? Yes and no. Yes, you can experiment with and substitute nonmanufacturer paper and other print surfaces. Many paper manufacturers provide compatibility information, like the Kodak recommendations shown earlier in Figures 5-3 and 5-4.

No, you should not substitute nonmanufacturer replacement inks or refill kits for photo printing. I know a number of people who save considerable money either by replacing the toner in their production printers with refill kits or using third-party manufacturers' ink cartridges. Some of them swear by this process but I don't know anyone who uses nonmanufacturer ink for quality photo printing. For the reasons I discussed earlier in this chapter, you should stick to the manufacturer's cartridges for your photo printer.

If you print a lot of photos, however, you will find it more economical to use a printer that allows you to replace individual ink cartridges when they run dry instead of a printer that requires a single color cartridge. What's more important, saving ink or enjoying the convenience of one cartridge? It's your call. Miniprinters tend to come with single cartridges. These little printers just don't have the room for four color cartridges, let alone eight. The Epson PictureMate squeezes six ink cartridges into a single replaceable packet, and the HP Photosmart 245 packs four colors into a single cartridge, as shown in Figure 5-11.

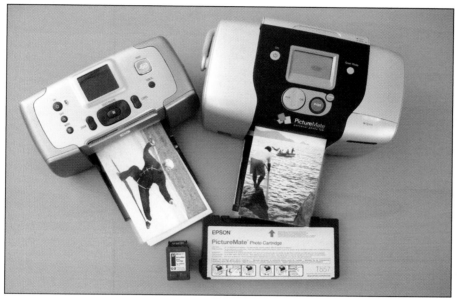

Figure 5-11: The HP Photosmart 245 and the Epson PictureMate are too small for separate cartridges each containing one color.

Shopping for Picoliters

All this discussion of picoliters might have you intrigued as to what size ink droplet your printer produces. If you're shopping for printers, you might want to know how much (or more to the point, how little) picoliter you can get for your buck.

In general, printers don't feature the size of their ink droplets. They promote resolution specs instead. Resolution is generally related to ink drop size but that relationship is hard to compute. Color quality is a product of both resolution and droplet size, with high-resolution and low-droplet size being optimal. Table 5-1 shows the ink droplet size and resolution of some selected printers.

Table 5-1 Inkjet Droplet Sizes and Resolutions

Printer Model	Droplet Size	Resolution
Epson Photo R800	1.5 picoliters	5760 × 1440
Canon I475D	2 picoliters	4800 × 1200
Canon I560	2 picoliters	4800 × 1200
Canon I860	2 picoliters	4800 × 1200
Canon I960	2 picoliters	4800 × 1200
Epson C84	3 picoliters	5760 × 1440
Lexmark P707	3 picoliters	4800 × 1200
Epson Photo R300	3 picoliters	5760 × 1440
Lexmark 45	3 picoliters	600 × 600
Epson C64	4 picoliters	5760 × 720
HP 5150	4 picoliters	4800 × 1200
HP Photo 7660	4 picoliters	4800 × 1200
Canon I9100	4 picoliters	4800 × 1200
Epson Photo 2200	4 picoliters	2880 × 1440
HP Photo 7960	4 picoliters	4800 × 1200
HP 1100D	5 picoliters	4800 × 1200
HP 5650	5 picoliters	4800 × 1200
HP 6122	5 picoliters	4800 × 1200
Epson C44UX	6 picoliters	2880 × 720
Lexmark Z705	7 picoliters	4800 × 1200
Lexmark Z715	7 picoliters	4800 × 1200

Table data source: www.upgradesource.com/Printers-Comparison.htm

Selecting Photo Paper

The digital printing industry has evolved a nice selection of paper for printing photos. Glossy paper has been the choice of photographers going back to the era of film and chemical printing but your options also include matte paper, textured paper, transparency sheets, and special paper and ink combinations that promise prints that will last 50 years or more without degrading in quality.

Glossy paper for photos has always been popular because it reflects more light than matte or textured paper and produces brighter colors. At the same time, modern matte paper reproduces extremely bright and sharp colors without the glare associated with glossy paper. Figure 5-12 shows the same print on both glossy and matte paper.

Figure 5-12: Glossy (*left*) and matte prints

Printing on Special Papers

The most realistic photo reproduction is accomplished with photo glossy paper, which reflects the most light and interacts very well with the inkjet process. Matte photo paper comes close to glossy paper in producing color photos. Furthermore, the soft, flat (nonreflective) surface often lends realism to a photo.

Cross-Reference

Learn more about issues involved in configuring your inkjet for optimal printing in Chapter 6.

Beyond the two basic options of glossy and matte paper lies a wide range of special papers. These papers provide surfaces that range from a raglike surface to hyper-glossy "chrome gloss" paper.

Earlier in this chapter I described the case for sticking with your printer manufacturer's paper because it is more precisely tuned to work with your inkjet's inking process. Now I'll modify that advice: Use your manufacturer's paper wherever possible but when you need special papers for artistic effects — like velvety texture, rag paper, or watercolor — then venture beyond your printer manufacturer's paper set. You'll find a handy and frequently updated list of special papers provided by printer manufacturers at www.inkjetgoodies.com/papers.htm.

Specialty Papers Are Expensive

Overwhelmingly, you'll be printing your photos on glossy or matte paper because they provide the most accurate reproduction of photos. The standard paper options are also considerably cheaper. Consider picking up a "sampler pack" of paper provided by many paper manufacturers and experimenting with various paper types and textures before committing yourself to an online or store purchase of specialty papers.

WOVEN AND FABRIC PAPERS

Fabric and woven photo paper can produce uniquely textured prints. Specialty photo paper is available in textures ranging from satin to canvas.

It's almost impossible to predict exactly how a print will turn out with textured paper — particularly special-effect papers like watercolor or canvas. The photo will look less realistic, but the additional texture might lend the print a unique and interesting look. Figure 5-13 shows the same photo printed on standard glossy paper and on special "satin" paper.

Figure 5-13: This photo was printed on glossy paper (*left*) and satin paper.

TRANSPARENCIES

One particularly challenging printing project is presenting your photos as transparencies for overhead projection. If you're projecting photos or using them for special effects on transparency film, colors will look quite different than they do when printed on opaque paper. I walk you through the process of selecting transparency sheets and printing high-quality transparencies in Chapter 9.

Transparency film distributed by your printer manufacturer is your best bet for the most faithful presentation of your color photo. Definitely avoid using regular transparency paper (non-inkjet or non-photo transparency sheets) — the inkjet ink will smear and slide right off the film. I'll return to special issues related to printing photos on transparencies for overhead projection in Chapter 9.

Creating Long-Lasting Prints: Archival Paper

The fact is, most prints you create with your inkjet printer will not last nearly as long as an old-style chemical print. Photos that I printed two or three years ago — admittedly with technology that continues to improve — already show some signs of fading. When I take my portable printer out to the beach, I've experienced fading that same day if I leave the photos exposed to direct, bright sunlight.

You can reduce this fading and improve the longevity of your digital photo prints by protecting them from direct light. Framing photos behind glass helps protect them as well. For prints that you really want to preserve, turn to a professional printing service that uses printing processes close to traditional photo printing. (I survey your options for doing this in Chapter 10.)

For many of us, the fact that our photo is encoded in a digital file is sufficient to archive our photos. It's possible, after all, to churn out a new photo print if the old one fades. Of course, 20 years from now, new digital imaging technology will likely have surpassed the way we take digital photos now, as well as the formats and media we use to save digital photos. Relative to the quality of digital photos in the future, digital photos archived today will seem lower in quality. But the quality of an image digitally archived today will not degrade for the foreseeable future.

Shameless Book Plug

For a full discussion of digital archiving techniques and technology, see *Total Digital Photography: The Shoot to Print Workflow Handbook* by Serge Timacheff and David Karlins (Wiley, 2004).

Even so, if you are producing high-quality prints as gifts, for display, or for sale, you want to check out recent developments in archival-quality prints that will last for decades without noticeable fading.

Printer manufacturers promise archival-quality prints because they have put together a combination of ink, inking processes, and paper that is very stable. All three elements are necessary for stability — and they interact with each other. Special inks are developed that last a long time. High-end photo printers use printing processes that incorporate drying and sometimes coating to protect photos. The ink and inking processes must mesh tightly with the absorption and other qualities of archival-quality paper. In short, if you want to print archival-quality photos, you need to invest not just in good paper, good ink, and a good printer but in a whole, integrated system.

Major printer manufacturers advertise printers that can create archival photos. Epson claims their Stylus Pro R800 with Epson UltraChrome Hi-Gloss pigment ink and special glossy and matte papers combine to create photos lasting up to 80 years. The key element in this combination is the UltraChrome high-gloss ink. These inks tend to be more pricey by the cartridge than other inks, but because there are so many factors in how ink is applied and how much is applied, price comparisons on ink cartridges tend to fall in the apples-and-oranges category.

Shop for acid-free photo paper, which is said to help preserve the longevity and quality of prints. However, most studies show that what degrades first is not the photo paper but the ink. UltraChrome ink generally survives light and air better than other print options. That said, the way you store and display photos has a big impact on their long-term survival. Protecting photos from heat and light adds decades to their life.

Cross-Reference

For more discussion about archiving photos, acid-free paper, archival environments, and framing techniques, see Chapter 11.

Ink Cartridges Versus Dye Sub Ribbons

Dye sublimation printing is a very different process from inkjet printing. I explain why in Chapter 7 but for now it's critical to note that dye sub printers require very specific matches of paper and ink. The dye sub process of compressing gas into color dots requires that the gaseous ink interacts with the paper just right.

Dye sub printers do not achieve quality color reproduction by packing a lot of dithered color dots into a tiny space. They create colors by mixing gaseous ink that then solidifies on the photo printer paper.

Furthermore, dye subs don't use ink cartridges; they use ink ribbons that are heated to release ink in gaseous form. These ribbons are packaged along with the paper in many cases.

Summary

Matching paper, ink, and printers is a bit more complex than it seems. Beyond choosing a paper surface that's best for your photo—glossy, matte, or other—you need to ensure that your paper is compatible with the process used to transfer ink from your inkjet printer.

Constant evolution of photo ink has produced inks that print realistic tones, last a long time, and generate a wide range of colors. Higher-quality photo printers generally have four, five, six, or even eight color cartridges. It's more economical to replace individual color cartridges than to purchase a new cartridge every time you run out of one color of ink.

You also have a wide variety of options when it comes to papers. You can stick with what the manufacturer recommends or use third-party paper and print media compatible with your printer. Your first and best option for specialty papers is to see if the printer manufacturer sells the paper you need first (such as transparencies). If they don't have what you need, find what you do need online or at an office supply store.

Finally, don't forget to use the correct ICC profile in conjunction with the right printer, paper, and ink. That's the one surefire way to get the best print on a calibrated computer.

Dye sublimation printers do not use ink cartridges; the ink ribbon is an integral part of the printer (although they do have to be replaced). It's still very important to make sure your dye sub is using proper, compatible photo paper.

Once you've put together an appropriate combination of paper, ink, and printer, the settings you choose in your printer's dialog box further enhance (or mess up) the quality of your print. I walk you through the process of configuring and printing from inkjets in Chapter 6 and show you how to set up and get the most from a dye sub printer in Chapter 7.

Chapter **6**

Printing Great Photos from Inkjets

In just a few short years, inkjet photo printers have branched off from their evolutionary predecessors, the inkjet office printer. From slow, crude producers of dotty text and marginal-quality graphics, the current generation of six-, seven-, and even eight-color photo printers produces prints that most people cannot distinguish from photo lab pictures.

Really? Well, photo printer manufacturers have surveys to prove it. A survey cited by HP concluded: "When presented with prints of five different photos, US consumer respondents preferred HP prints more than other inkjet and silver halide [photo lab] prints... Most participants did not realize inkjet printers are capable of producing true-to-life photographs. The test proved to be a real eye-opener."

Spencerlab Study

The previously mentioned study is called "Consumer Preference Research: Photographic Print Quality, HP 8-Color vs. Conventional Processing & Competitive 6-Color Inkjet Printers." You can read it at `http://spencerlab.com/Spencer-hpPIQ_Sep03.pdf`.

It's worth dissecting this claim a bit. First, the survey said "US consumer" respondents, which I interpret as significantly less demanding than those of us who aim to produce great digital photos. I have conducted many informal surveys and I think it's true to say that, overall, people who like photos and take and print photos at photo labs are generally rather amazed at the quality of a well-done inkjet photo, even compared with a photo lab print. Inkjet quality is good, but there is more involved in achieving great results from an inkjet. The elements of preparing a photo for digital printing covered in this book — ranging from editing and touch-up techniques to the ink and paper you choose — play a major role in raising the quality level of digital prints.

This means if you send an average photo from a digital or film camera to a professional print lab for traditional (chemical-based) photo printing, that print will rarely look anywhere near as good as a photo that was touched up using photo editing software. Photos that have been well prepared with photo editing software, and printed using high-quality photo ink and high-quality photo paper, look very good indeed.

The debate over whether inkjet quality really equals or exceeds traditional photo printing is bound to rage for some time, as are arguments over dye sub quality versus inkjet color. But the very fact that there *is* a debate — and that large numbers of people find inkjet prints as good as or better than traditional photo prints — says much about the state of photo inkjet printing.

Cross-Reference

To explore the dye sub (dye sublimation) alternative to inkjet photo printing, see Chapter 7.

Given that very high-quality prints are available from inkjet printers and building on the previous discussions in this book about photo editing, paper options, and ink quality, you can see that two basic factors determine the quality of inkjet photo prints:

- Quality and options available in the inkjet printer
- Correct use of the settings available with the printer

The rest of this chapter explores both these factors. I'll help you identify features that improve inkjet quality and help decipher the sometimes confusing printer property options available for photo inkjets. Along the way, you'll find advice on features that make inkjet photo printing more convenient, economical, and reliable.

Inkjet Types, Sizes, and Features

The biggest single factor determining inkjet photo quality is the interaction of the inkjet method itself with appropriate photo paper. Chapter 5 explained the processes that combine to align ink with paper to generate precise dithering (combining ink colors), which produces a wide range of colors. Remember that with all the advances in inkjet technology, there have remained certain colors that aren't easily generated by combining droplets of cyan, magenta, yellow, and black.

Cross-Reference

For a detailed explanation of how inkjets combine a few primary colors to generate a wide array of color tones, see Chapter 5.

In general, six-, seven-, and eight-color inkjets do significantly better at managing challenging color tones and transitions between colors. A photo of the sky with subtle gradations of color, a close-up of a face, or a delicate transition between clouds, like the one in Figure 6-1, will be much improved when printed on a six-, seven-, or eight-color inkjet as opposed to a printer limited to cyan, magenta, yellow, and black ink.

Beyond the benefits of additional ink cartridges, other elements make photo prints look good and print quickly. High printer resolution — the number of tiny inkjet droplets per inch — produces sharper photos with a better color range than printers with lower resolution. Printers with top or back sheet feeders subject photo paper to less stress than bottom-feeding printers that print on the back of paper as it is inserted into the printer. Finally, printers that use inking

processes that mesh well with photo paper produce longer lasting and better color prints than printers using "quick drying" photo paper, or photo paper not configured specifically for a particular printer.

Figure 6-1: This photo looks much better printed on a six-, seven-, or eight-color inkjet than on a four-color inkjet.

Inkjet Features

Photo inkjets come in all sizes, ranging from cute, football-sized miniprinters to huge professional printers costing tens of thousands of dollars. Consumer-level (as opposed to professional print shop) printers generally cost between $100 and $600, with printers that support wide sheets costing significantly more.

Options for Large Prints

For poster-sized prints, consider the online print services surveyed in Chapter 10.

In addition to the number of ink cartridges, other features that influence print quality include the type of paper loading, the paper drying and finishing process, resolution, ink drop volume (the smaller the drop — measured in picoliters — the better), borderless printing, and support for nonpaper media like CDs and DVDs.

Features that make inkjets more convenient include card readers that accept memory cards from cameras, USB connections that import photos directly from a camera, paper trays that feed 4 × 6 and smaller paper, LCD windows that preview photos, and features like duplex (two-sided) printing that allow the inkjet to do double-duty as a home or office printer.

In general, inkjets trend to provide trade-offs. Those with the most convenient features, including those that double as office printers, tend not to offer features like six-, seven-, or eight-color printing. Among the major manufacturers of photo inkjets, Epson and Canon inkjets tend to provide six, seven, or eight individual color cartridges, while HP photo printers combine four or six colors of ink into a single cartridge. The mini Epson PictureMate, shown in Figure 6-2, uses a six-color ink cartridge.

Figure 6-2: The Epson PictureMate, shown with ink and paper, is tiny but has a six-cartridge color system packed into the ink cartridge.

Stuffing a lot of convenient features into a tiny printer, the four-color HP Photosmart 245 printer provides five different slots supporting the most popular printer memory cards and combines an LCD display and minimal in-printer editing tools to print without a computer, as shown in Figure 6-3.

Paper Loading

Paper-loading options include the freedom to feed different sizes of photo paper conveniently and the ability to feed photo paper through a printer without bending the paper through rollers. Consumer-level photo inkjets offer two basic options for loading paper: front or top. Top- or back-loading printers run paper past the inkjets in a straight path without bending the paper. These printers sometimes include rollers that accept long rolls of photo paper.

Figure 6-3: The HP Photosmart 245 includes an LCD photo display and a built-in card reader.

Paper trays under the printer, like that in the HP Photosmart 7960, allow for a smaller printer footprint but force paper to wrap around rollers before printing. Photo paper is inserted face-down in these printers, which risks scratching the paper. The Photosmart includes a convenient feeder compartment for 4×6 photo paper, as shown in Figure 6-4.

The contrast in paper-feed options between the HP Photosmart and the Epson Photo Stylus printers illustrates a trade-off between convenience (easy loading, less space) and quality (no bending during paper-feeding). The Canon i860 shown in Figure 6-5 feeds from the top and includes a 4×6 feeder tray. It even does duplex printing for office tasks or double-sided photo projects.

Overall, top-loading printers produce less handling stress on photo paper but take up more vertical space and often have fewer convenient features for managing small prints.

Connections

There are several ways to get photos from your computer to your printer. Printer connections include the ubiquitous USB (Universal Serial Bus) connection, as well as FireWire or IEEE 1394 cables, wireless connections, and the old-but-reliable parallel port connection. Each connection has its advantages and disadvantages and varies significantly in speed.

Figure 6-4: The paper tray reduces printer height-space requirements. The tradeoff is rougher handling of paper during the print process.

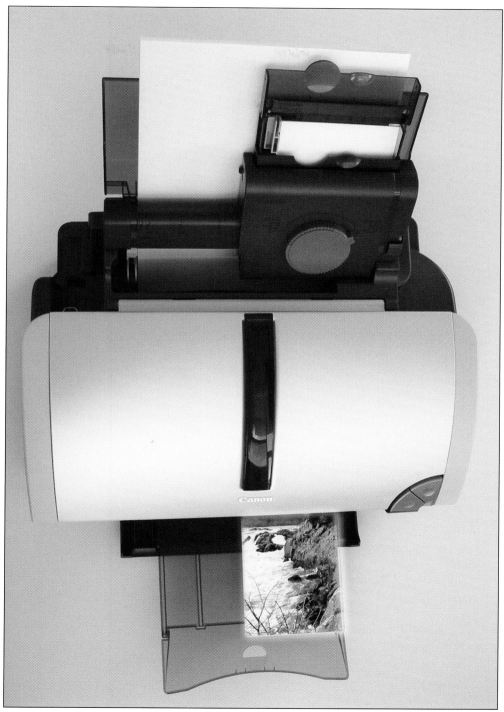

Figure 6-5: The Canon i860 feeds from the top and includes a 4 × 6 paper tray.

It's important that your printer connection be compatible with your computer input ports. Most computers have USB connections and most printers support USB but computers and printers manufactured before 2002 often do not support USB 2.0, which is quite a bit faster than older USB connections. Because different printers come with different connections, or sets of connections, I review the main connection options to help you choose a printer with a configuration that works for you.

You can also transfer photos directly from your printer to your computer. Many printers ship with card readers that accept as many as five of the most widely used memory cards. This means you can insert CompactFlash, SmartMedia, Memory Stick, Secure Digital/MultiMedia, xD-Picture Card media or another memory device directly into a printer and essentially use the printer as an additional hard drive to move photo files to your desktop computer's hard drive.

USB PRINTER CONNECTIONS

The USB connection is establishing itself rapidly as the global connector between all kinds of peripherals and computers. USB connections work with PCs and Macs and have replaced awkward, clunky, and slower computer/printer connections. Many cameras connect directly to a PC or a printer with a USB cable.

The USB 2.0 standard provides a fast data transfer rate between your computer and printer, which is helpful when transferring massive files associated with high-resolution photos. If your system supports only the older, slower USB configuration, it's most likely that your connection to a USB printer will work but it will be slower than if you have a high-speed USB 2.0 connection.

High-Speed USB

High-speed USB and USB 2.0 are the same. They describe a standard that supports high-speed data transmission (480 megabytes per second). Some peripherals — USB keyboards for example — do not require or utilize this high data transfer rate, but USB 2.0 connections are backward-compatible so peripherals with slower speed connections work just fine with USB 2.0. In short, there's no reason *not* to upgrade to USB 2.0 if your computer has older USB ports. USB 2.0 cards for PCs and Macs are available for under $50.

The biggest problem with USB connections is that printers, external hard drives, and other peripherals all require USB connections, so you need multiple ports and enough bandwidth to support it. Five-port USB hubs help this situation by increasing the number of printers and other peripherals you can connect to a single computer.

Overloaded USBs Slow Down Printing

Theoretically, 127 USB devices can be connected to a PC at the same time. However, each peripheral (that is actually running) shares the same USB management resources in your computer, so the more active peripherals you have, the slower the printing.

If you find yourself tripping over unsightly cords, one solution might be the newest printer link technology: wireless connections. I discuss that option a bit later in this chapter.

FIREWIRE AND IEEE 1394 CABLES

FireWire and IEEE 1394 cables (the same thing) provide connections between your printer and computer that are as fast as USB 2.0 connections. FireWire works well with peripherals that require real-time interaction with a computer, like video cameras. A maximum of 64 FireWire devices can be hubbed into a FireWire port.

FireWire Nomenclature

Apple calls them FireWire ports. Sony calls them iLink ports. Other PC manufacturers use the catchy name IEEE 1394 (even I could come up with a catchier product name than that). They're all the same thing.

As with other connection options, FireWire hookups are almost always a second option and nearly every printer comes with USB 2.0. If your USB hubs are overloaded, and you have a FireWire port in your computer, that option can speed up printing. But there's no need to add a FireWire port to your computer if you have USB 2.0.

PARALLEL PORT CONNECTIONS

The parallel port is following the serial port into the dustbin of history but several current photo inkjet printers continue to support this connection. Although parallel ports are significantly slower than USB connections, if you have many USB peripherals plugged into your computer sharing the same computer resources, parallel printing might be just as fast as USB printing.

Also, parallel ports don't use up any of those precious USB slots. If USB resources are at a premium and your computer has a parallel port, it might be advantageous to choose an inkjet that supports a parallel connection. All current printers support USB so if a parallel connection is available on a photo printer, it will be a second option.

WIRELESS PRINTER CONNECTIONS

Even if your desktop or office isn't crammed with photo printers, you might want to consider going with a wireless connection.

Wireless printer connections, like the AmbiCom WPKIT Wireless Printer Adapter, plug into the USB port in a supported printer and the USB plug in your computer. Many of these wireless connectors use Bluetooth wireless technology.

There's no need to do a lot of configuring with wireless printer hookups. There is no server to configure or connect to. However, the downside is that each wireless kit works with just one computer and additional computer connections are sold separately. Wireless printer connections are advertised to work at distances up to 100 feet, but users report mixed experiences in connecting beyond 20 feet.

Compatibility Issues

Check the wireless connection manufacturer's Web site to see if your printer is compatible with their connector technology. AmbiCom frequently updates its list of compatible printers and operating systems at www.ambicom.com.

Using Inkjet Card Readers

Many photo printers allow printing directly from a memory card without any interaction with a computer. One theme of this book is that great digital photo prints generally require some touching up with at least some basic photo editing software. To that end, this chapter does not spend much space discussing the slim set of options available for printing directly from you're a flash memory card.

This does not mean, however, that there's no point in getting a photo printer with flash memory card slots. Even if you're not planning to use your inkjet to print directly from a camera, any card slot that comes with a printer can function as a card reader. HP Photosmart printers, for instance, include a card reader that supports CompactFlash, Memory Stick, SmartMedia, Secure Digital/MultiMedia, and xD-Picture Card media, as shown in Figure 6-6.

Memory cards in printer slots — and memory cards in card readers — work like an additional hard drive. You can move files from a memory card to your hard drive just as you would manage any other files with your operating system.

Cameras can connect directly to printers. The easiest and most widely supported method is a USB cable running from a printer to a PictBridge-enabled digital camera.

Digital cameras and photo printers with card readers offer minimal cropping and editing features. These options often include enlarging, cropping, and sometimes a "one-step" color/level/contrast photo fix button.

Other instant-print features can be handy for quickly seeing what's on a memory card. HP Photosmart printers include menu options for printing contact sheets from a card, combining photos into an album, and printing selected batches of photos. These printers include display screens that preview photos too.

Hybrid Options

Dedicated photo printers tend to offer more features for printing great photos but hybrid models that function as general office printers can produce very nice photos as well. A four-color ink cartridge combined with high-quality photo paper yields very nice photos on printers that double as duplex printers, scanners, photo copiers, and even fax machines.

In fact, some printer/scanner/copier machines include card reader slots and print photos directly from a card or accept photos directly from a camera with PictBridge technology. If your budget or desk space constrains you to one printer, you'll find a nice set of options, particularly from HP, that provides special photo color and black cartridges for all-in-one printers.

Figure 6-6: The HP Photosmart supports five popular types of memory card.

Features you are not likely to find in a hybrid printer include the ability to print 4 × 6 and smaller prints; the use of six, seven, or eight color ink cartridges; individual, replaceable cartridges for different colors; and paper feeding features for roll paper or special media.

Setting Print Options

Quick quiz: You need to adjust the orientation of your photo from portrait (tall) to landscape (wide). Do you do this in your printer settings or your image editor? How about choosing the size of your photo paper? In fact, both image editing software and printer preference dialog boxes often provide menus for defining page orientation and size. So the first thing to sort out is the relationship between print options defined in an image editor dialog box and those defined in printer dialog boxes.

You *can* print a photo directly from your digital camera, CD, storage device, or memory card. Both Mac OS X and Windows provide features that print photos without accessing any photo editing program. To put all this in perspective, it's helpful to divide the process of editing and

printing photos into two distinct stages. Use photo editing software to touch up color and contrast, crop, and make other content changes to photos. Think about printing as a distinct process.

Whether you print from an image editing program or using the print tools in your operating system, printer options are managed in a specific printer properties dialog box. Thus if you select a file in your operating system's file management tool (like Windows Explorer or Mac Preview window) and choose File → Print, you will access the printer properties dialog box directly. If you print from an image editor instead, you will be prompted at some point to select a printer — and then see a button to access that printer's properties dialog box.

Let's return to the confusing quiz at the beginning of this discussion. There are a few features defined by both the image editing software and the printer's properties. For instance, Figure 6-7 shows page orientation defined in the Page Settings dialog box in Photoshop (accessed by selecting File → Page Properties in Windows or File → Page Setup on a Mac). Similar page properties dialog boxes exist in other photo editing software. As you can see, Photoshop's dialog box allows you to select landscape or portrait orientation.

Figure 6-7: Selecting landscape orientation in Photoshop

Figure 6-8 shows the same feature being selected in the Properties dialog box for an Epson printer. So where *do* you go to define page orientation — or size? Read on to find out.

Photo Editing Software Versus Printer Properties

In general, use image editing software to control color, contrast, levels, cropping, and other image-specific tweaking. Use printer properties dialog boxes to control which printer to use,

the number of copies, the quality of the print, the type of paper, and other printer-specific issues. Unfortunately, as I noted, some options straddle the line between printer and software.

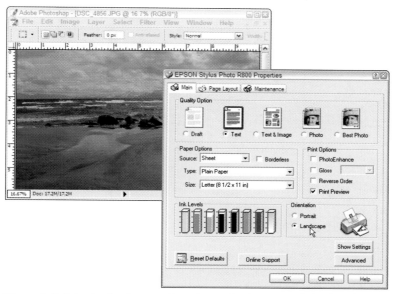

Figure 6-8: Selecting landscape orientation in the Properties dialog box for an Epson printer

I've complained to printer manufacturers about the confusion posed by the fact that both image editing programs and printer properties dialog boxes allow people to set conflicting settings for page size and orientation. They agree that this is an area where standards continue to be baffling to users. In the meantime, avoid confusion by breaking down print jobs into three categories:

- Photo printing options defined in image editing software
- Photo printing options defined in printer properties dialog boxes
- Photo printing options that must be synchronized between both the printer and the image editor software in Windows

Not Quite as Confusing in Mac OS X

The printer properties dialog box for Mac OS X does not define page orientation or page size; it inherits this information from the photo image file itself.

In Windows, make sure to select the same settings for page size and orientation in image editing software as well as printer dialog boxes. Some printers include a preview option in their printer properties dialog boxes, like the one in Figure 6-9 showing a photo about to be printed in portrait mode that should be printed with landscape orientation — the sides of the photo are cut off and the top and bottom of the page are empty.

Figure 6-9: The Epson dialog box preview feature reveals a photo configured to print with the wrong orientation.

Rules Are Meant to Be Broken

As I introduce the relationship between printer and software formatting, I emphasize the distinction between the two and warn against making printer-related adjustments in your image editor and image-related adjustments in your printer. Later, I discuss briefly some situations where it is sometimes useful to cross these lines.







































Another alternative is to do your image editing in a photo editing program and then use the Properties dialog box (accessed by clicking the Properties button in the Print dialog box of your photo editor) to select the paper size and type.

Either path — printing from your operating system or accessing printer properties from your image editor — will open the properties dialog box for your inkjet printer and access the features to be explored in the remainder of this chapter.

Let's return to the warped logic of printer/software interaction I referred to earlier. Image editors assume that the last printer setup (printer, page size, orientation) should be applied to the next photo you open for editing. If you switch printers, paper size, and orientation often (and many of us do), you'll soon grow tired of this situation. To reconfigure the image editor's printer, page size, and orientation settings, pretend to print a photo. Do this by choosing File → Print, choosing the printer, page size, and orientation in the printer dialog box, and then closing the dialog box (without actually printing anything).

Setting Print Quality

As I discussed in Chapter 5, photo printers use ICC profiles to translate what you see on a monitor into a printed photo with — hopefully — the same coloration. In order for these profiles to transform a photo file into a great print correctly, proper paper and ink settings are necessary.

When you select File → Print, either from your operating system or an image editor, the first dialog box provides an option for choosing the printer. Figure 6-11 shows a printer selected in Mac OS X.

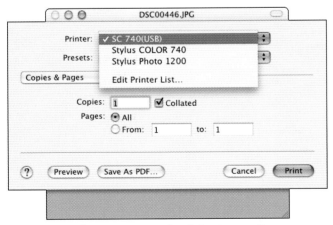

Figure 6-11: Choosing a printer first helps image editors configure page size.

With the correct printer selected, the Properties button in the Windows Print dialog box accesses the appropriate ink and paper options. These options depend on the printer's make and model, although families of printers, like the Canon "i" series, the HP PhotoSmart series,

the Epson Stylus Photo series, and so on tend to have similar paper and ink features. Figure 6-12 shows the print properties dialog box for a Canon i860 photo printer.

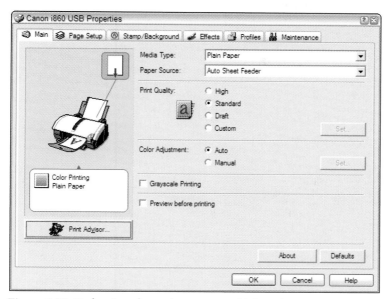

Figure 6-12: Each printer has unique paper and ink options.

In Mac OS X, these unique printer options become available in the Media Type, Ink, and Mode areas of the printing dialog box, as shown in Figure 6-13.

Cross-Reference

Chapter 5 covers the range of ink and paper options available for photo printing.

DEFINING THE PAPER TYPE

The "big decisions" to be made about paper and ink are made when you purchase the paper and ink. The settings you choose in the printer properties dialog box match only the actual paper you have loaded in your printer. Because the process of mixing inkjet sprays with absorbable photo paper is quite fragile, choose the setting closest to the actual paper in the printer.

For HP Photosmart printers, paper or media type is defined in the Paper/Quality tab of the Properties dialog box, as shown in Figure 6-14. Usually, paper selection is available from the first tab in a printer dialog box. In Mac OS X, paper settings are found in the Print Settings section of the print dialog box.

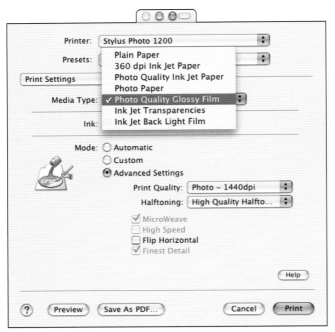

Figure 6-13: Printing options for an Epson Stylus Photo 1200 in Mac OS X

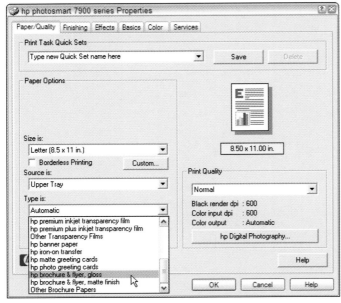

Figure 6-14: Choosing a paper type for the HP Photosmart 7960

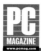

SETTING PRINT QUALITY

Photo printers provide a series of quality options that balance speed and ink usage with quality. These options are different for every printer. Some offer a set of options for high quality, standard quality, or draft. Others offer more intermediate steps (fast normal, normal, fast draft, and so on). Epson printers provide options depending on the type of content.

Sometimes printers provide an advanced set of options so you can configure ink settings manually, like the Epson dialog box shown in Figure 6-15. The warning messages that accompany activating these advanced configuration interfaces are well deserved. Few people have any idea how to start messing with the individual color controls associated with these advanced color dialog boxes.

Figure 6-15: Beware of advanced color settings. It's better to rely on preset color configurations that match your paper and ink.

You certainly can, and should feel free to, choose among different quality settings. Frequently, I print a draft version of a photo to get a sense of how it will look, and then only after a final round of retouching do I spring for the ink and best-quality paper required for a great photo print.

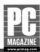
PRINTING WITHOUT BORDERS

The current generation of photo printers supports borderless printing. Better said, the current combination of photo paper and photo printers supports borderless prints. Most photo printers disable the borderless print option in the print properties dialog box unless a paper that supports borderless printing is selected.

Manufacturers claim that attempting to print borderless photos on unauthorized paper will produce smeared and unsatisfactory results and they're not about to let us try for ourselves to see whether it's true or not. For instance, in Figure 6-16, the Borderless Printing option is grayed out because a nonphoto paper type (Plain Paper) is selected.

Figure 6-16: Index cards cannot be printed borderless but 4 × 6 photo paper can.

Evading Borderless Rules

The criminal minded among you have already figured out that you can test a borderless print on non-photo paper by lying to the printer properties dialog box. Most photo printers refuse to print a borderless photo on plain paper but you could, for instance, print a draft version of a borderless photo on plain paper by claiming that you're printing on photo paper. Expect the colors, of course, to be different when you print on real photo paper.

The drivers for many Epson printers refuse to allow you to define a print job for borderless printing on plain paper. To print proofs, I have to "lie" to the printer driver and claim I'm printing on photo paper. I prefer the message from Canon, indicating that my plain paper draft will not look as good as a borderless print on photo paper (see Figure 6-17), while still allowing me to print a photo on plain paper for proofing before committing to a quality print on expensive photo paper.

PHOTO EDITING WITH PRINT OPTIONS

Photo printers offer a variety of features for editing the color, contrast, and levels. In the Canon "i" series, these features are found in the Effects tab, shown in Figure 6-18. In the Epson Stylus Photo series, these options are revealed by clicking the Advanced button in the Main tab, as shown in Figure 6-19. HP Photosmart printers make these features available in the Color tab.

Figure 6-17: Canon's advisory

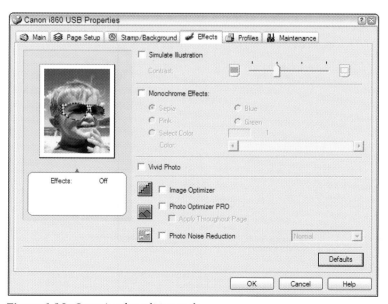

Figure 6-18: Canon's color editing tools

The color editing features in printer dialog boxes offer limited options. Worst of all, they do not allow you to preview the actual photo you are printing, only a sample photo — if that. For these reasons, editing color, contrast, and levels in any image editor is preferable to making these adjustments in a printer dialog box where the only "proofing" available is churning out one print after another until you get lucky.

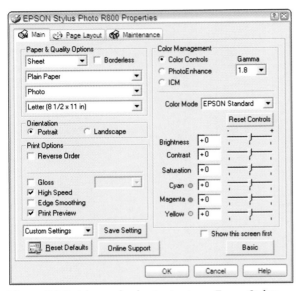

Figure 6-19: Advanced color tuning in an Epson Stylus Photo R800

Proper Inkjet Care and Feeding

Photo inkjets are remarkably self-diagnosing and self-tuning. Like automobiles, they're chock full of sensors that tell you when a door is open or fluid is low. If an ink cartridge is gummed up, built-in cleaning features can wash it out.

The most important elements in inkjet quality — paper and ink — get replaced periodically, in effect reviving your printer. It usually isn't necessary or recommended to use nozzle clearing features to clean up ink, unless you've badly abused your printer by running paper and material through that doesn't absorb ink properly. Some photo printers include alignment tools if inkjet heads are misaligned. Unnecessary cleaning and alignment uses up quite a bit of ink.

Ink-level displays in the current generation of photo inkjets are pretty accurate. Most photo printers periodically display print levels when you print and indicate when new cartridges are required. The Epson indicator is shown in Figure 6-20.

Avoid Unauthorized Inks

Experimenting with unauthorized ink refills and third-party ink cartridges is one thing for an office document printer but a bad idea for photo printers that require precise matching of ink and paper. I've heard complaints from Epson users who use non-Epson refill inks that this disables the ink level indicator. I'm all for saving money, but messing with photo ink cartridges is not the way to do it.

Figure 6-20: Checking ink levels in an Epson printer

Self-cleaning features that clean out sticky inkjets are needed only when photos print with streaks or come out missing lines, as shown in Figure 6-21.

If you ever experience unsatisfactory printing, use the nozzle-check features in the printer dialog box. The location of that feature depends on what system you use:

- For many Epson printers, these features are found in the Maintenance tab of the properties dialog box.

- For HP photo printers, these features are often found in the Services tab.

- Canon diagnostic and maintenance tools are in the Maintenance tab of the dialog box.

- In Mac OS X, maintenance utilities are activated by a file in the Applications folder on the drive or partition where the system files are located. The file is called "Applications/EPSON Printer Utility."

Calibration features in printer property dialog boxes differ from the calibration tools I described in Chapter 2. These options do not calibrate your monitor or color output of your printer. They simply calibrate how cartridges are aligned, making sure inkjets are shooing ink where it is supposed to go. Most photo printers auto-calibrate each time a cartridge is replaced and that is generally sufficient.

Figure 6-21: Self-cleaning tools for an HP photo printer

Summary

Inkjets are the 500-pound gorilla of photo printing—they dominate home and office photo printing and consistently improve in quality to the point where a genuine debate exists about whether people prefer good inkjet photos to those produced by traditional photo labs.

Inkjets come in all sizes but those that print photos wider than 11 inches are priced far beyond the $200–$600 cost of very good 8½-inch-wide printers. Inkjets include a wide variety of options and features, with HP photo printers generally providing more in-printer viewing

and editing tools, while Epson and Canon photo printers provide features like top-loading paper trays and replaceable color cartridges. USB 2.0 has emerged as the connection standard but printers often offer a second option of a FireWire/IEEE 1394 cable or even a parallel port. Wireless printer connectivity works through USB ports.

Do your photo editing in photo editing software and avoid the sparse, unpredictable tools for editing color, contrast, and levels in some printer dialog boxes. Use your printer dialog box to define page size and orientation instead. This determines how image editing software sizes a photo. Pay close attention to choosing media options that match your paper.

Ink cartridges and paper have much to do with the quality of your printed photo, and you replace them periodically — paper more quickly than ink, of course. Replacing ink cartridges as needed is the main factor in maintaining printer quality.

Chapter 7

Printing Great Photos from Dye Subs

Dye sublimation ("dye sub" for short) is an alternative process for printing digital photos with uniquely vibrant, lifelike, and smoothly transitioning colors. Dye sub printers work their magic by using a very different process for generating the wide range of colors needed for accurate color photo printing than inkjet printers.

So why isn't everyone using dye subs? Dye sub printing tends to be significantly more expensive than inkjet printing. There are other economic disadvantages to dye subs, too: Dye sub printers don't do double-duty as general document printers and they require somewhat hard-to-get printer ribbons instead of easily accessible print cartridges.

Dye sub printers produce color photos that closely approximate old-style photo lab prints. This chapter explains how to produce great color photos from a dye sub printer and, in the process, compare and contrast dye subs with the more widely used photo inkjet printing technique.

Folks who print their photos with dye subs swear by them. And there certainly is no better option for printing vibrant yellows, reds, and greens than a dye sub printer. Figure 7-1 shows a couple of prints from my Sony DPP-EX50.

Figure 7-1: Dye subs produce sharp and accurate yellows, blues, reds, and greens.

For cost reasons that I explain in more detail later, dye subs tend to be miniprinters — comparable in size, speed, quality, and fun to inkjet miniprinters. Figure 7-2 shows the same image printed on a Sony PictureStation DPP-EX50 dye sub printer and the similarly sized HP Photosmart 245 inkjet printer.

Figure 7-2: A Sony dye sub printer facing off with an HP mini Photosmart printer

Magic of Dye Sub Color

Dye sublimation is a very different process from inkjet printing or, for that matter, traditional photo printing. Chapter 1 explained the two basic ways of generating a wide range of colors by mixing three or more primary colors.

One way to create colors is by adding them; another way is by subtracting them. Computer monitors generate colors by adding red, blue, and green in each pixel (the tiny dots that compose your screen). Inkjet printers generate colors by stacking cyan, magenta, and red layers on top of each other — essentially subtracting those colors from the white light that bounces off the paper and into your eyes.

Traditional photo printing allows for a more fluid, flexible system of generating color. The chemicals used to process photo paper interact with the paper on a *molecular* level — in bits far smaller than even the finest inkjet blast. For this reason, traditional chemical photo printing is often considered superior for producing natural, fluid, blended colors in photos. A photo like the one in Figure 7-3 — with its yellows, blues, reds, and greens — benefits from the dye sub process.

Figure 7-3: The color gradation in this photo is preserved with dye sub printing.

What Is Dye Sublimation?

Dye sub printing is a whole different ballgame. Dye sublimation refers to the fact that dye (a form of ink) is sublimated. Sounds obvious enough, but the verb *sublimate* has two related meanings that some clever scientist seized upon in naming this print process. It means the process of converting a liquid into a gas. It also means to focus energy — as in "I promise to sublimate my inclination to goof around with digital photo printing goodies into focused energy directed toward finishing this book."

To be specific: Dye sub printers heat up an ink-permeated sheet, transforming cyan, magenta, and yellow dye into a gas. Unlike inkjet printing, where colors are laid down on top of one other in a more or less liquid state, dye sub printing shoots gaseous dye at the photo paper, allowing molecules of cyan, magenta, and yellow to mix before drying, producing very subtle coloration. The dye sub process is illustrated in Figure 7-4.

As you might guess, the complex interaction between dye and paper in dye sub printing makes it essential that you match the paper to the inks. Dye sub manufacturers sell dye cartridges and paper together, as shown in Figure 7-5.

Paper is loaded into dye sub printers in cartridges, similar to those used in small inkjets. The dye ribbons — wide strips of acetate imbued with dye, as shown in Figure 7-6 — are inserted into the printer.

Figure 7-4: Dye sub printing involves heating an ink-saturated film to release gaseous dyes that merge into dots on the photo paper. The glowing triangle represents the heating element interacting with a strip of yellow, magenta, and cyan film to produce the magenta shape on the blue background on photo paper.

Figure 7-5: Packets of dye sub paper and ink

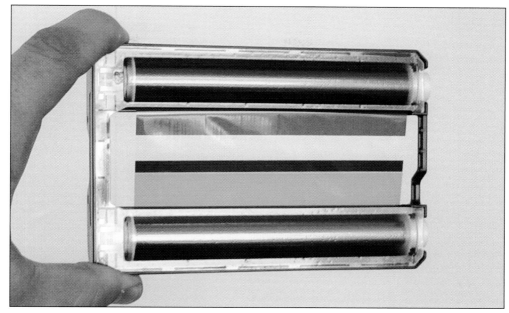

Figure 7-6: Loading a dye ribbon into a dye sub printer

Comparing Dye Sub and Inkjet Photos

How do dye sub prints compare to inkjet prints? Before I get too scientific, to the trained eye there's an easily noticeable difference between the look of a dye sub print and an inkjet print. Under equal conditions, printing many different photos on both my Sony dye sub and several inkjets reveals that dye sub photos have softer, smoother, more natural color. This is especially true of very light skin tones, which tend to appear blotchier and more reddish in inkjet prints.

On the other hand, inkjet photos tend to show more detail than dye sub prints. I notice this particularly when photos have writing on them or when I print technical photos (like some of the detailed photos I've used to illustrate printer components in this book).

The reason dye subs have less detail is that they print at about 300 dpi, while inkjets print up to 4800 dpi. You might recall from Chapter 1 that, in a sense, no printer produces more than 300 dpi. High-resolution inkjets use the almost invisible droplets of ink they shoot at the page to dither (combine) and simulate colors. That finer resolution seems to translate into crisper, sharper differentiation of details.

Dye Subs Are Resolving the Resolution Issue

The resolution for dye subs is increasing. Some dye subs print at a resolution of 400 dpi and higher. That is still only a fraction of the dpi available from high-quality photo inkjets.

These impressions tend to confirm most studies and insights by industry experts that dye subs can potentially produce truer color but with somewhat less detail. Figure 7-7 shows a comparison of a touched-up photo printed on an inkjet and a dye sub. I used the "best" setting on my inkjet and premium coated photo paper. I hope the subtle differences are obvious to you in this book's printing process, but in real life they are definite and quite visible. Look at the color gradation in the clouds, for instance, to see the difference that dye sub printing can make when fragile color gradation needs to be preserved.

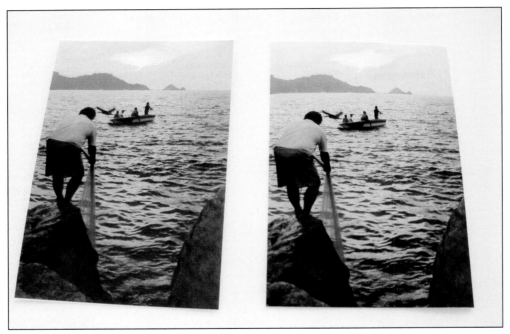

Figure 7-7: The dye sub print (*left*) captures a more nuanced color gradation in the sky and sea than the inkjet print.

Cross-Reference

For a detailed discussion of colors and resolution in photo printing, see Chapter 1.

Dye Sub Economics

Why hasn't the photo printing industry thrown equal resources into developing dye sub printers as they have into inkjet printers, given the wonderful colors they reproduce? The short

answer is price. Dye sub photos, particularly large ones (8 × 10 and larger), are very expensive to print. They cost as much as sending the file to a commercial print lab.

While dye subs are dwarfed by inkjet printers in mainstream consumer adoption, they dominate in three not-so-small niche markets. The printer spitting out snapshots at your nearby drug store or photo lab is probably a dye sub — nobody there wants to tweak and manage an inkjet all day and large, commercial dye subs produce photo-quality prints.

There are also dye subs capable of printing 8½ × 11 and larger prints at a fairly high cost per print that professional photographers use for making their finished prints for sale. These folks favor dye subs because of the photo processing–like results.

The third type of dye sub is more accessible to photo enthusiasts like us. These dye subs print 4 × 6 photos or smaller, in general. It is these small, snapshot-sized printers that I focus on for the rest of this chapter.

The economics of dye sub printing varies distinctly from inkjet printing. You don't shop around for deals on paper and ink because they're packaged together; you have to use the manufacturer's dye/paper sets. The printers themselves are acknowledged to be loss-leaders. Very nice dye subs (limited to printing 4 × 6's) are available for under $200. But once you buy one from Canon, Sony, or another manufacturer, you're hooked because you need to purchase their specific dye ribbon/paper sets.

Dye Sub Pricing

The fact that you have to buy dye sub ink and paper together in a set makes it easy to calculate an estimated price per print. A pack with enough paper and ink to make 75 dye sub prints (4 × 6's) currently runs about $40, which comes to a little more than 50 cents per print. Sounds high, doesn't it? But inkjet paper costs about 25 cents per sheet (for 4 × 6 paper in large packs), and the ink bill for a 4 × 6 inkjet print brings the price of a print into the same ballpark as the dye sub. Many dye sub fans appreciate knowing exactly how much they pay for each print.

Cost Comparison

Depending on your circumstances, the ink bill for an inkjet brings the price of a print within a few cents of the cost of printing a photo on a small dye sub printer. The exact cost per print is based on which printer you own, the type of cartridge you buy, its sale price, and the volume of ink needed for the print.

Still, there's no getting around the fact that dye subs are a little more expensive to use at this point in the evolution of photo printers. Does that mean they will evolve out of existence? In the early days of home video, two formats contended — the VHS format that eventually became the industry standard and the Betamax format that many experts felt provided a better quality viewing experience but for a variety of reasons was abandoned by the industry. Will dye sub printing go the way of the Betamax, supplanted by improved inkjet quality?

Maybe, maybe not. I got some insight into the economics of this issue from an industry representative who told me that because of limitations on print size and overall cost, the investment by technology companies into improving dye sub technology is very limited compared to inkjets. Key features such as the user interface, imaging pipeline technology, auto-image adjustments, and overall ease of use will not be on par with what inkjet solutions offer consumers.

On the other hand, improvements to the latest generation of small dye subs, and their lower prices, are producing fun, competitively priced printers that have certain advantages in color quality.

Everyone seems to agree that the high-quality (and very expensive) dye sub printers used by professional photographers and retail photo labs will be around for a long time.

Dye Sub Printing Happens in Batches

Perhaps the biggest limitation I've found with the paper-plus- dye-packet system of reloading my dye sub printer is that you cannot switch between postcard and small (3½ × 5) prints until you run out of paper.

Not too infrequently do I find myself wanting to switch from the more economical, small paper to the more impressive, larger postcard-sized paper in the middle of printing a batch of photos. Figure 7-8 illustrates both print sizes.

Figure 7-8: A small print (*left*) and a postcard-sized print

Because of the unique process of transferring dye from the wide printer ribbon to the photo paper, the inking ribbons that come with dye subs generally have to match the width of the paper. That means that if you want to alternate between small prints and postcard prints, you have to pull both your paper from the paper tray and change your ink cartridge.

I solved this problem by stashing my exposed print ribbon and paper safely in a sealed, shaded plastic bag. As long as I don't leave a batch of paper or an ink ribbon out of the printer for too long, I can shuffle back and forth between print sizes without wasting any ink or paper.

Printing Photos with Your Dye Sub Printer

Don't expect a dialog box full of options or an LCD preview screen to come with your dye sub printer. Printer manufacturers don't put the same resources into developing highly defined user interfaces for dye subs.

In fact, if you want to print directly from one of the small, reasonably priced dye subs discussed in this chapter, instead of from your image editing software, you're pretty much dependent on whatever zoom, crop, and touch-up features come with your camera.

Printing Directly from a Dye Sub

Dye sub printers don't match the in-printer features of inkjet printers. Inkjet printer menus aren't much to brag about but at least they offer a tiny LCD screen where you can enlarge, crop, and make some crude adjustments to color, contrast, and cropping. Not so on most smaller dye subs. My basic advice on printing directly from your dye sub is to avoid it.

There are a variety of ways you can print from your dye sub. Many dye subs have USB plugs and accept images directly from a camera. Most accept at least some memory cards — including CompactFlash cards.

Many dye subs support the PictBridge standard, so any camera with a USB output jack that supports PictBridge plugs into a compatible dye sub printer. You can use the photo editing tools in your camera to zoom, crop, and adjust colors before printing on your dye sub. Generally speaking, the previewing is done in your camera.

The PictBridge Standard

PictBridge (from "picture bridge") is technology from the Camera and Imaging Products Association that allows digital cameras to plug into printers so that photos can be printed directly from a camera to a printer. The PictBridge standard allows cameras and printers to understand each other. Many digital PictBridge cameras and printers include editing features for cropping, resizing, and enhancing photos before printing. You can find more information about PictBridge at www.cipa.jp/pictbridge/.

My Sony DPP-EX50, for instance, supports four modes of input: Sony's own Memory Stick and a CompactFlash card, as shown in Figure 7-9.

In addition to printing with a flash card, the DPP- EX50 prints directly from a PictBridge camera or a computer. Figure 7-10 shows a PictBridge-compatible camera connected to a dye sub printer.

Printing Dye Sub Photos from Your Computer

When you are out in the field with your miniature dye sub printer, you can print photos with nothing more than your camera and printer. You can't beat that for easy, quick, and decent-quality prints!

Figure 7-9: Images can be printed directly from CompactFlash cards or other storage devices. The top slot is for a Sony Memory Stick, the bottom for a CompactFlash card.

Figure 7-10: Printing directly from a PictBridge-compatible camera to a dye sub

On the other hand, you can do much more with image editing software on your desktop or laptop computer before you print.

Maybe I'm too attached to my computer (or it's too attached to me) but I haven't been tempted to use the video cable that came with my Sony dye sub to view my photos on a TV and edit them there. I'd rather run a USB cord from the printer to my computer and access the full range of editing and printing features available there.

You Can't Print from a Mac to the Sony DPP-EX50

The Sony DPP-EX50 does come with a full set of drivers to install on a computer, but these driver files are not — at this time — available for Mac OS.

Printing to your dye sub from your computer has all the advantages that printing to *any* printer from your computer has. You can edit your photo using a photo editor like Photoshop Elements and you can control printing easily with onscreen menus. I find that I waste fewer precious sheets of dye sub paper when I preview my photos before printing them.

CROPPING FIRST

Before you send your photo from the computer to your dye sub, use your image editing software to crop it to the correct dimensions of your printer paper. For postcard-sized paper, crop to 4 × 6 inches. For smaller photos, crop to 3½ × 5 inches. Check your paper dimensions for other sizes. Figure 7-11 shows a snapshot being cropped to 3½ × 5.

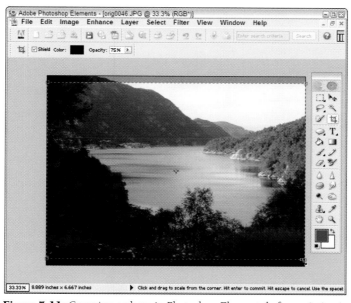

Figure 7-11: Cropping a photo in Photoshop Elements before printing it

If your photo is wide, print it in Landscape mode. This setting is defined in the printer properties dialog box, which I describe shortly. For now, note that if your photo is wider than it is tall, you need to set your crop settings accordingly. Figure 7-12 shows a photo cropped to a landscape, postcard-sized print.

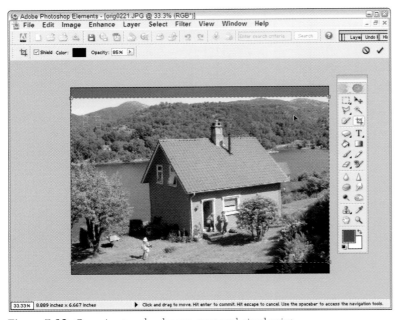

Figure 7-12: Cropping to a landscape, postcard-sized print

If you don't crop the photo before printing to the dye sub, you entrust the cropping decision to your printer or image editing software. Better to make that decision yourself.

Cross-Reference
For a full discussion of cropping, see Chapter 3.

SENDING YOUR FILE TO YOUR DYE SUB
Once you've edited and cropped your photo, it's ready to print. Dye subs do not provide the same full set of print options that accompany inkjet printers. Nevertheless, your dye sub printer drivers provide a basic set of print options. To print a dye sub photo from your computer, follow these steps:

1. Open your file in any photo editing software.

2. After making necessary adjustments to the color, levels, cropping, and so on, choose File → Print or the print feature from the photo editing software.

3. In your printer dialog box, select a dye sub printer and click on the Properties button to access a dialog box associated with your dye sub printer, as shown in Figure 7-13.

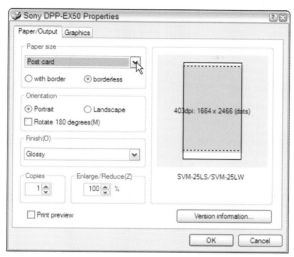

Figure 7-13: The Properties dialog box for the Sony DPP-EX50 dye sub printer

Know Your Print Options

Print options vary but are generally divided between a tab that controls paper size and one that modifies resolution, color, and graphics settings.

4. Use the Paper/Output settings to define the size of your paper, orientation of the page (landscape for wide photos, portrait for tall ones), type of paper, and number of prints.

5. Use the Graphics tab in the Properties dialog box to adjust colors if necessary.

Maximize Your Use of Image Editing Software

It's better to touch up your colors in the image editing software and leave the color settings in your print dialog box at their defaults. If you don't have access to an image editor, however, and you know you need to alter color settings, use the minimalist tools in your printer's Properties dialog box. For a full discussion of adjusting color in an image editor, see Chapter 3.

6. If your dye sub printer comes with ICC profiles, select a profile that matches your printer, as shown in Figure 7-14.

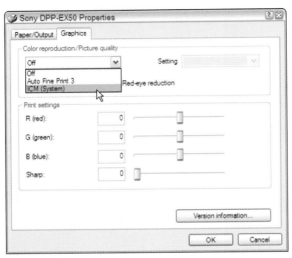

Figure 7-14: Synchronizing your printout with an ICC/ICM profile associated with your printer

Choosing an ICC Profile

ICC profiles — which follow standards set by the International Color Consortium — are embedded in printer drivers. When you choose a printer, paper type, and desired quality, your operating system tells the printer the appropriate inking methods to produce the best results and match the colors displayed on your monitor. Profiles have ICC or ICM (integrated color management) filename extensions. For more information about ICC profiles, see Chapter 2.

7. After you make adjustments in the Properties dialog box for your particular printer, click OK to return to the Print dialog box. Click OK again to print the photo.

8. Your printer driver may provide a preview screen like the one shown in Figure 7-15. Use this to verify that the printer settings are correct and to preview your photo before clicking Print to complete the process.

As the dye sub process begins, you'll hear the friendly whirring sound of dye being converted to gas and blasting onto the photo paper. In Figure 7-16, the printer software documents the application of yellow ink. Dye sub printers make three passes over the photo paper as they mix cyan, magenta, and yellow.

Figure 7-15: Previewing a dye sub photo before printing it

Figure 7-16: Applying yellow to a print. The dye sub printer makes three passes over each pixel in the photo to mix yellow, cyan, and magenta dye.

Printing Postcards with Your Dye Sub

Because dye sub prints are small and great looking, it's a natural fit to send them off as postcards to friends and foes alike. Both the Canon and Sony dye sub paper and dye packets supply 4 × 6 paper with postcard markings on the back. There's room for you to affix a stamp, write a message, and address the postcard. Figure 7-17 shows the postcard layout on Canon dye sub paper.

Cross-Reference

For a list of the allowable dimensions for U.S. Postal Service postcards, see Table 8-2 in Chapter 8.

Figure 7-17: Canon provides this handy mailable back on its postcard-sized dye sub paper.

Summary

Dye sub prints provide superb color handling and, using small photo paper, are competitively priced with high-quality inkjet prints and photo processing at your local photo store. If you print to your dye sub printer from your computer, you can edit and touch up photos before sending them to your own, "photo-quality" printer. Keep in mind that the level of detail (such as handwriting, and so on) is slightly less in a dye sub photo than in an inkjet photo.

The limitations of dye subs stem primarily from the fact that as a secondary consumer photo-print system, manufacturers provide limited support for it. The print dialog boxes aren't as robust, the in-printer editing features are close to zero, and it's a bit awkward to switch paper sizes when printing. Dye subs provide limited print media options — glossy or matte photo paper are your choices. If you want to try some of the special print projects in Chapters 8 and 9, an inkjet printer provides more choices. An exception is postcards, which print perfectly on a dye sub printer.

Chapter 8

Special Photo Projects: From Greeting Cards to Calendars

Many people enjoy creating a unique greeting card from a special photo for a special recipient. A calendar, featuring some of your favorite shots, is another great gift idea. The best thing about printing your photos on great greeting cards, in calendars, or in nice displays is that other people really enjoy seeing or receiving them.

And why not? If you've worked hard on a photo and have the skills and tools to make nice prints, you can use what you've already got to create truly special albums, postcards, calendars, and greeting cards — without much of an extra investment in special inks or papers.

Cross-Reference

If you want to print photos on special media, like T-shirt iron-ons, photo stickers, transparencies, or coffee mugs, skip to Chapter 9.

This chapter covers a variety of ways to create and print fun photo projects such as:

- Greeting cards
- Albums
- Calendars
- Postcards

A Look at Layout Tools

Now for some bad news: Although you can create calendars, greeting cards, photo albums, and other projects (collages and postcards) using your existing supply of photo printer, paper, and ink, you will likely need some additional software.

Yup! All that money you invested in Photoshop doesn't even buy you a decent way to lay out calendars or design greeting cards.

One option is to stretch the layout features of a program like Microsoft Word to design your projects. Don't laugh — it's possible, but it's a matter of pounding a round peg into a square hole. Later in this chapter, I explain how to design projects like greeting cards and calendars in Word.

Page Layout Software

Even with a variety of free layout tools from which to choose, if you get serious about creating great photo projects, you should invest in software that's dedicated to your particular task. Although it's something of a chore, if you're proficient with Photoshop, Photoshop Elements,

or another image editor, you can manipulate images, add text, and align objects to make your own template. (It *should* be easy to find built-in project templates for Photoshop and Elements, but it's not.)

At the expensive (and hard-to-learn) end of the spectrum, you can use professional layout programs like Adobe InDesign, QuarkXPress, and Adobe Illustrator CS for your projects. InDesign CS and QuarkXPress are overkill for nonprofessional designers, but if your designs begin to approach professional quality, Illustrator is worth a look.

Illustrator CS includes some decent templates for laying out greeting cards and postcards. Some of these designs are pretty professional-looking, as shown in Figure 8-1. Buying and learning Illustrator is not an investment you want to make just to lay out greeting cards, but if you have a serious interest in graphic design and incorporating photos into your designs, it's a road you might wish to consider.

Figure 8-1: A sophisticated greeting card template in Adobe Illustrator CS

If you work in Windows, you can use Adobe Photoshop Album, a dedicated tool, for designing photo projects like calendars, cards, and albums. (There is no version for Mac OS.) You probably have a demo version of it somewhere among the software CDs that accompanied your recent computer or printer purchase; if not, you can order it from Adobe (www.adobe .com) or download the free "Starter Edition." While there are many useful free options for designing projects in this chapter, I focus on showing you easy, reliable ways of doing so in Photoshop Album.

Before you spend your hard-earned money on Photoshop Album, however, let's see what some other products can do for you. One example is Broderbund Print Shop, which is great for creating greeting cards.

Print Shop Is Everywhere

Broderbund Print Shop, and other page layout software, is often used for school projects like newsletters, posters, flyers, announcements, and banners. It is widely available and provides an easy way to integrate photos into a variety of layout projects.

Free Project Templates

You can find some decent design templates for free on the Web—some of them sponsored by printer manufacturers, such as Epson. You might also find tools for creating photo projects in the software that came with your printer. The Sony PictureStation dye sub printer comes with PictureGear Studio for printing postcards, albums, and calendars. Many HP printers come with a program that prints photo albums. These packages are similar to those that come with other printers, so consider them as examples of what you might find on that CD you tossed into a pile when you opened the box and set up your printer.

Photo Project Software Used in This Chapter

Most of the rest of this chapter concentrates on showing you how to print greeting cards, post-cards, calendars, and other projects using a variety of software packages—ranging from free-bies to Photoshop Album. Table 8-1 lists the software used for these projects and tells you where to find it, how much it costs, and what you can do with it.

Table 8-1 Photo Project Software

Software Package	Where to Find It	Cost	What to Use It For
HP Photo Album Printing Software	Bundled with HP printers	Free	Album pages
Epson Film Factory	Bundled with Epson printers	Free	Album pages, greeting cards, calendars, and stickers
Broderbund Print Shop	www.broderbund.com	$29+	Greeting cards, calendars, banners, postcards, and more
Adobe Photoshop Album	www.adobe.com	$50	Greeting cards, photo books, and calendars
Sony PictureGear	Bundled with Sony printers	Free	Album pages, greeting cards, calendars, and postcards

I won't attempt to demonstrate every feature of each of these packages, but I'll show you a few ways to use free or cheap software to print great greeting cards, albums, calendars, and postcards.

Cross-Reference

Most of the printing projects discussed in this chapter are geared toward inkjet output. Some work with dye sub printers. For more information on dye sub (dye sublimation) printing, see Chapter 7.

Managing Photos with Photoshop Album

Because there is such a variety of options for photo editing and printing, and what you need depends on your budget and requirements, this book avoids singling out any one product. That said, there are some products that do set the standard. Fairly frequently those products come from Adobe. Photoshop Album does a very nice job of laying out and printing photo albums, greeting cards, and calendars. It offers more options than most program, short of a full-fledged desktop publishing package like QuarkXPress or Adobe InDesign, or a professional illustration program like Adobe Illustrator.

Photoshop Album Is Not Available for Macs

At this time, Photoshop Album is available only for Microsoft Windows.

The selection of templates and ease of use of Photoshop Album both make it a worthwhile investment if you plan to spend a lot of time designing nice projects for your photos. Many of us easily spend over $100 a year on cards and gifts for birthdays, Valentine's Day, Grandparents' Day, and the like. A store-bought calendar costs $10 or more and there's no way to customize it for six months, 18 months, or any other odd cycle of months. Creating a customized calendar that doesn't center around New Year's and giving it to everyone on your gift list would be much cheaper than finding it somewhere else or having someone make it for you. The money saved would pretty quickly equal the money spent on Photoshop Album.

Using Photoshop Album as a Digital Photo Manager

Both professional photographers and serious enthusiasts need to organize their photos — sometimes thousands of them. Photoshop Album offers a "tagging" system that helps you keep track of and sort thousands of photos.

I won't digress into digital photo management here, but if organizing, sorting, and tracking thousands of photos is an urgent issue for you now, consider reading a book on digital photography workflow management, such as *Total Digital Photography: The Shoot to Print Workflow Handbook* by Serge Timacheff and David Karlins (Wiley, 2004).

Defining Photos for Your Album

Before you create a project with Photoshop Album, you need to define a collection of photos to draw upon when you make your greeting card, calendar, or other design. Photoshop Album offers some complex options for tagging and organizing photos that you might want to explore. The easiest way to add photos to your available stockpile is to follow these steps:

1. In the opening view in Photoshop Album, choose File → Get Photos from the menu.

2. From among the menu options that appear, choose a source for your photos: digital camera, card reader, cell phone, or other option. Figure 8-2 shows me importing files from a file folder on a hard drive.

Figure 8-2: Importing a folder of photos into Photoshop Album

3. Once you select a source for your photos, the Files and Folders dialog box appears. Click on a single photo or press Ctrl+click to select all the photo files you want to include in your project.

Select Multiple Files

Don't worry about using all the photos you select at this point. Because you're not wasting any file space by including extra images, select as many photos as you *might* want to include in this project — or future ones.

In the Get Photos from Files and Folders dialog box, you can press Ctrl+click to select multiple files in a folder or select an entire folder by clicking on it.

4. After selecting the folder(s) or file(s) you want, click Get Photos. All the files in the folder will be imported into Photoshop Album and become available for projects, as shown in Figure 8-3.

Figure 8-3: Imported photos ready for a calendar or greeting card

Set Up Photos First

Whenever you do a photo print project described in this chapter using Photoshop Album, refer to the steps above to set up your photos before starting.

Adding Captions to Photos

Some types of Photoshop Album creations, like photo albums, allow you to associate a caption with a photo. You don't have to include captions in a design. However, you can add captions to a design only if they have been assigned to the photo first. The last thing you want to have to do is back out of a calendar, greeting card, or other project design midway to assign a caption to a photo. Captions help you track which photo is which by providing a detailed description of it — which is often more helpful than relying on the filename alone. If you think you might want to implement that feature as you design a photo album, add captions to photos before starting your design.

You can view all the photos you have connected to your Photoshop Album project by choosing either View → Organize View or View → Photo Well View. In either view, you can add a caption to a photo. To add captions, follow these steps:

1. Double-click a photo in either Photo Well or Organize view.

2. Click the "Click here to add caption" text, as shown in Figure 8-4.

Figure 8-4: Adding a caption to a photo in Photoshop Album

3. Type a caption of up to 63 characters (letters, spaces, and symbols) in the caption area.

4. Click the Home icon in the icon bar at the top of the Photoshop Album window to view all your photos again, as shown in Figure 8-5.

Figure 8-5: Viewing all available photos in Photoshop Album's Photo Well view

Printing Photo Greeting Cards

Oddly enough, in the age of e-mail, e-greetings, and e-cards, nicely designed greeting cards seem to be flourishing. When I go out to get some fresh air, I stroll past a row of shops ranging from a beauty salon to a copy shop to an alternative grocery. All of them display nice, unique, artsy greeting cards.

A well-done greeting card featuring a borderless photo is almost a frameable piece of art, and certainly something a friend might keep on a desk or mantel for some time. Printed with a high-quality printer on photo paper, a "home-made" photo greeting card can be a special gift or a cottage industry for a digital photo printing enthusiast like yourself.

In this section, I show you how to use Broderbund Print Shop, Microsoft Word templates, and Adobe Photoshop Album to create and print photo greeting cards.

Greetings from Print Shop

In search of a bargain, I've experimented quite a bit with Broderbund Print Shop. You can download a truncated (not full featured) trial version for free from Broderbund (`www.broderbund.com`) or purchase a full-featured download for under $50. Broderbund offers a nice collection of auxiliary products like special papers and sells a software package for every print project imaginable.

The issue I have with using programs like Print Shop is that they aren't really geared toward placing and managing your *own* photos in greeting cards. If you want to create a greeting card with a customized message, a prefabricated background, and clip art, then Print Shop rules. But with all the funny fonts and goofy backgrounds available, there are too many features not terribly useful for creating nice photo cards. Those that are there are somewhat hidden.

On the other hand, if you skip through the card, calendar, or banner building wizards, you will come across a decent card design and editing environment. The image editing features don't include such abilities as cropping, much less color correction, but if you don't mind that — or you've already touched up your photo elsewhere — you can make the following edits to your card:

- Rotate or flip the photo
- Align the photo on the page
- Move graphics in front of or behind each other (a primitive layering feature)
- Resize the photo
- Design a frame
- Touch up contrast and brightness

To create a greeting card in Print Shop, follow these steps:

1. Select a project — like Greeting Cards from the opening screen in Figure 8-6 (click the New icon if this screen does not appear). Click Next.

2. Click the Start from Scratch icon and then click Next.

Figure 8-6: Choosing a greeting card project in Print Shop

3. Choose one of the types of folding cards, as shown in Figure 8-7, and click OK to generate your card layout.

Figure 8-7: Selecting a half-fold, tall card

4. In the front panel of the card, select Insert → Image and choose an image (or acquire one from your digital camera).

5. Use the Effects menu options to rotate (see Figure 8-8), scale, frame, or tint the image.

Figure 8-8: Rotating a photo in Print Shop

6. Choose Effects → Image Effects to access Print Shop's set of photo editing tools for adjusting contrast, brightness, and blur, as shown in Figure 8-9.

Figure 8-9: Photo editing with Print Shop

7. Choose View → Inside Panel to edit the inside content of the card.

8. Choose View → Back Panel to edit the content of the back of the card.

9. When you finish your design, choose File → Save to save the card and then select File → Print to print it.

Don't Forget to Use Two-sided Paper!

When printing two-sided cards, be sure to use two-sided photo paper. Many matte photo papers support two-sided printing, but few glossy papers do; having at least one non-glossy surface helps move the paper through the printer.

My own preference for photo-layout software is for programs that provide simple, classic designs that emphasize the photo. The groovy special effects and wild art backgrounds seem more aimed at the amateur or lighthearted crowd than folks designing professional-quality greeting cards that show off beautiful photographs. However, you cannot beat the price or simplicity of generating greeting cards with Print Shop.

Cross-Reference

Throughout this chapter I mention selecting File → Print to print your project. To find out how to get the most out of your inkjet printer, see Chapter 6.

Printing Greeting Cards with Photoshop Album

Photoshop Album comes with a selection of greeting card templates that I think are rather classy. What I mean is that they are designs that feature your photo. If you have a great photo you want to use in a card, why mess it up with text, background graphics, or colors?

Figure 8-10 shows a few simple templates for photo greeting cards in Photoshop Album. Unfortunately, there is no template style that omits the white border around the photo, but the designs do display a photo nicely. (In fact, you may not mind the border at all.)

To create a greeting card in Photoshop Album, follow these steps:

1. Make sure you import your photos into Photoshop Album, as described in the earlier section "Defining Photos for Your Album."

2. Choose Creations → Greeting Card to start the Greeting Card wizard.

3. Choose a Greeting Card style from the list and click Next.

4. Enter a title, greeting, and message for your card, as shown in Figure 8-11. Click Next.

Figure 8-10: Photo greeting card templates in Photoshop Album

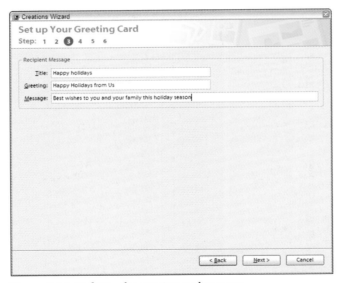

Figure 8-11: Defining the greeting card message

5. Choose a photo for your card from the imported set and click Next.

6. Use the Full Screen Preview button to display your card as it will print — as shown in Figure 8-12.

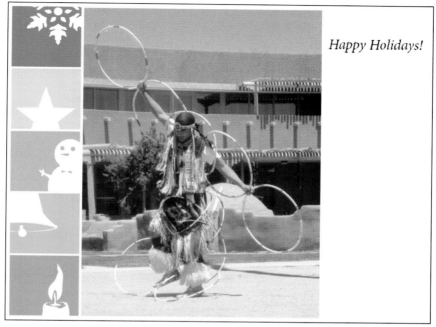

Happy Holidays!

Figure 8-12: Previewing the cover of a greeting card

7. Use the Next Page and Last Page navigation icons to see the text you defined for the inside of the card. Use the Back button to return to earlier screens to edit the photo or card's content. Press Next (for the last time).

8. In the final wizard screen, click Print to print your greeting card.

Displaying Your Photos in an Album

Whomever you share your home with might be happy to learn that there is an alternative to the boxes and boxes of photo albums that waste shelf space throughout the house. Digital photo albums fit on a CD (or any other storage device) and can be printed as needed to share at family events, show off to clients, or keep as personal mementos.

Many printer manufacturers bundle software you can use to generate photo albums. Epson Film Factory includes a wizard that helps you select photos, pick a layout, and print the album.

Printing Albums with HP Software

My HP printer came bundled with a program called HP Album Printing Software. Intuitively named, it organizes and prints photos in an album, much like the old-style ones where you secure your photos behind plastic.

With HP Album Printing Software, first click the Open Files icon to load your files. Next click the Album icon and choose between a wide range of templates that you can configure to work with many different pages sizes. Figure 8-13 shows me choosing a layout template that holds four small pictures and two large ones on each page.

Figure 8-13: Choosing a layout template for a photo album

Finally, drag photos from the left side of the program window into placeholders on the right — in the album page — as shown in Figure 8-14.

Figure 8-14: Dragging a photo into a picture holder in HP Album Printing Software

HP Photo Album Printing Software even comes with a nice, minimalist photo editing module, as shown in Figure 8-15. Double-click an image to open this window and use it to darken or lighten, adjust color, rotate, scale, sharpen, or edit levels of your photo with the Histogram icon.

Figure 8-15: Editing color in HP Album Printing Software

To print your album page, choose File → Print to send the page to your photo printer.

Creating Adobe Photoshop Albums

As with all Photoshop Album projects, start by defining photos to use (see "Defining Photos for Your Album" earlier in this chapter). With photos already added to your project, follow these steps to create and print your album:

1. Choose Creations → Album from the menu bar.

2. Choose one of the album templates from the list of Album styles and click Next.

3. In the Set Up Your Album screen in the Creations wizard, enter a title for your entire photo album, choose the number of photos you wish to display on a page, and define header and footer text if you want to include it. Click Next.

4. In the Pick Your Photos window in the Creations wizard, click the Add Photos button to add more photos to the album. To remove a photo, click it and then click Clear. With a set of photos selected, as shown in Figure 8-16, click Next.

5. In the Customize Your Album window in the Creations wizard, you can view any page using the Forward and Back buttons and then use the Layout drop-down menu to choose alternate layouts for any particular page in your album. Figure 8-17 shows me selecting a three-photo layout. Click Next.

Figure 8-16: Selecting photos for an album

Figure 8-17: Customizing a page layout

6. In the final Creations wizard screen, click the Print button to print your album. Figure 8-18 shows a few pages from a customized photo album.

Figure 8-18: A customized photo album printed in Photoshop Album

Printing Photo Calendars

Compared to greeting cards or postcards, calendars require significant text and text editing. Wizards that come with your printer's software may help generate the calendar you need just fine.

If you need a lot of freedom to edit the content of the calendar — like defining your own holidays, marking vacations, or adding custom text, consider using one of the decent calendar templates that Microsoft provides in Word. I also show you how to generate and print a nice photo calendar easily with Photoshop Album.

Using Downloadable Calendar Templates in Word

Microsoft Word is not the most elegant tool for creating greeting cards. However, many people already have Word on their computer, the text editing tools are fine, and (once again) many people have Word already on their computer and know how to use it.

Microsoft provides a few templates for photo calendars. You will find a link to a couple of the best ones on this book's Web site (www.davidkarlins.com/PrintGreatPhotos.htm). You can also search for calendar photo templates on the Microsoft Web site (www.microsoft.com). Figure 8-19 shows one of the template files from Microsoft's site.

Figure 8-19: Finding and preparing to download a calendar template for Microsoft Word from the Microsoft Web site

Word Is Different

The concept of a "template" is different in Microsoft Word from what it is in programs designed to guide you safely through the process of generating a printable photo project. The calendars, greeting cards, and other designs you generate in Paint Shop Pro, Photoshop Album, and other dedicated photo-layout software are pretty foolproof. On the other hand, templates in Word are quite fragile; your project could disintegrate if you add too much text or even hit the Enter key by accident. Designing a photo printing project in Word is appropriate only if you are skilled at editing graphic layouts in Word.

Once you download a Word calendar file, save it so you can use the file as a template for other calendars. Customizing the calendar is then basically a matter of editing in Word. Follow these steps to replace the template's sample photos with your own:

1. Click the first template picture image — the first one you are going to replace — to select it.

2. Choose Insert → Picture → From File, as shown in Figure 8-20, to replace the selected picture.

3. Navigate to one of your own photos and click Insert to replace the template's photo with yours, as shown in Figure 8-21.

Figure 8-20: Selecting a photo from a file in Word

Figure 8-21: Inserting your own photo into a document based on a Word template

4. Continue through the calendar, replacing all the template's photos with your own.

5. Select File → Print to print the completed photo calendar from Word.

Generating Calendars with Photoshop Album

Photoshop Album includes a set of seven calendar templates that produce a variety of nice calendar layouts that fit each month on an 8½ × 11 sheet of photo paper. I personally prefer matte paper, but glossy, matte, or other special photo paper works fine for these templates. Figure 8-22 shows the most basic calendar design template.

Figure 8-22: A sample calendar template in Photoshop Album

Photoshop Album calendar templates include a nice option: You can generate a calendar for any set of months. If six months remain in the current year, you can create a July through December calendar easily. You could also print a 16-month calendar.

To print a calendar in Photoshop Album, follow these steps:

1. As with all Photoshop Album projects, make sure you identify which photos to use (refer to the earlier section "Defining Photos for Your Album" for details on how to do that).

2. From the Photoshop Album menu bar, choose Creations → Calendar.

3. From the set of Calendar styles in the second window in the Creations Wizard, choose a calendar layout. Click Next.

4. In the third Creations wizard window, choose a start and end date for your calendar, as shown in Figure 8-23. Click Next.

5. In the fourth Creations wizard window, click the Add Photos button to choose the photos for your calendar. Select one photo for each month. Don't forget to select one photo for the main title page of your calendar. Drag the photos to move them around and change their order in the calendar, as shown in Figure 8-24. Once you have selected and arranged the photos, click Next.

Figure 8-23: Defining your calendar's beginning and ending dates in Photoshop Album

Figure 8-24: This six-month calendar was custom-defined in Photoshop Album.

6. In the fifth step in the Creations wizard, preview your calendar. Click the Back button to return to earlier steps and revise your layout. When you're happy with your calendar design, click Next.

7. In the final window in the Creations wizard, click Print to print your calendar (see Figure 8-25).

March 2005

Sun	Mon	Tue	Wed	Thu	Fri	Sat
		1	2	3	4	5
6	7	8	9	10	11	12
13	14	15	16	17	18	19
20	21	22	23	24	25	26
27	28	29	30	31		

NEW MEXICO

August 2005

Sun	Mon	Tue	Wed	Thu	Fri	Sat
14	1	2	3	4	5	6
7	8	9	10	11	12	13
14	15	16	17	18	19	20
21	22	23	24	25	26	27
28	29	30	31			

November 2005

Sun	Mon	Tue	Wed	Thu	Fri	Sat
		1	2	3	4	5
6	7	8	9	10	11	12
13	14	15	16	17	18	19
20	21	22	23	24	25	26
27	28	29	30			

Figure 8-25: A calendar created with Photoshop Album

Printing Postcards

Back in the day, we actually used to send postcards through the mail. After e-mail increased in popularity, people predicted the demise of postcards. These days, folks use postcard-sized photo prints to promote their business, make an artistic statement, invite people to parties, or announce a gallery opening, birth of a child, or any other number of things. The ubiquitous use of photo prints in the 4 × 6 size range has reinvigorated the postcard. You might come up with your own creative uses for postcard sized prints.

If you do want to mail a postcard, make sure the print fits official U.S. Postal Service size regulations, as shown in Table 8-2.

Table 8-2 Size Requirements for U.S. Postal Service–Approved Postcards

Dimension	Minimum	Maximum
Height	3½ in.	4¼ in.
Length	5 in.	6 in.
Thickness	0.007 in.	0.016 in.

Postcard Thickness

You're not going to measure the thickness of the photo paper you use for printing photo postcards. But the folks who manufactured the paper did. Look at the "MIL" value on the package of 4 × 6 photo paper you use to print postcards. A MIL is one-thousandth of an inch. So, for instance, 9 MIL photo paper (a frequently used thickness for 4 × 6 glossy photo paper) is .009 inches thick and falls within the USPS rules for mailed postcards.

Printing a postcard amounts to the same as printing a regular 4 × 6 (or 3½ × 5) photo. In fact, you can mail any 4 × 6 photo (consult Table 8-2 for more details) in the US as is just by writing an address and affixing a stamp on the back of it.

Postage Varies

Many people send professionally printed postcards that are 6 × 8 or another non-regulation size for postcards. That's allowable; however, you cannot send them at the postcard rate. You must pay the first-class rate. For complete Postal Service rates in the United States, visit www.usps.com.

Summary

If you want to print calendars, greeting cards, or photo albums that you design with your photos in mind, you might find that the free software that came with your printer, camera, or other digital photo gadget does the trick. Once you design your project, however, the basic principles of creating nice prints on your inkjet are the same as those explained in Chapter 6.

For a wide variety of nice layout templates for use in greeting cards, albums, and calendars, consider investing in Adobe Photoshop Album. But first look closely at the package your printer came in; some companies bundle Photoshop Album with their digital printing equipment.

Printing custom photo postcards is really just a matter of printing a 4 × 6 photo that conforms to your country's postal requirements.

Postcards, calendars, photo albums, and greeting cards are printed on regular photo paper — although some companies make special pre-folded paper for greeting cards. Other special print projects require media other than paper — such as for CDs or DVDs, photo transfers for T-shirts, and photo stickers. I explain how to print photos on these surfaces in Chapter 9.

Printing to Other Media: CD Labels, T-shirts, and More

You can print digital photos on a wide variety of printable media. Epson alone sells printable surfaces that include scrapbook photo paper, Memorex inkjet printable CD-Rs, glossy photo greeting cards, inkjet transparencies, iron-on transfer paper, and photo stickers. In short, you can use your digital photo portfolio for all kinds of projects that display excellent-quality photos on surfaces ranging from overhead transparencies to DVDs to T-shirts.

In addition to special media, special papers are available to enhance projects you might normally print on plain photo paper. Textured, glossy, or matte greeting card kits, for instance, include matching envelopes that allow you to print highly professional projects.

This chapter describes ways you can enhance your photos with special paper. It focuses on two exciting developments in inkjet printing: high-quality photo iron-ons and photo-printed CD/DVD labels.

Matching the Media with the Message

Back in the '60s, creative thinker Marshall McLuhan was associated with the dictum "The medium is the message." One sided, perhaps, but I think you'll find that your great digital photo takes on a very different character when it's printed on a DVD, T-shirt, or professional-quality greeting card packaged with a matching envelope.

McLuhan's extreme emphasis on media was a product, in part, of rapid technological developments in how art and information were made available. The evolution of technology in the realm of digital photo printing has opened up new vistas for printing photos.

Improving Projects with Special Paper

Many of the print projects discussed in this book look better when printed on specialized paper. For instance, the greeting cards discussed in Chapter 8 look fine when printed on a sheet of high-quality glossy or (better yet) matte photo paper. But those same greeting card images look even more impressive, and truly professional, when you use one of the greeting card paper and envelope packages available from HP, Epson, or a specialty paper distributor. HP's lineup of greeting card sets is shown in Figure 9-1.

If you go to your printer manufacturer's Web site, you'll find specialized paper for specific projects. The photo album projects explored in Chapter 8 look better on photo album pages that are sized for scrapbooks and album sleeves, can be printed on both sides, and are composed of cotton, acid-free paper that helps preserve photos. Figure 9-2 shows options for scrapbook photo printing.

Specialty Papers and Dye Sub Printers Don't Mix

Specialty papers are often thicker than normal photo paper and are not always suitable for all printers. This is definitely the case for dye sub printers. Do not insert a sheet of special postcard stock through your dye sub! Be sure also to check the packaging or online specs to make sure any paper you use is compatible with your printer. In general, photo printers can handle thicker paper for postcards, greeting cards, or scrapbook pages.

Figure 9-1: A variety of photo print greeting card sets from HP

Figure 9-2: Scrapbook photo paper from Epson

Pushing the Limits of Photo Print Media

While there's a photo paper for every project, there are some print media that aren't paper at all. The most intriguing new developments in printable media are CD/DVDs on which you can print directly, instead of printing on stickers provided by manufacturers like CD Stomper.

Special media require special handling. The iron-on photos on my T-shirts still look crisp and sharp—much better than the blurry, faded photos you often see on commercial T-shirts. But I followed the directions carefully, letting the iron-on dry properly after I printed on it, heating the iron to the right temperature, and washing the T-shirts inside out in cold water. Don't worry; I won't go into detail about how to wash your clothes. The point is that when you experiment with printing on special media, the tricks, rules, pitfalls, and joys differ from when you print on photo paper.

Using Iron-on Transfer Photos

Everyone is familiar with printing photos on T-shirts. Not everyone knows that you can produce really nice photo iron-ons. Booths at street fairs and inside shopping malls churn out disappointing, poor-quality photo T-shirts. Repeated washing in hot water and bleach doesn't help either. However, if you print iron-ons with a high-quality photo printer, you can create really beautiful, art-quality T-shirts. Figure 9-3 shows a T-shirt produced with HP's iron-on transfer sheets for dark T-shirts.

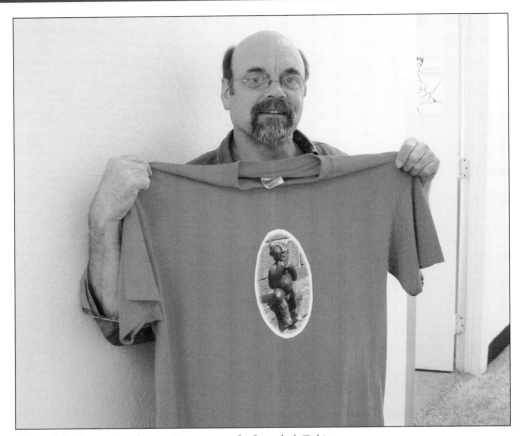

Figure 9-3: Photo printed on an iron-on transfer for a dark T-shirt

Epson, HP, and other manufacturers sell two types of iron-on transfer paper: sheets for white T-shirts and sheets for colored shirts. Colored shirt transfers are thicker so that none of the black background color shows through the iron-on and darkens the image.

Creating a photo transfer iron-on involves two basic steps: printing the transfer and ironing the transfer onto a T-shirt.

Checking Ink and Printer Compatibility

In Chapter 5, you read that inkjet printing involves the transfer of tiny droplets of ink to specially designed photo paper. Not all inks work with photo transfer media. Epson's UltraChrome inks, for example, do not work with iron-on transfer paper.

Don't Use UltraChrome Inks for Special Projects

Epson's UltraChrome inks do not work with most of the special print projects I describe in this chapter, including transparencies and stickers. UltraChrome inks also do not work with many special papers for greeting cards and other projects.

Printer manufacturers provide compatibility information on their Web sites that will help you match ink, paper, and media to make sure your iron-on transfers work.

Printing Iron-on Transfers

Store all photo paper in a cool, dry place and keep it sealed as long as possible to preserve its quality. This is truer for iron-on transfer paper than other paper because you need to protect not only the surface of the paper but also the state of the adhesive that bonds the iron-on to the shirt fabric after ironing. Keep your transfer paper stored properly and especially avoid exposure to heat and sun that can degrade the adhesive.

If you haven't printed an iron-on sheet recently, you'll be surprised at how similar the feel of the paper is to regular matte photo paper. Quality iron-on transfers reproduce photos almost as well as regular photo paper and don't lose quality when heated and adhered to a T-shirt.

Printing an iron-on is similar to printing any photo. It works best when you select the appropriate paper in your printer's preferences dialog box. The following steps reflect the process of creating an iron-on photo with HP's iron-on transfer paper. HP's iron-on transfer paper includes tissue cover sheets (one per iron-on). You place the tissue between the iron and the transfer during ironing. The cover tissue not only protects the photo during the transfer process but can also be used with a warm iron to revive colors. Other iron-on sets (for example, Print 'n' Press from Wal-Mart) don't come with cover sheets for ironing. If that's the case with your particular iron-on kit, ignore my directions that relate to the cover tissue.

1. Select which photo you want to print and prepare it for printing. Figure 9-4 shows a photo project from Chapter 3 that will be printed on a T-shirt.

Don't Overcompensate

When you prepare photos for printing on a T-shirt, don't overcompensate for the dullness or faded coloring you might expect after the transfer is complete. If you oversharpen an image or apply too much contrast, it will look unnatural on the shirt.

2. From your image editor, select File → Print and click Properties in the Print dialog box to access your printer's properties.

Figure 9-4: Selecting a photo for a T-shirt. This one has been cropped to produce the oval shape.

3. Choose the paper type recommended by the iron-on manufacturer, as shown in Figure 9-5.

4. In the printer properties dialog box, choose "best quality" in the print quality list or follow the directions that came with your transfer paper for selecting the quality.

5. Place only one sheet of iron-on paper in your printer. Follow the icons on your printer to determine if the sheet should have the print surface facing up or down. The print surface is plain; it's the backing that has the image on it.

Remove (and Save) the Cover Sheet Before Printing!

If your iron-on paper comes with tissue cover sheets, don't place the cover sheet in your printer. This sheet is for ironing purposes only.

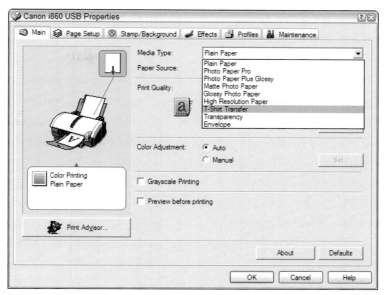

Figure 9-5: Selecting an appropriate paper for an iron-on transfer

6. With your print options selected and your paper loaded, click OK in the printer properties dialog box and click OK in your image editor's print dialog box.

Adhering Iron-on Sheets to a T-shirt

After you print the iron-on sheet, allow time for the ink to dry completely. While you're waiting, channel your excitement into ironing the T-shirt that the iron-on will go on. The process works better if the T-shirt is ironed first, providing a flatter surface than otherwise. When the paper is dry and the T-shirt is ironed, follow these steps to adhere the iron-on to the shirt.

Parental Supervision Required

Pay attention to the safety instructions that come with your iron-on. The sheet is applied to a T-shirt with a hot iron. Please do not let unsupervised children attempt this task.

1. Use scissors to trim excess material, leaving only the printed area, as shown in Figure 9-6.

Figure 9-6: Trimming a printed iron-on sheet before applying it to a T-shirt

Trim the Corners Anyway

If your image does not require trimming, use scissors to round the corners of your sheet slightly. This helps prevent the iron-on from peeling off the shirt later.

2. After you trim the excess material from around your photo, and before you actually iron it on the shirt, peel the backing paper away from the back of the photo paper to reveal the surface that will adhere to the fabric.

3. Place the trimmed, peeled iron-on paper on the shirt.

4. Cover the iron-on paper with the tissue-like cover sheet. Carefully follow the advice that came with your iron-on paper to determine how high to set your iron and how long to iron the iron-on. Figure 9-7 shows the cover sheet over the T-shirt.

Figure 9-7: Protecting the photo from the iron with the cover sheet

5. Carefully and patiently follow the ironing directions that came with the transfers, as shown in Figure 9-8.

Figure 9-8: Heating the transfer with an iron

Some Iron-ons Reverse the Image (and Text)

Some iron-on methods reverse left and right when you apply the transfer to the T-shirt. For some photos, this won't matter much, but if your image includes any text, you'll need to reverse it before printing the transfer. Check the directions that come with your iron-ons to determine whether you need to do this or not. In general, transfer sheets that do not use a cover sheet do reverse the image.

To make the reversed image of the iron-on appear correctly after the T-shirt transfer, use the horizontal flip feature in your image editing software to mirror the original image. In Photoshop (or Photoshop Elements) the menu command is Image → Rotate Canvas → Flip Canvas Horizontal.

Caring for Iron-on Photos

To maintain the photo-quality character of your shirt, look carefully at the advice in the iron-on paper packet provided by the manufacturer. HP suggests that you wash the shirt by itself when you wash it for the first time. Also, wash it inside-out and in cold water. If you wash with care, manufacturers promise long-term durability and color of iron-on photos.

These same steps and cautions apply to adhering iron-on transfers to other cotton clothing and accessory items — for instance, to make custom book bags, tote bags, and other custom items.

Printing Photos on CD/DVDs

Wouldn't it be fun to print your own, customized labels on the CDs or DVDs that you burn, as shown in Figure 9-9, rather than simply write on them with a pen? You can. The ability to produce CDs and DVDs easily with customized, professional-looking surfaces that feature digital photos is one of the more interesting and innovative, not to mention fun, developments in digital photo printing.

The Epson Stylus Photo series — including the Epson Stylus Photo R200 printer, which you can find for close to $80 — comes with a special tray that allows you to print directly on CDs and DVDs that are manufactured with printable surfaces. (You cannot print on conventional CD/DVDs.) The configuration is shown in Figure 9-10.

New Technology on the Way

HP has announced a new technology called LightScribe Direct Disc Labeling that allows photographers to burn silkscreen-quality labels using lasers.

Figure 9-9: Popping a self-produced CD full of your very own photos into a computer

The Stylus Photo CD/DVD tray comes with fairly easy-to-follow directions and is packaged with Epson Print CD software. To print on CDs you need to purchase special printable-surface CDs or DVDs made by Memorex, Maxell, Imation, or other manufacturers. You can order these special media online or purchase them at your local computer supply store. As more manufacturers join the party, the cost of printable CDs has begun to drop — as this book goes to press, packs of fifty printable CDs are available for around $20.

Copy First, Print Later

Make sure you copy your photos (or music or other files) to your CD/DVD *before* you print on it. Printing on it first can make writing data to it later more error-prone.

Figure 9-10: Printing on a CD surface using the Epson Stylus Photo R800

Setting Up Epson Photo Stylus Printers for CD/DVDs

Once you have your Epson Stylus Photo printer ready to roll, the normal inks in place, a printable CD nearby and ready to load, and the Epson Print CD software installed, follow these steps to configure the printer to print on a CD:

1. Follow the directions in the Epson Stylus Photo R800 user's guide to move the paper output tray to the upper position that allows the CD tray to be inserted.

2. Insert the CD tray and place your CD in the slot, as shown in Figure 9-11.

Figure 9-11: Placing a CD in the CD printer tray

3. Press the paper/CD toggle button (next to the On/Off button) on the printer.

4. Align the arrows on the CD tray with the arrows on the front of the paper output tray. Now you're ready to design your CD and print on it.

Designing a CD/DVD with Epson Print CD

With your CD in place, the next step in the process is to design the CD photo layout. To do that, follow these steps.

1. Launch Epson Print CD software.

Software Comes with the Printer

You can install Epson Print CD for Windows or Mac OS from the CD that comes with the R800.

2. Click the Background icon to select a photo for use in the background of the CD label. The icon appears is shown in Figure 9-12. The Select Background dialog box opens.

— Select background

Figure 9-12: Opening the Background
selection options

3. Choose the File tab in the Select Background dialog box and use the Browse button
to navigate to a folder on your hard drive, camera, or card reader.

4. From the displayed photos, choose one for a background, as shown in Figure 9-13.

Figure 9-13: Choosing a photo for the CD label's background

5. Click OK. Your selected background appears as it will on the CD, as shown in
Figure 9-14.

6. Click the Text icon and enter text in the Text area of the Text Settings dialog box,
as shown in Figure 9-15.

Figure 9-14: Previewing the CD label's background image

Figure 9-15: Entering text for the CD label

7. Use the Text Settings tab to define any text formatting, as shown in Figure 9-16.

8. Use the Text Color tab in the Text Settings dialog box to format the text color. You can also use the Shadow or Distortion tabs to add special effects to your text. After you format the text to your satisfaction, click OK. The CD previews the label showing the image and text.

Figure 9-16: Formatting the text on the CD label

9. Drag the text to a suitable location on the CD, as shown in Figure 9-17.

Figure 9-17: Positioning the text on the CD label

After you are happy with the label's design, you can print it on a real CD/DVD.

Printing the CD/DVD

Setting up the CD/DVD print tray in an Epson Stylus Photo printer is one of the easier things I've done with a printer — much easier than popping ink cartridges into their respective slots. The directions in the printer's handbook and the icons on the tray make this part of the process pretty hassle-free. But do make sure that you follow the directions carefully and that the CD/DVD tray is set up properly.

With your printable CD/DVD — already burned with data — in place and the label's design visible in the Epson Print CD software (see the previous section), follow these steps to print on the CD/DVD:

1. Click the Print button in the Epson Print CD software.

The Defaults Are Good

A dialog box opens with all settings already set correctly for printing on a CD/DVD on the Epson Stylus Photo printer. You can edit those presets by clicking the printer's Settings button in the Print dialog box. The settings include Size A4 paper, CD/DVD paper or media type, portrait orientation, and text-quality printing.

2. Do a final check to make sure the CD tray is correctly positioned in the printer.

3. Click OK in the Print dialog box.

4. After you print on the CD or DVD, wait a full 24 hours before playing the disc in a CD/DVD player or placing it in a CD/DVD drive.

Creating Inkjet Transparencies

Before the advent of the under-$1000 digital projector, teachers, sales people, and other presenters relied exclusively on overhead projectors to display charts, bullet point lists, and photos. While digital projection provides more flexibility, old-style overhead projectors are still the norm in many classrooms and in more than a few conference rooms. Because they are generally large (8½ × 11), projectable transparencies are a fine way to share your photos with an audience.

One at a Time, Please

As with inkjet transparency paper and all special print media, load only a single sheet of it into your printer at a time. Because special media is often thicker than normal paper, it presents a special challenge to your printer's feeder tray. To minimize the chance of a paper jam, load just one sheet at a time.

Printing on transparencies presents a special challenge because the material is highly non-porous. I've tried to print photos onto transparency paper that did not match my inkjet properly, and the smeared results were unacceptable. As long as I pay attention to the handling directions, however, mixing and matching transparency paper with my printer produces fine results. Figure 9-18 shows Transparency selected as a print medium for the Canon i860 printer.

Figure 9-18: Choosing an appropriate paper type to print transparencies

Do a Clean Sweep Before Printing on Transparencies

Because transparency material tends to absorb less ink than normal paper absorbs, you should run a cleaning sheet through your printer after you print on a sheet of transparency paper. The cleaning sheet removes any excess ink that might smudge your next print job. If your package of transparency paper comes with a special cleaner sheet, place it in the printer's sheet feeder and press the printer button that sends a blanks sheet of paper through the printer. (Alternately, you can feed the blank sheet through the printer using the printer's software.) Cleaning sheets are generally packaged with a protector sheet of paper that shields them from picking up dirt or dust, and they can be recovered for storage and reused as necessary.

Printing Photo Stickers

Sticker paper comes in all shapes and sizes — everything from name tags to printer covers, and CD covers to mailing labels. In general, the relatively glossy, thick paper used in peel-off stickers is a fine surface for printing digital photos. For even better quality photo prints, special photo sticker paper is available from suppliers like Epson and HP.

To print one-of-a-kind photo stickers, use paper like photo-quality self-adhesive sheets from Epson. Print your photo, trim it with scissors or a paper cutter, peel off the backing, and paste your label on a jar of fruit, book cover, desktop, or windowpane.

Another option is to use precut sticker paper. Unless you have the skills and inclination to design your own page layout and template using Adobe Illustrator, just make sure that whatever photo-printable sticker paper you purchase matches the software that helps you lay out and design your project. I walk you through an example of using precut sticker paper to print CD covers — an alternative to printing directly on printable (but rather expensive) CD/DVDs.

Printing Custom Photo Labels

My friends and I exchange homemade preserves, honey, salsa, jars of garlic, and other goodies at holiday time. What makes the gifts really special are the attractive labels that feature photos, such as the one shown in Figure 9-19.

Figure 9-19: A homemade label featuring a photo-paper quality sticker

A quick and easy way to print sticker photos that fit almost any jar or container is to use the Windows XP Printer and Fax Viewer utility to print a sheet of wallet-sized photos. These photo stickers fit on almost any jar, can, or container. The following steps walk you through the process of designing and printing a photo sticker label.

Requirements

This tutorial requires Windows XP.

1. Navigate in Windows Explorer to any photo you wish to use for your label.

Cross-Reference

See Chapters 3 and 4 for tips on editing a photo with image editing software.

2. Right-click the photo file and choose Open With → Windows Picture and Fax Viewer, as shown in Figure 9-20.

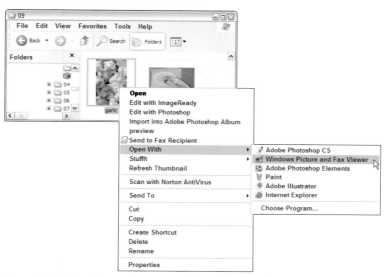

Figure 9-20: Opening a photo in Windows Picture and Fax Viewer (in Windows XP only)

Know Your Size

Wallet-sized photos are generally about 2 × 3 inches.

3. Click the Print icon in Windows Picture and Fax Viewer, as shown in Figure 9-21. The Photo Printing Wizard appears.

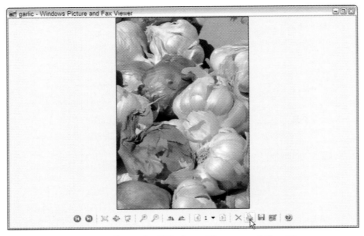

Figure 9-21: Printing from the Windows Picture and Fax Viewer

4. Click Next in the first Photo Printing Wizard window to access the Picture Selection window. Your photo will be selected. Click Next again.

5. Choose your printer in the Printing Options window. Use the Printing Preferences dialog box to open your printer's Preferences dialog box and adjust the print quality. Select a paper type and size that match your photo sticker paper, as shown in Figure 9-22.

6. Click OK in your printer's Properties dialog box to return to the Photo Printing Wizard. Click Next.

7. In the Layout Selection window of the Photo Printing Wizard, choose Wallet sized photos and select 9 as the number of times to use each picture because that is the number of wallet-sized photos that fit on an 8½ × 11 sheet of paper.

8. Click Next for the last time to send your photo sticker paper to the printer.

9. After your stickers print, cut out the wallet-sized stickers and attach them to bottles, jars, or containers.

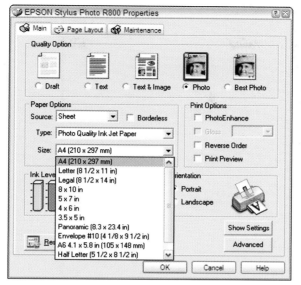

Figure 9-22: Choosing the sticker paper

Use the Gridlines for Straight Cuts

Some photo sticker paper has layout gridlines on the back to help you cut straight lines.

Printing CD/DVD Stickers with CD Stomper

Earlier in this chapter I showed you how to print inkjet-friendly CD/DVDs in Epson Stylus Photo printers. These customized CDs have a really professional look but they cost about a dollar each — $1 per printable CD and more for printable DVDs. Not many printers currently print on CD/DVDs.

The solution for the rest of us is printable CD/DVD stickers. These peel-off stickers go through a printer on a standard, letter-sized sheet of paper. The stickers I'm familiar with aren't of the highest photo quality, but they look nice enough and are easy to produce.

A number of packages online and at your local computer or office supply store provide software, CD/DVD stickers, and sometimes hardware to attach the sticker cleanly. One of those packages I've used for almost 10 years is called CD Stomper (www.cdstomper.com). This software includes crack-and-peel stickers to place on CD/DVDs as well as templates and special paper to print jewel case inserts. These stickers are an easy and attractive way to cover CDs if you don't want to invest in the printable media plus Epson printer combination. The jewel case package is also a nice way to create a really professional-quality CD package for holiday gifts.

Besides the CD Stomper software, you can purchase sticker paper refills or jewel case insert paper. You can also purchase a funky little stamping machine that centers and applies the sticker to the CD. (I find that I can adhere a sticker to a CD just fine without that device.)

CD Stomper Templates Do Not Work in Mac OS X

The dedicated template software packaged with CD Stomper was not compatible with OS X Panther at this printing. Check the CD Stomper Web site for software upgrade information and download patches.

The software that ships with CD Stomper changes periodically but includes templates that can be used to design CD cover templates in Adobe Illustrator, Microsoft Publisher, Microsoft Word, and other programs. You can also use CD Stomper directly to design your CD cover. Regardless of your version of CD Stomper or an alternate CD sticker printing package, you can create a print CD using the following basic steps:

1. Launch CD Stomper or another software package that supports the peel-off CD/DVD stickers you wish to print.

2. In the first dialog box, choose the layout of your CD/DVD stickers, as shown in Figure 9-23. Click OK.

3. Steps do vary, but choose a background photo or place a photo image over the CD design.

4. Use the Text tool in your software to add a text label if you wish, as shown in Figure 9-24.

Figure 9-23: Choosing a layout for a CD sticker

Figure 9-24: Adding text to a CD label

5. With the CD sticker paper properly inserted in your printer, print it. If no recommended printer setting is associated with your CD sticker paper, select Matte photo paper.

6. Affix the CD/DVD sticker to your disc.

Photo Gift Ideas

In the course of writing this book, I've produced dozens of jars with photo labels, customized CDs and DVDs, greeting cards, post cards, and more. The coolest thing about all this has been the fun of giving friends and relatives gifts that feature photos of themselves, a trip we took together, or a picture they appreciate.

Here's a list of gifts and projects you can create from high-quality photo prints on various types of surfaces:

- Make unique food gift jars. Package homemade barbeque sauce, flavored honey, or fruit and nut mixes in jars with photo labels made by printing a photo on a high-quality photo sticker and attaching it to a cleaned jar.

- Use a photo of grapes or wheat to make a label for your home-brewed wine or beer.

- Customize thank-you notes for gifts. Use photo greeting card paper to make thank-you cards featuring a photo of yourself (or child, spouse, and so on) using or wearing the gift you received.

- Help fundraising projects for charities, schools, sports teams, and so on. A greeting card printed on photo-quality greeting card paper can be customized with a photo of a person, project, or other cause (the animal you saved at the pet shelter?) to solicit funds or thank donors.

Continued

Photo Gift Ideas *(continued)*

- Customize calendars. It's June 15 (or some day of the year other than January 1), but because you're designing your own calendar, create just enough months to last until the end of the year. Feature large 8 × 10 prints on legal-sized glossy photo paper, take the pages to a copy shop for spiral binding, and have a hole drilled so the calendar can be easily hung on a wall.

- Send out individual invitations to parties. Use a photo of your latest trip to Hawaii to invite people to your backyard luau.

- Mail birth announcements. Combine a photo of the baby (with red-eye removed as necessary — see Chapter 4) with a greeting card to make your own announcement.

- Deliver announcement post cards. Churn out customized, beautiful-quality 4 × 6 postcards on a dye sub printer or inkjet announcing your party, opening, business venture, or school play. The 4 × 6 dye sub paper often comes with postcard layout (for address, message, and stamp) on the back.

- Print high-quality photo T-shirts. Friends will be amazed at the look of a photo-quality iron-on T-shirt featuring a portrait of themselves or just a great photo. Include washing and care instructions. This is a great idea for family reunions.

- Choose a favorite photo of a couple, edit it for effect, and iron it onto the pillowcases they registered for as a wedding present. This makes a good idea for an anniversary gift too.

- Design tote bags with appropriate photos — your son or daughter playing soccer or wearing leotards at dance class. These all make useful gifts.

- Give away CD/DVDs with photo labels. Put together a collection of photos or create a personalized music mix that shows a photo-based design either directly on the CD surface or on a sticker. For a music CD, include a song list; for a photo CD, add a subject title. Always burn the CD/DVD before printing on it.

Summary

You can print digital photos on a wide range of surfaces, from printable CDs and DVDs to overhead transparencies, photo stickers, and labels. High-quality T-shirt transfers are available specifically for printing color photos on them.

Wherever possible, printing on quality photo paper or special photo-friendly surfaces produces great digital photos. You can also get nice, quality photos printed on regular media for CD stickers or labels.

To push the limits further of printing photos on different media, consider various online print options. Technology exists to print photos on everything from mugs to mouse pads, but most of that technology is out of reach of a home or small office operation. For that you have the Internet at your disposal. In Chapter 10, I show you how to print your photos using some interesting, helpful online resources.

Creating Great Prints Online

A wide selection of online printing options provides an alternative to, and complements, what you can produce on your own photo printer. If the challenges of producing great photos from your home printer seem a bit overwhelming, you can turn to the very high-quality printer/paper combinations used by online photo shops. You can also opt to handcraft most of your photo printing at home or at the office, while turning to specialized online resources for unique projects like posters, mugs, T-shirts, or even mouse pads.

Why would you consider online printing when you already own a photo printer? For some sizes and quantities of prints, online printing saves you money. In many cases, the professional-quality dye sub printers and traditional silver halide photo processing used by online printers yield a color quality not easily achievable from inkjets. Furthermore, online vendors offer more paper sizes and media than normal desktop photo printers can handle.

To prepare you to take advantage of various online printing resources, this chapter surveys the features available at some of the most popular online print shops and walks you through the process of preparing and printing your photos online.

Online Print Options

Online photo printing outlets include many, very different types of printing options. Many people are aware of high-profile online print services like Kodak's Ofoto, Apple's iPhoto, Walmart's Digital Photo Center, and Shutterfly. Volume-wise, those online print shops account for a huge amount of photo printing among digital photo enthusiasts. There are other options online as well.

If you already own a photo printer, cost is not a particularly compelling reason to experiment with online printing. Even so, the range of options available for online printing makes a good case for being aware of the additional online services available that probably are not accessible on your desktop photo printer. Likewise, if you print hundreds of prints on a regular basis, online shops offer a very efficient, economic alternative to doing it all yourself.

Online photo printing comes in three basic sizes:

- Consumer-oriented services with a wide range of print options

- Professional print services using very high-quality paper and state-of-the-art printers

- Specialty printers that can reproduce photos on almost any material

Online photo prints are not significantly cheaper than high-quality inkjet or even dye sub prints—assuming you have a high-quality photo printer of your own. That is a rough assumption because the price of printing your own photos is hard to estimate. It depends on ink coverage, paper quality, and so on. For example, ordering 4 × 6 prints online ranges—as I write this—from a low of 24 cents each (at Walmart) to 29 cents at Shutterfly, iPhoto, or Ofoto. Costs run significantly higher at professional-quality photo labs. However, the online print market is highly competitive, and online photo services often have sales, specials, and introductory offers of free prints. Be sure to shop around.

Cross-Reference

I explore the pros and cons of high-end, professional-quality photo labs at the end of this chapter.

Those prices are lower than the 35 to 50 cents for 4 × 6's (a bit higher for dye sub prints) that I've figured as average for printing on your own printer, but not that much lower. When you factor in shipping, the costs pretty much even out (unless you're ordering large numbers of prints to offset the shipping costs).

Furthermore, 8 × 10's are significantly less expensive to print on a photo inkjet. Online printers charge between two and three dollars per print for 8 × 10's, while the cost of printing an 8 × 10 on your own color inkjet is between one and two dollars per print, according to industry studies.

You will save money ordering online if you haven't already invested in a photo printer. Another reason to order online is when you need to ship photos somewhere anyway. It's convenient one-stop-shopping to order prints and have them sent out, rather than send them yourself (waiting in line at the post office or paying more for overnight courier service).

The times when online printing can save you considerable money is when you need to ship large numbers of small prints. Printing a handful of prints online at 23 cents each is hardly worthwhile when you factor in the shipping cost. However, printing several sets of a few dozen photos definitely justifies saving wear and tear on yourself and your printer.

One reason to recommend online prints is their quality. They are produced by high-quality dye sublimation printers that offer truer colors, often surpassing those in inkjet prints. Online photo printers also offer a wide range of media for photo printing, from T-shirts to mugs and specialty albums.

Preparing Photos for Online Printing

The online photo printing services surveyed in the next section, "Printing Great Digital Photos Online," provide built-in, online editing options that perform many basic retouching features. You can crop, resize, recolor, and apply relatively crude, one-size-fits-all adjustments to photos right on the companies' Web sites.

Doesn't the concept of using rather crude photo editing tools contradict my emphasis (especially in Chapters 3 and 4) on using photo-editing software to improve photos before printing them? Sure. But every rule has its exceptions; and quick-and-dirty photo editing on online print shop Web sites has its place.

That said, if you're going to print online, you are better off editing and cropping your photos before sending them to the online site. The photo editing features available online are not as robust as even those available in the most basic photo editing software you already own — certainly not in the league of Photoshop Elements, for example.

Edit First ... Most of the Time

The primitive editing tools available at online print sites have their time and place. For example, it's useful to be able to upload a photo and crop it online. The online service keeps the original photo and you can crop it at any time using their editing tools. You could crop the same photo you originally uploaded to print a 4 × 6, a 5 × 7, an 8 × 10, and even a poster-sized print. Figure 10-1 shows some photo cropping at an online print service.

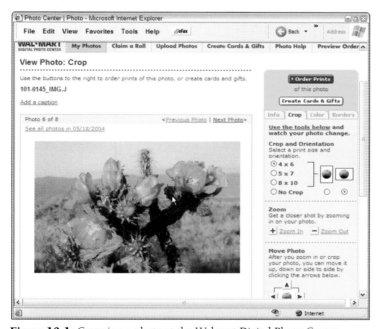

Figure 10-1: Cropping a photo at the Walmart Digital Photo Center

Another appropriate editing choice after uploading a photo is changing the photo's orientation from landscape to portrait or vice versa.

Make Sure You Have Enough Resolution

If you upload a photo to print at 5 × 7, 8 × 10, or larger, make sure you have enough resolution at that size for a quality photo print. For a full review of resolution, refer to Chapter 1. As a quick reference, to print an 8 × 10 photo, you should capture it with a 3 megapixel or higher digital camera and save the file in a lossless format (like TIFF) at a resolution of at least 180 pixels per inch.

Uploading Your Photos

Online print services provide various options and use different methods to prepare photos for printing. However, the process of online printing always begins with uploading photos to the online print service's Web server. Online photo services maintain large, very fast servers that facilitate quick uploads.

Most of the time, online print providers include some kind of online album or gallery feature. Some online services allow you to share your photo gallery and all provide options to protect your photos from being viewed by visitors. These online galleries generally provide a couple ways to look at your photos. Figure 10-2 shows the online gallery at Ofoto in slideshow mode.

Figure 10-3 displays another online gallery view — this time at the online photo print site Shutterfly.

Every online photo print service requires that you register first with them. You will be issued a password and login name and supplied with server space for uploading your photos. The most popular online services provide their own drag-and-drop software that runs on your computer. Figure 10-4 shows the drag-and-drop program that comes with Walmart's online print program.

It's possible to use an online print service without using its associated downloadable software. But then you cannot access some of its useful features, such as easy upload tools, cropping and preview features, and some other online editing features.

Figure 10-2: Viewing an online slideshow on the Ofoto site

Figure 10-3: Online photos, ready to share or print on Shutterfly

Figure 10-4: Easy uploading with a drag-and-drop upload program from the Walmart Digital Photo Center

Printing Great Digital Photos Online

Major online print sites are fast and reliable, and they ship quality prints. They vary considerably in price, as I noted earlier, as well as in their range of services and interfaces. Walmart Digital Photo Center uses very high-quality printers and paper and, not surprisingly, provides online prints for the lowest cost of any major service. The Apple-branded iPhoto service is pricier than the same service from Kodak at Ofoto, but iPhoto meshes neatly with Apple's other Mac OS X products.

Because registration is free at all nonprofessional online photo services, go ahead and experiment with different services and compare their quality. I think you'll find that the main factor in getting great digital prints online is to do a careful job preparing your images before uploading them to the service you decide to use — including making sure levels, contrast, and colors are adjusted, and cropping the photo properly.

Edit at Home, Crop Online

As I noted earlier, you can perform rudimentary and inflexible color, contrast, and level tune-ups on some of the online print Web sites. But you'll have much more control over the look of the final print if you do your color, level, and contrast adjustments before you upload. At the same time, you can get away with cropping online if you plan to print several sizes of the same photo.

Table 10-1 summarizes the types of services, photo sizes, editing features, and special media available on various online sites.

Table 10-1 Online Photo Printing Comparisons

Online Vendor	Photo Sizes	Special Media	Editing Tools
Shutterfly www.shutterfly.com	4 × 6, 5 × 7, 8 × 10, posters	Mugs, posters, T-shirts, mouse pads, note cards	Cropping, red-eye removal, color adjustment, borders
Walmart www.walmart.com (click on the Photo Center tab)	4 × 6, 5 × 7, 8 × 10, posters	Calendars, mugs, postcards, mouse pads, T-shirts, plates, puzzles, posters, magnets	Cropping, red-eye removal, rotation, auto-color fixing
Ofoto www.ofoto.com	4 × 6, 5 × 7, 8 × 10, posters	Cards, calendars, framed photos, scrapbooks, posters	Cropping, red-eye removal, rotation, "instant fix" (level, contrast, color adjustment), flipping (horizontally)
iPhoto (launches Kodak Print Service automatically)	4 × 6, 5 × 7, 8 × 10, posters	Cards, calendars, framed photos, scrapbooks, posters	Enhance (leveling, contrast, and color), red-eye removal, retouch, brightness, and contrast

Using Ofoto

Ofoto (www.ofoto.com)—which is operated by Kodak—provides a wide range of editing tools. The flexible cropping options at Ofoto reduce the chances of your printing an awkwardly cropped photo when you switch among 4 × 6, 5 × 7, and 8 × 10–sized prints. Ofoto is midrange in price and easy to use, and it provides online photo album features so you can share your photos on the Web along with printing them. As you might expect, Ofoto prints photos on Kodak's long-lasting Duralife photo paper. Kodak uses silver halide print processing to achieve photo-quality printing.

Like other online print services, Ofoto requires that you first register. Once you are assigned a login name and password, you can upload and print photos as follows:

 1. Click the Add Photos tab at the home page of the Ofoto Web site to upload your photos.

2. The first time you upload photos, you'll be prompted to download Ofoto's upload software.

Download the Upload Software Just Once

When register with Ofoto, you are prompted to download its drag-and-drop photo uploading software, OfotoEasy Upload. This software takes just a minute to download (with a broadband connection — minutes with dial-up) and installs itself on your computer. After you download this software once, you use it each time you upload more photos to Ofoto. If you don't wish to download this uploading software, you can use Ofoto's more primitive upload tool. Ofoto's upload software includes the editing tools that I refer to in the following steps.

3. Use the drag-and-drop feature to drag photos from folders on your computer into the upload window of the Ofoto upload software (which was installed on your computer), as shown in Figure 10-5.

Figure 10-5: Using Ofoto's drag-and-drop upload software

4. With all your photo files dragged into the upload window, click Start to upload.

5. When the upload process is complete, click the View and Edit Albums tab to see your photos online in your Web browser.

6. Click a photo to see an enlarged view, as shown in Figure 10-6.

Figure 10-6: Viewing a photo at Ofoto before editing, cropping, or printing it

7. Click the Edit & Borders link. Three tabs allow access to the Edit, Effects, and Borders tools.

8. On the Edit tab, use the Crop tool to choose among 4 × 6, 5 × 7, 8 × 10, wallet size, or other sizes. Also choose portrait or landscape orientation. The Red Eye tool fixes red-eye, and the Flip tool flips the selected photo horizontally. Figure 10-7 shows the instant fix tool touching up a photo.

9. Use the Effects tab to apply tints or convert to grayscale.

10. On the Borders tab, choose a border (or no border).

11. Use the tools on the Borders tab to zoom in and out, crop your photo, and choose between landscape and portrait orientation. (This last feature duplicates the landscape/portrait option in the Crop window of the Edit tab.)

Figure 10-7: Applying an instant fix to a photo at Ofoto

12. Use the navigation arrows in slideshow mode or click a different photo in album mode to select another photo. Apply sizing, cropping, and editing to all photos you wish to print.

13. After selecting and editing your photos, click the Buy Prints tab to place an order and check out. The Ofoto purchase form appears in Figure 10-8.

Using Shutterfly

Shutterfly online printing is available directly on their Web site (www.shutterfly.com) or from Yahoo Photos (http://photos.yahoo.com). The service is the same in both places, and the interface is similar. I personally find the Shutterfly interface less messy than Yahoo Photos' because you don't have to go through the whole Yahoo login procedure. Either way, Shutterfly provides very good online prints. I've also experienced smoother photo uploading and less congested server access on the Shutterfly site. Photo processing and printing are identical on both sites.

Shutterfly prints photos on Fuji Crystal Archive paper, which is high-quality, long-lasting photo paper. If you're feeling frugal, compare Shutterfly with Yahoo Photos from time to time; sometimes one service offers a discount not available on the other site.

Both Yahoo Photos and Shutterfly prompt visitors to download special drag-and-drop software before uploading and printing photos. There is no limit on the number of photos you can upload.

Figure 10-8: Checking out your Ofoto order

Shutterfly Equals Yahoo Photos

The following steps apply to the Shutterfly site, which I recommend over the Yahoo Photos version—
mainly because of the smoother photo uploading experience. The procedure is very similar on the
Yahoo Photos site.

1. After joining and logging in with your e-mail address and password, click the Add
 Photos tab at the Shutterfly home page to upload photos. The first time you upload
 photos, you'll be prompted to download Shutterfly's upload tool.

2. Select an album for the new photos from the first Web page in the Add Pictures wiz-
 ard, and click Next. Either click the Choose Pictures button and select photos you're
 your computer, or use the drag-and-drop software to add photos from folders on
 your computer. In either case, after selecting the photos to upload, click the Add
 Selected Pictures button to upload your photos, as shown in Figure 10-9.

3. After photos upload, they will display as shown in Figure 10-10. Click the View &
 Enhance tab in the Web page to access the site's editing tools, as shown in the figure.

Figure 10-9: Photos uploaded to Shutterfly

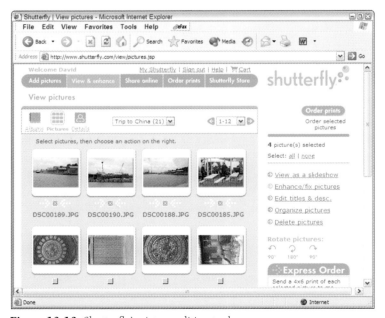

Figure 10-10: Shutterfly's picture editing tools

4. In the View & Enhance page of the Web site, select a photo for editing. To get rid of red-eye, click the Fix link. Use the three-step Fix process to remove red-eye, as shown in Figure 10-11.

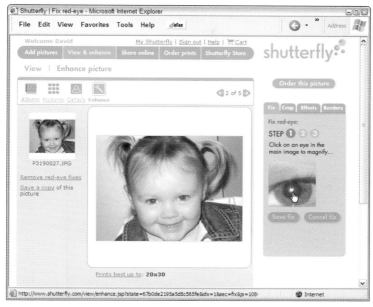

Figure 10-11: Cleaning up red-eye at Shutterfly

A Good Cure for Red-Eye

Interestingly, the red-eye fix feature in Shutterfly's online editing software works awfully well. Consider this as an alternative route to take if the tedious process I outline in Chapter 4 is too frustrating.

5. Use the Crop tab in the View and Enhance window to crop the photo for the size of the print, as shown in Figure 10-12.

Shutterfly's Flexible Crop Feature

Shutterfly has a nice feature that allows you to define a crop area and then see how the photo would print if you selected a print size that didn't conform to your cropped dimensions. You can also define a 4×6, 5×7, or 8×10 crop area automatically.

Figure 10-12: Cropping a photo for an 8 × 10 print

6. Use the Effects tab in the View & Enhance window to apply effects like black-and-white, color, saturation, or soft focus.

7. Click the Borders tab to define borderless prints, or white, black, shadow, or blurred borders.

8. Use the Previous and Next navigation buttons in the View & Enhance window to navigate to additional photos and edit them for printing.

9. After editing and cropping your photos, click the Order Prints tab and proceed through the order form to purchase your prints.

Using the Walmart Digital Photo Center

You can't beat Walmart's online photo prices, and the quality of their prints is often fine. Don't expect to find out from their Web site which printing process or paper type they use. Don't look for much technical advice either. When I used the generic Walmart customer assistance online form to post my questions about their photo process, I got the following perplexing reply: "The page you're looking for is either temporarily unavailable or no longer exists." If you plan to store your photos on their servers for more than 30 days, Walmart charges a nominal annual fee for server space. The other services I describe in this chapter provide unlimited uploading and storage for free.

On the other hand, features like drag-and-drop uploading and online editing are comparable with other online options. Walmart's online service also has as large a selection of print media—ranging from posters to puzzles.

Did I mention that Walmart's photos are cheap? Every survey of major online print services places Walmart near the bottom in price. Other services offer periodic discounts, sales, and free giveaways, however, so if price is your main consideration, shop around.

To upload and print photos at the Walmart Digital Photo Center, go to `www.walmart.com` and click the Photo Center tab on their Web site. Then follow these steps:

1. Create an account to get a login name and password.

2. Click the Upload Photos link and click Easy Upload to install Walmart's upload software.

3. Use the drag-and-drop software to upload your photos. Then click Begin Upload to transfer the files from your computer to the Walmart Digital Photo Center.

4. After you upload your photos, click the View button to display them, as shown in Figure 10-13.

Figure 10-13: Viewing photos at the Walmart Digital Photo Center

5. Click a single photo in the My Photos tab to access the online editing tools. The photo will appear in a new Preview window with online editing tools. Click the Crop tab to crop to a 4 × 6, 5 × 7, or 8 × 10, as shown in Figure 10-14.

Figure 10-14: Cropping a photo for a 4 × 6 print

6. Click the Color tab to access tools that remove red-eye, auto-adjust color, or print black-and-white photos.

7. Click the Borders tab to define custom borders or to print borderless photos.

8. Click the My Photos tab to jump back to the list of all your uploaded photos. Choose other photos for editing, as necessary.

9. After editing or cropping your photos, click the Order Prints button. Fill out the online order form to select print sizes and quantity, as shown in Figure 10-15.

10. Click the Add to Cart button to begin the shopping cart process.

Figure 10-15: Ordering online prints from the Walmart Digital Photo Center

Using iPhoto Plus Kodak (for Mac OS X Users)

Apple iPhoto, available on Macs, works a bit differently from the online services I've surveyed so far. With iPhoto, you do all your editing on your own Mac, using Apple iPhoto software, and then order your prints online from iPhoto.

There is no software to download when you use iPhoto, although if your Mac's operating system is earlier than OS X, you can purchase iPhoto from Apple as part of their iLife suite of programs. iPhoto provides nice, seamless integration between editing on your own computer and printing via an online service.

To print a photo from iPhoto, follow these steps:

1. Launch the iPhoto program in Mac OS X and select a photo from the Organize view.

2. Switch to Edit view to access iPhoto's editing tools, as shown in Figure 10-16.

3. If you wish to crop your photo for a standard print size (4 × 6, 5 × 7, or 8 × 10), select a cropping size from the Constrain pop-up list, as shown in Figure 10-17.

Figure 10-16: Editing a photo in iPhoto

Figure 10-17: Cropping the image to fit a 4 × 6 print

4. Use the Enhance tool to adjust leveling, contrast, and color automatically.

5. Use the Red Eye tool to clean up red-eye.

6. Use the Retouch tool to cover over unwanted elements in the photo.

7. Adjust brightness and contrast using the Brightness and Contrast sliders.

8. After you edit the photo, click the Organize tab to return to Organize view. Click Order Prints, as shown in Figure 10-18. The Kodak Print Service's Order Prints screen appears.

Figure 10-18: Connecting to Kodak from iPhoto

9. Fill out the print form, as shown in Figure 10-19, and follow the links to check out.

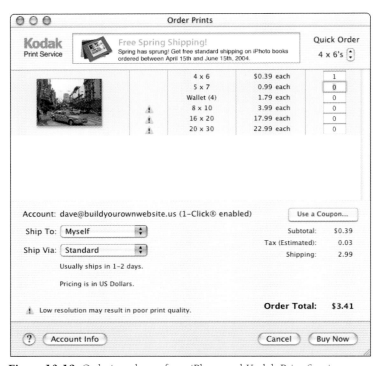

Figure 10-19: Ordering photos from iPhoto and Kodak Print Service

Specialty Heat Transfer Print Shops

A rather amazing network of craftspeople operate online dye sub print shops that produce dye sublimation–quality photos on an imaginative array of surfaces. Need your photo on a baseball jersey? How about a plate?

These small, regional print shops use both dye sub and heat transfer technology to apply photos to these materials. Heat transfers are durable, long-lasting, and apply high-quality color printing. My friends at North Texas Graphics (www.northtexasgraphics.com), for instance, use an Alps printer to place photos on jackets, hats, mouse pads, aprons, polo shirts, bags, and many other materials.

Thermal printers produce near-photo quality output using a process similar to dye sub printing. The thermal print process involves heating film to release vaporized ink that impregnates fabrics and other surfaces. Because colors are released in gaseous form, a full range of color can be reproduced without the high resolution required for inkjet dithering, much like the process of generating color in their dye sub cousins.

Cross-Reference

For a full exploration of dye sub technology, see Chapter 7.

Figure 10-20 shows a mug press in action. Artwork is printed on special paper using sublimation inks. The design (logo, artwork, or photo) is cut out of the paper and taped to the mug. The mug is then wrapped with brown paper and placed in the press. A clamp tightens, and the mug press heats for four minutes to perform the sublimation process.

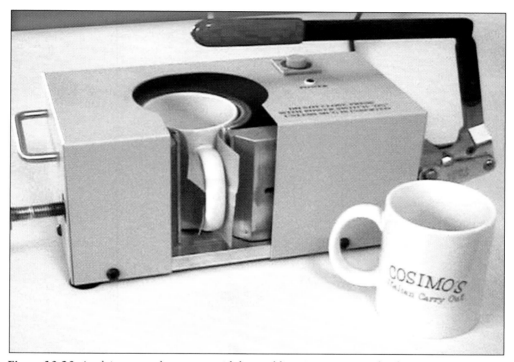

Figure 10-20: Applying artwork to a mug with heat sublimation printing technology

After the artwork is applied to a mug or other material, glaze is applied and the special ink is converted to gas bubbles. As the mug cools, the ink sublimates (returns to a solid state) and blends into the actual mug, becoming part of the glaze. The photo, or other artwork, cannot be scratched off; it is one with the mug.

If You Try This at Home ... (Even Though You Won't)

Mugs used in heat sublimation printing have to be purchased from a sublimation supplier. You cannot use just any old mug.

High-Quality Professional Printing

Professional photographers use a select level of online print services that combine higher-quality paper, more attention to detail, better customer service, and cutting-edge print technology to produce professional-quality, archival (long-lasting) prints. One such service is Printroom.com. (I use their service at `www.printroom.com/pro/davidkarlins` to fulfill orders for some of the photos you see in this book.)

Professional print services offer similar features as those for the nonprofessional—such as sharable online photo albums—but with more options for album design.

Professional galleries are used most often by photographers who sell photos of weddings and other special events. They allow buyers to view and purchase any variety of print quantities and sizes online.

To protect photos from unauthorized downloading, professional online photo services provide proofs with watermarks to prevent unauthorized prints, as shown in Figure 10-21.

Figure 10-21: Professional photographers can protect their photos from unauthorized reproduction by using watermarks.

The galleries in professional photo labs are generally more customizable than those available in consumer-oriented print labs. Professional photographers can provide various sizes of thumbnails and have more freedom to design and lay out their photo galleries. At the same time, options like black-and-white prints, posters, special media printing, and a variety of photo sizes are similar to those available at consumer sites.

The additional level of quality available at professional print services includes very expensive, state-of-the-art photo printers, and archival quality paper. Photo printers from manufacturers like Fuji or KISS used by professional online shops cost in the $150–$200 range ... and that's *thousands*.

Professional print services also provide highly accurate, frequently updated sets of ICC profiles so that photographers can soft-proof their photos before uploading and can approximate very closely the colors that will appear when a client purchases a photo online.

Cross-Reference

For a discussion of printer profiles and ICC standards, see Chapter 2.

You don't need to be a professional photographer to use professional print services; you just need to pay the higher fees they charge. Unlike the consumer online printing services surveyed in this chapter, professional print services charge setup fees to cover the additional services they provide. If you decide to "go pro," or simply want the highest print quality, by all means investigate professional print sites.

Summary

There is a time and place for turning to Web sites for your photo printing needs. Online printers use high-quality dye subs or photo printers that produce unrivaled color. Depending on quantity and photo size, you can sometimes save money with online printing.

Online printing can produce print sizes inaccessible to desktop photo printers, including large posters and 8 × 10's that you don't need to trim by hand.

Turn to an online printer for special projects. To adhere a photo to a T-shirt, you can experiment with the techniques explained in Chapter 9 or you can upload your photo and have the T-shirt printed by a professional. For even more esoteric media, ranging from mouse pads to mugs, a local or online photo print shop can create a wide variety of products using heat sublimation print processes.

Finally, if you aspire to the highest-quality photo prints for framing, professional use, or display, consider turning to a professional-quality online print shop that provides a higher level of print quality, as well as more features for selling photos online.

Preserving and Presenting Your Digital Photos

As you build your library of great digital prints, you will want to get more serious about storing and displaying them. Professional photographers sell limited editions of signed, archive-quality digital prints at steep prices. Moms, dads, and teenagers scrapbook and frame excellent-quality photos and expect them to last for decades.

On the one hand, some digital photo prints are best passed around, enjoyed, and left to pile up in a drawer to be organized into a folder "someday." Part of the fun of printing digital photos is the immediacy of sharing an experience with others — just minutes after it happens. Digital photos can also be saved for reprinting later, as long as the files are safely stored on a carefully labeled CD/DVD or other storage medium. On the other hand, this entire book is dedicated to helping you print out seriously high-quality digital prints. Now that you've learned everything you ever wanted to know about printing great digital photographs, this chapter covers what to do with all those fantastic-quality prints you're churning out with your newfound skills.

Digital photography has passed into the realm of fine art. Nicely framed digital photos, like the one in Figure 11-1 — on display at the studios of LightRoom digital photo lab in Berkeley, California — can be enduring and inspiring.

Figure 11-1: A framed digital print

Digital Archiving

This chapter explores some approaches and techniques for storing, displaying, and sharing your digital photo prints. Before examining how to preserve and display photo prints, it is worthwhile to talk briefly about storing those files electronically, also known as digital archiving.

Entire chapters in professional-level digital photography workflow books are dedicated to creating systems to organize, name, and store your original photo files. That level of digital archiving advice is beyond the scope of this book but as your collection of photos grows, you need to figure out a system for storing and accessing them. A simple, relatively safe method is to store groups of photos on accurately labeled CDs and store them safely for future access.

Save Photos at Their Full Size

Archived digital photos should be saved in non-lossy formats like TIFF (or JPEG 2000) and should never be reduced in size or resolution.

One way to avoid accumulating stacks of memory cards or CD/DVDs randomly around the living room, study, or kid's room is to rename the photo files right before you store them permanently on CD/DVD. After you move your photos from the camera or memory card to your computer's hard drive, rename them ASAP so that you can easily distinguish among those taken on your recent vacation from those taken at your cousin's wedding, your neighbor's graduation, and so on. Some image editing programs have tools for renaming photos.

You can quickly rename all photo files in a folder in Windows XP by following these steps:

1. View a folder of photos in thumbnail view in Windows Explorer by choosing View → Thumbnails from the Explorer menu, as shown in Figure 11-2.

Figure 11-2: Viewing a folder of photos in Thumbnail view

2. Press Shift+click (to select blocks of contiguous photos) or Ctrl+click (to select photos one at a time) to select the photos you want to rename.

3. Right-click the first photo in the sequence and then choose Rename from the context menu.

4. After entering a new filename, click anywhere in the folder outside the selected photos. The entire set of selected photos is renamed, using the filename you provided for the first file as the root name for all the rest, as shown in Figure 11-3.

Batch Renaming in Mac OS X

To rename a series of photos in iPhoto, choose View → Film Rolls and click the Organize button. Click a film roll and enter a new name in the Title field to rename all the files in the roll.

Store your helpfully named photos on a CD/DVD and store them safely in a CD album for safekeeping. CDs hold hundreds of photos and are easy to share because any photo CD can be read on any current-generation computer running Windows or Mac OS.

Figure 11-3: Renaming a batch of photos

Future of Photo File Storage

As new photo file formats (like RAW) emerge and attain widespread use, and as digital cameras support the capturing of more megapixels of data, photo file storage devices continue to evolve. The current selection of options — CD, DVD, memory cards, and so on — will no doubt be supplanted by better designed and smaller devices that hold ever-larger quantities of digital data. This is something to keep in mind as you store your files today.

Online Archiving

Many of the online photo printing services surveyed in Chapter 10 also provide online galleries to store and share digital photos. The amount of photos you can store, the length of time you can store them, and the tools for sharing (or not sharing) photos vary greatly among these online photo processing sites. Professional-quality online print services (like Printroom.com) provide additional safeguards and protect your original photos from unauthorized duplication.

Online archiving is a great way to store a lot of photos and share them. But don't bet on online storage as your ultimate backup solution. The editing features available at many of these online sites for cropping, altering, and resizing photos actually corrupt the original file, and you cannot always revert them to the original format. Besides, do you really want to trust your important photos to someone else's Web site?

In Windows you move your photo files from the hard drive to a CD/DVD by selecting a folder of files (use Ctrl+click to select many different files). Then right-click the selected files or folder(s) and choose Send To. Select a CD (or other external) drive from the context menu, as shown in Figure 11-4.

The SendTo Folder

It's likely that your internal and external drives (if any) are among the default choices when you right-click and select Send To from the pop-up menu, but if not, note that you can customize the destinations that appear there by adding shortcuts to the SendTo folder. In Windows 98, the path is C:\Windows\SendTo. In Windows 2000 and Windows XP, the path is C:\Documents and Settings\ *username*\SendTo. (If you don't see the SendTo folder in these locations, it's probably hidden. To show it, select Tools → Folder Options in any Explorer window, and on the View tab of the ensuing dialog box, check the radio button for "Show hidden files and folders.")

Figure 11-4: Moving selected photos to a CD or other external drive

In Mac OS X, you can burn any file to a disc by defining how blank CD/DVDs are handled. To do this, first set your system preferences correctly and follow these few simple steps:

1. Select Apple menu → System Preferences → CDs and DVDs.

2. Set "When you insert a blank CD:" to "Open Finder" in the drop-down menu.

3. Insert a blank disc.

4. After defining which files should be saved to the CDDVD, drag the disc icon to the burn icon (normally the trash icon). The disc will burn. You can also select photos in iPhoto and click the burn icon in the iPhoto window.

Preserving Prints

While digital archiving in theory allows you, your descendants, or generations to come to print high-quality photos from your original photo files, there are times when it's appropriate to preserve and display the print itself for a long time. Particularly as your skill at printing digital photos increases, there will be wonderful prints that are worth saving and displaying.

Printed digital photos can be protected in scrapbooks to share with friends or be displayed in expensive frames as works of art that will keep their original quality for decades. Of course, some photos are meant to be passed around immediately after they're taken — and then forgotten. As your expertise in taking and printing photos increases, however, you might come across a print you wish to display or give as a gift.

What Does Archival Quality Mean?

The word *archival* generally refers to the ultimate standard in preserving artwork. A bit of a controversy is brewing over "archival" quality digital photos. Archival prints last a long time without deteriorating in quality, but how long is that? What is archival *quality*? Are there particularities to the way digital photos are created that present unique archiving issues?

The short answers to these intriguing questions are as follows:

- While there is no official definition of longevity, an archival print is generally considered to be safe for 60 to 80 years.

- Archival quality refers to paper, print, and storage techniques that preserve the photo's original print quality for the life of the photo.

- There are some particularities to archival issues for digital photos, including the fact that the ink used in most inkjet processes is not as stable as traditional photo printing. Many of the challenges (and solutions) for long-lasting prints are the same as those for traditional film photography or other artwork.

The vast majority of printed digital photos do not need to meet archival quality. However, knowing how digital photos attain that standard is helpful to anyone interested in preserving photos. Pick and choose from the techniques and tools used for archival preservation and

presentation of digital photos, and decide for yourself how much time and money you want to invest in your own photos.

Maintaining an Acid-Free Environment

From paper selection to storage and framing, a key element in reducing the rate of deterioration of a photo is to maintain an acid-free environment. This is not the only factor in preserving photo quality — air, light, and other obvious factors like water or damage affect the life of a photo too — but avoiding acidic products in printing and presenting photos is a truism that applies to all situations where longevity of photo prints is paramount.

Unfortunately, wood-based products are acidic. Because pictures are printed on paper, mounted in wood frames, and protected by and presented in paper matting, this presents an obvious challenge: How do you avoid wood products in printing and storing photos?

The best acid-free paper is made from cotton rag or other non-wood material. Acid-free paper is becoming more accessible as legions of home digital photographers begin to demand longer-lasting photo paper. Other acid-free paper is wood-based but has its acid chemically neutralized or removed. Cotton-based, acid-free paper is more expensive and provides the ultimate in acid-free protection for photos.

Epson makes acid-free matte scrapbook paper, semi-gloss paper, and other products. Other manufacturers offer a wide variety of acid-free paper, ranging from under $2 per sheet to $20 per sheet, and on up.

To protect valuable photos from exposure to acid, handle them with cotton gloves, avoid using wood-based (acidic) paper, and use non-acidic options to store and frame photos. I address those options throughout the rest of this chapter.

Acid-Free Paper Resources

You can find many choices for acid-free paper at Inkjetart.com. Try `www.inkjetart.com/wc/ hahnemuhle.html` or go shop at the Inkjet Mall at `www.inkjetmall.com/store/paper/ legion-paper.html`.

Using Archival-Quality Inks

As demand for long-lasting prints grows, manufacturers are developing inkjet inks and inking processes that last longer than photos produced by early generations of inkjets. Chapter 5 explored in some detail the complicated process of shooting droplets of ink onto, and into, photo paper — the process used by inkjet printers. Dye sub printing (covered in Chapter 7) applies ink in a more direct way and is generally considered more permanent.

Inkjet, dye sub, or traditional photo processing is a temporary process. One important factor deciding whether a photo fades or degrades in quality in two years, 20 years, or 100 years depends on the ink used for printing. Epson's UltraChrome inks were a breakthrough in ink longevity. But in the past couple of years, Epson's other inkjet inks — and those of other manufacturers — have improved significantly. Manufacturers claim they can last up to 200 years if properly stored in photo albums.

Care and Handling of Digital Photo Prints

Much of the deterioration of digital photos happens not decades or centuries after printing but *minutes* after printing. Care in handling digital photo prints for their first, fragile 24 hours of life is important if you want a long-lasting, good-looking print to scrapbook or frame.

Two rules summarize proper handling and care of digital photos: Let photos cure properly and handle them with cotton gloves. Do not frame or store digital prints for *at least* 24 hours after printing — the ink takes time to dry and cure and become stable. Avoid smudging photos with fingerprints. Cotton gloves protect prints from acid and grease.

If you trim photos, or handle them in the storing and framing process, take care to avoid getting fingerprints on them. This advice isn't particularly new to the world of digital photos. However, digital photos fresh out of an inkjet or dye sub printer are particularly susceptible to smudging and smearing. Let them dry face up in a clean, room-temperature environment and definitely avoid exposing them to bright lights or direct sunlight.

Framing and Displaying Photos

High-quality framing involves many elements. Proper backing paper helps preserve the photo. Matting plays an important aesthetic role in how a photo looks in a frame and is critical for preserving the photo as well. Appropriate choices of glass contribute to how long a photo lasts without deterioration.

Displaying framed photos can shorten their life. All artwork deteriorates in directly light — take that into account when you hang photos.

A professional framer can help you select mat board, backing, frame, and glass that are appropriate to your photo. High-quality professional framers use acid-free materials and handle photos in a way that respects the fragility of the finish. If you frame the photo yourself, you can incorporate techniques used by museum-quality framing studios to achieve attractive, protective results.

Professional framers provide aesthetic advice on how to color-coordinate frame and mat colors to emphasize the colors in your photo. Frame colors can enhance, or detract from, a photo by drawing out its colors. Schools of thought for mat board colors range from shades of white on the conservative end of the spectrum to adventurous color schemes that complement or contrast the image. In Figure 11-5, a dark mat provides a contrast to the bright colors in the photo.

Photo and Frame Size

My first word of advice: Photos that are prepared for framing should have borders. Borderless photos are very cool for 4 × 6 snapshots — they add 10 percent or so more space to the photo and improve the image. Borderless 8 × 10 or 8½ × 11 prints are fine as well. You can display 8 × 10's in frameless glass, pass them around the office, or even use them in court as evidence. They just don't frame very well.

Part of the reason is that framing requires a method for mounting photos against backing material so that the photo doesn't slide around in the frame. Matting is also an important part of the framing process (see the next section, "Framing and Matting Techniques").

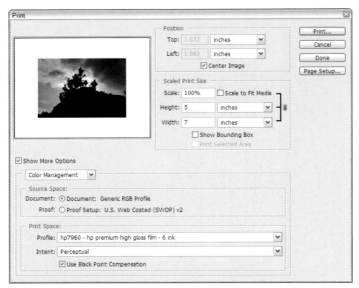

Figure 11-6: Preparing to print a 7 × 5 print on letter-sized paper, leaving plenty of room for framing later

Table 11-1 What Size Frame You Need

Photo Size	Frame Size
3½ × 5	5 × 7
4 × 6	8 × 10
4½ × 6½	8 × 10
5 × 7	8 × 10
8 × 10	11 × 14

Figure 11-7 shows the elements of a framed digital photo: the frame itself, the mat, the photo, the photo paper on which it is printed, and the acid-free cotton paper clips that hold the photo paper in place.

All these materials are available at various price levels. Framing stores like Aaron Brothers (stores in the West, South, and East of the United States or online at www.aaronbrothers. com) have frames with matching acid-free mats and backing paper in a wide variety of sizes.

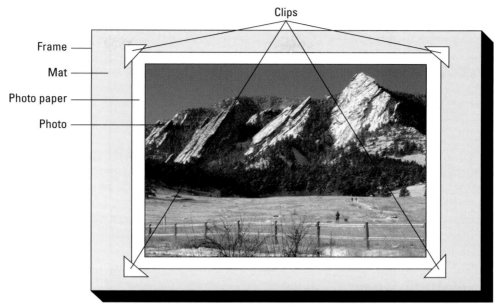

Figure 11-7: Elements of a framed photo

Framing and Matting Techniques

Proper framing protects a photo from exposure to glass or acidic paper. Photos should be printed with sizable borders and then trimmed to fit the framing material. Framing also enhances the effect of a photo—often in dramatic, surprising ways. While a photo frame and mat should not overshadow or compete with the photo's content, a well-chosen frame and mat combination emphasizes elements in a photo and allows it to be viewed with a new perspective.

The advantage of using 100 percent cotton rag mat and museum board is that it prevents acid contact with the back of the photo, thereby preserving the paper. Regular matting or backing paper can leave an imprint on a photo within a couple of years as a result of the acid degrading the photo paper.

Wood Contains Acid

Part of the role of framing is to separate the photo paper from contact with a wood frame. Because wood contains acid, direct exposure to wood (or wood-based paper) contaminates the photo paper.

Aesthetically, mat color and design is a matter of taste. Fun, decorative matting and framing has a place. In general, however, the adage "less is more" applies. Museum-quality matting is generally constrained to various shades of white, while other gallery art can stretch the color bar a bit. Muted mat colors enhance but do not disrupt a photo's presentation, as shown in Figure 11-8.

Figure 11-8: Subtle color matting emphasizes the photo, not the display.

Glass Options

The first rule of applying glass to a framed digital photo is to avoid direct contact between the photo and the glass. It's not that digital photos — from inkjets or dye subs — are more inclined than other artwork to soak into glass. All artwork tends to seep into glass and should be kept separated by the padding provided by the mat.

For exceptional protection, UV-protected glass can help prevent ink and paper from degrading. Perfectly clear framing glass is available with up to 98 percent UV protection. For display in homes with kids, consider non-shattering plastic instead of glass. Specialty framing shops can direct you to glare-free glass as well.

Avoid Gas on Glass

Framing a photo too soon can result in gas — generated as part of the curing process of inkjet ink — clouding the inside of the photo frame glass. Let photos air out for at least 48 hours before covering them with glass or plastic.

Digital Scrapbooking

Precious photos of memorable events, or collections of nicely done photos, can be preserved and shared with scrapbooks. A grassroots community of online scrapbook enthusiasts provides tons of resources for scrapbooking concepts, design ideas, and tools — as does the network of scrapbook shops and professional scrapbookers.

Digital photos are easily organized onto digital scrapbook pages that can be bound and stored in traditional scrapbooks. With archival ink, special archival digital scrapbook paper, and proper handling, you can create long-lasting digital scrapbooks to document any event, experience, or collection of photos.

Archival-Quality Digital Scrapbooks

Printer manufacturers and third-party paper distributors offer a range of software and paper for digital scrapbooking. The software helps you organize and lay out photos on a page, add captions, create collages, and even superimpose photos on top of each other, and then print on special acid-free scrapbook paper for long-term storage.

Epson Matte Scrapbook Photo Paper is available in traditional 12 × 12 scrapbook size as well as in the 8½ × 11 size that fits most printers. All digital photo scrapbook paper is printable on both sides for double-sized scrapbook pages. Special scrapbook layout software is available from a number of sources. Cottage Arts (www.cottagearts.net), for example, sells several digital photo design programs at nominal prices.

Digital Photo Collages

Just as digital editing makes it easy for everyone to run a digital darkroom, digital scrapbooking makes it fun for everyone to create scrapbook pages from digital photos. Before you lay out and print digital scrapbook pages, you can trim photos to create wild, layered collages that combine several photos.

Many programs can help you do this. Adobe Photoshop Elements (or Photoshop) is great for creating collages, but if you don't want to wade through the rather high learning curve required for that level of program, you can use special collage software that makes it easy to create collages by dragging photos onto a virtual scrapbook page.

A program called Microsoft Digital Image Pro prepares digital photos for printed scrapbooks (available at www.microsoft.com/products/imaging/products/dipinfo.asp).

Collage Tutorial

A tutorial for using Photoshop Elements to make collages is available from Adobe at www.adobe
.com/education/digkids/lessons/activities/valentine_scrapbook.html.

Digital scrapbookers willing to invest the time, or who have Photoshop Elements (or Photoshop) already, can design enjoyable collages with Photoshop Elements with the help of this detailed tutorial.

A very simple and fun program for generating collages for digital scrapbooks is ArcSoft Collage Creator (available from www.arcsoft.com). Collage Creator works in Windows only. Because it creates only photo collages, it's easy to use.

When you launch Collage Creator, follow these steps to put together a photo-and-text collage:

1. Use the Browse button to navigate to a folder containing photos you want to use in the collage, as shown in Figure 11-9.

Figure 11-9: Choosing photos from which to put together a collage in ArcSoft Collage Creator

2. Drag your photos onto the page. Simply click and drag to move them to new locations on the page, as you like.

3. With the Crop tab selected, choose one of the preset cropping shapes and click on a photo, as shown in Figure 11-10. Click the Apply button to edit the photo shape.

4. For special scrapbooking effects, including fades and newspaper cutouts, use the various tools in the Effects tab, as shown in Figure 11-11.

5. Use the Add Pieces tools to add text and doodling to the scrapbook page.

Figure 11-10: Choosing layout shapes for photos

Figure 11-11: Applying special effects to scrapbook photos

6. After you are satisfied with the page design, click the Print tool. Use the Printer Setup button to access printer properties and then click Print to create a scrapbook page, as shown in Figure 11-12.

Figure 11-12: Digital scrapbooking is easy with Collage Creator.

Summary

Digital photos are no longer good just for using once and throwing away. This book has given you all the information you need to create your own personal masterpieces for future generations to enjoy. Digital photos can be preserved as digital files on CD/DVDs and reprinted whenever necessary. The unique experience of sharing and enjoying a great digital photo print requires care in printing, handling, and preserving the photo.

Digital photo files should be cataloged with names that make them findable and saved on CD/DVDs. Online galleries that provide storage space are a good way to share photos but they are not a reliable way to save them.

Framing digital photos is similar to framing any work of art. Framing materials—backing paper, mat board, and clips should be acid-free to protect the photo from exposure to acidic wood or paper, and to protect the photo from direct exposure to glass. UV-protective glass or high-quality plastic offers different advantages for photo framing. UV glass provides the most protection for photos, while shatterproof, high-quality plastic is safer for homes with kids.

Finally, the digital industry has clued in to the fact that scrapbooking has gone digital. Special papers and software from various manufacturers allow you to lay out, print, and store photos in scrapbooks that promise to preserve them for over 100 years.

No matter how you choose to display your digital photographic prints, you can achieve a longer lifespan for your photos by following a few simple rules:

- Print on acid-free paper whenever possible

- Always allow prints to dry untouched at room temperature without exposure to direct sunlight

- Use cotton gloves whenever handling the photo print

- Mount the print under a mat to prevent the glass from coming into direct contact with the photo print

- Use acid-free mounting supplies whenever possible

Index

Numerics

A

B

continued